Splash 17

Inspiring Subjects

THE **BEST** OF WATERCOLOR

EDITED BY RACHEL RUBIN WOLF

NORTH LIGHT BOOKS
CINCINNATI, OHIO
artistsnetwork.com

CONTENTS

INTRODUCTION

What is the first step in watercolor? Some practical types may say it's buying materials or having a good space to work. True enough. But once that is done, what motivates us to paint? Well, we can all thank Thomas Edison for a visual metaphor that seems as natural as the sun—a light bulb indicating the "light going on," representing an idea or an inspiration.

What is inspiration? The word literally means "the drawing in of breath." And so Kathleen Lanzoni's thought on the facing page captures it perfectly.

Inspiration—something that makes us draw a breath or takes our breath away—can come from outside or inside, usually a combination of both. We are designed to respond emotionally to the natural world, and so the radiance of light on the earth's beauty speaks to most of us. But we can also be inspired by things that touch us because of past experiences or connections, or simply by unexpected beauty or something curious, like watching watercolor move and blend on paper.

Why does one painter love painting people in daily life, and another artist can't get enough of sunlit still lifes? Still others find inspiration wherever they go, whether a lovely table setting, a rain-splattered windshield or a funny-looking cow in a pasture. Some artists prefer to play with watercolor until they find inspiration in an emerging imaginary subject. At times, a deeply moving experience, perhaps the birth of a child or the death of a loved one, drives us to express ourselves in paint.

These are all responses of the uniqueness of our particular human nature. We breathe in together, yet exhale with fascinating variety—as we see in this volume of *Splash*.

Rachel

4

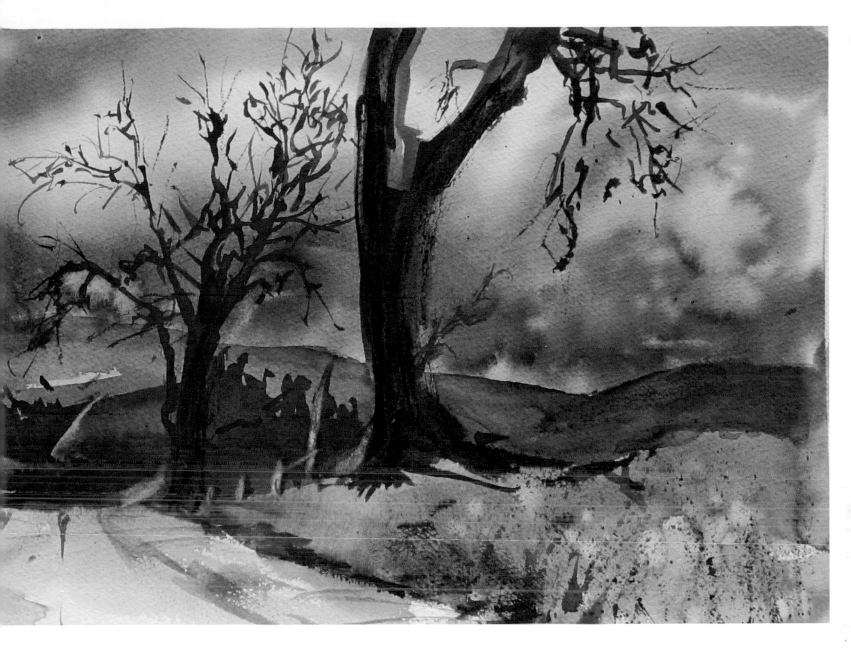

PURPLE RAIN
Dieter Wystemp
Transparent watercolor on 140-lb. (300gsm)
cold-pressed Saunders Waterford
10" × 27" (25cm × 69cm)

COLOR EXPRESSES MOOD

Landscape paintings have been my first love ever since I dove into the world of watercolors about ten years ago. *Purple Rain* was inspired by a black-and-white reference photo, but as I often do, I deviated from the colors of the original setting. I was captured by the overall mood and the sense of imminent rain that the dramatic clouds conveyed, and I tried to exaggerate this feeling by the choice of purplish colors. Because of the wet-into-wet technique, the piece was done rather quickly, avoiding too many details.

Whatever made you hold your breath or turn your head the first time you saw it, that is what you should paint! —Kathleen Lanzoni

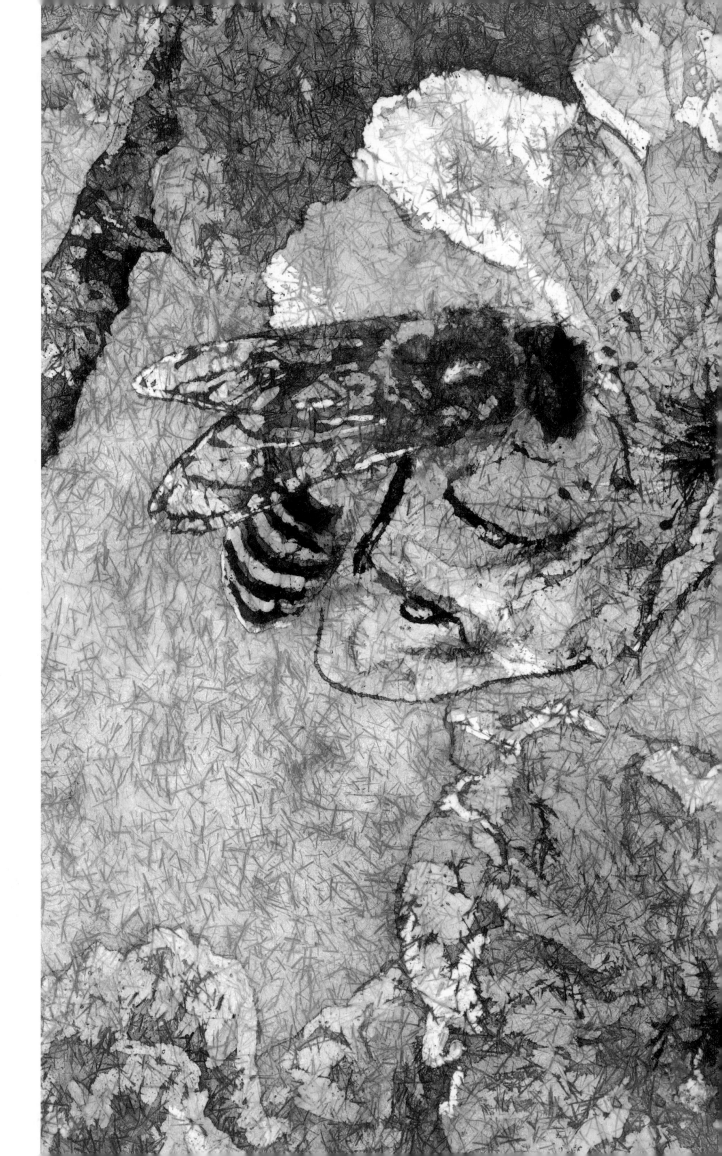

1 FRUIT & FLOWERS

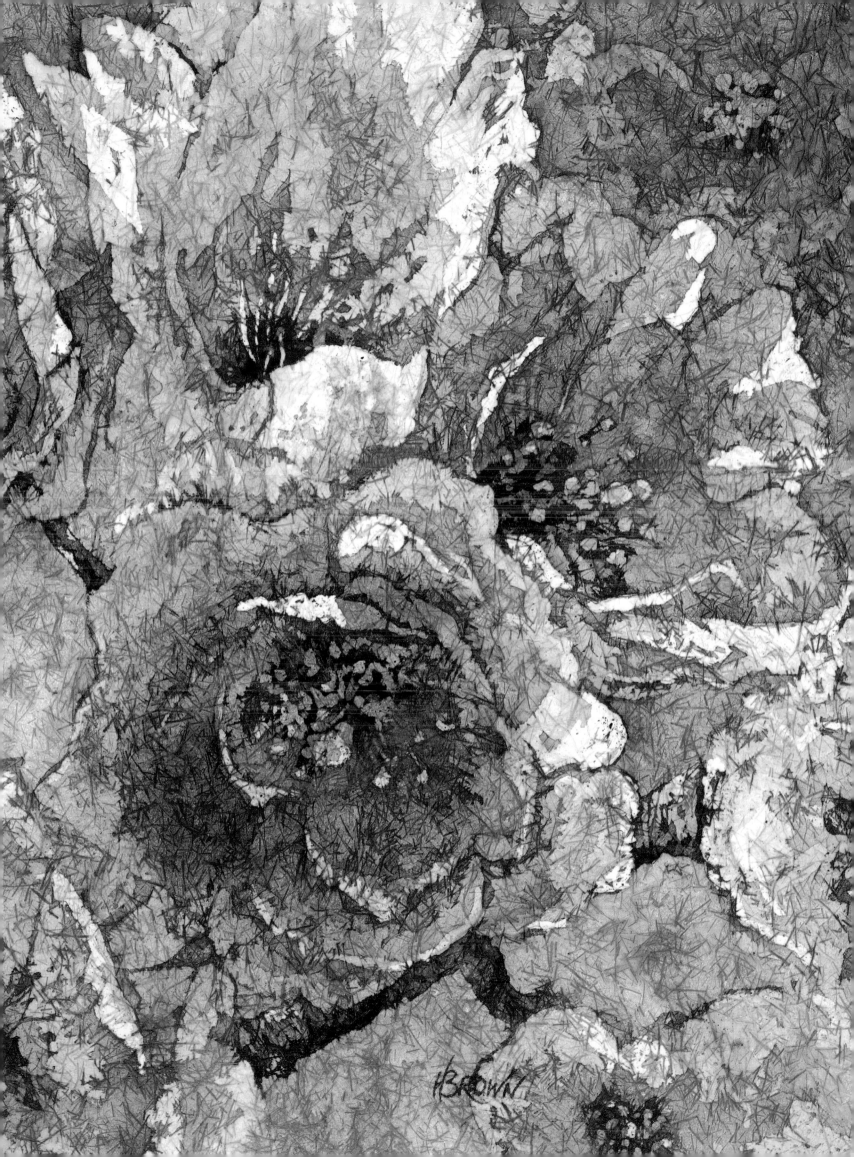

BEE MY GUEST
Helen Brown
Transparent watercolor batik on
rice paper
21" × 28" (53cm × 71cm)

CALL ATTENTION TO A CRITICAL ISSUE

This watercolor is part of the *Struggling Species* series that I painted for the benefit of the Nature Conservancy. While the series included wolves, bald eagles, puffins and monarch butterflies, the struggle that most inspires me is the plight of the honeybee. Many of the fruits and vegetables we eat are heavily dependent upon a healthy population of bees for pollination. These crucial insects deserve our attention and action to restore the well being of their colonies. I live in Oregon where we see orchards of fruit trees blossom and attract bees to their flowers. My painting is a tribute to these valuable creatures and our bountiful orchards.

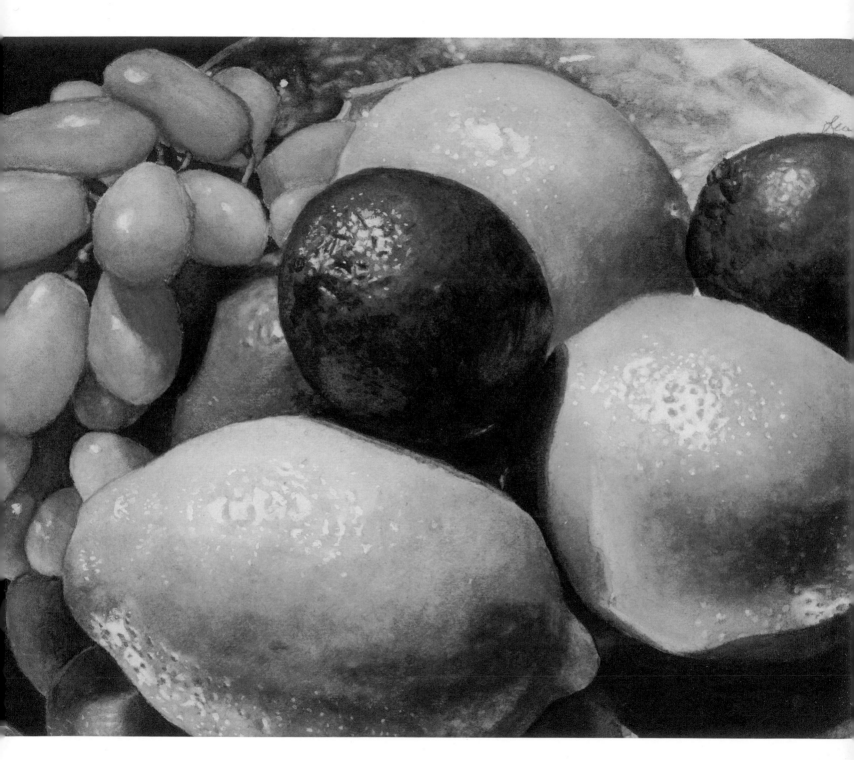

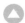

LEMONS AND LIMES
Lea Barclay
Watercolor on paper
7½" × 9½" (19cm × 24cm)

EXTRAORDINARY SUMMER LIGHT

In my twenties I lived in France and the lasting impression of the extraordinary light and the beautiful color of the south will always remain. The depth of intense hues and the incredible contrast that vibrant light can create gave me lasting inspiration. With this in mind I framed this still life on a hot summer's day outside my studio. Having a background in oil painting, I applied a multitude of glazes of rich watercolor in an attempt to capture the sublime beauty of a summer in Provence. My goal was to create the sensation as if you could pluck a piece of fruit right from the canvas.

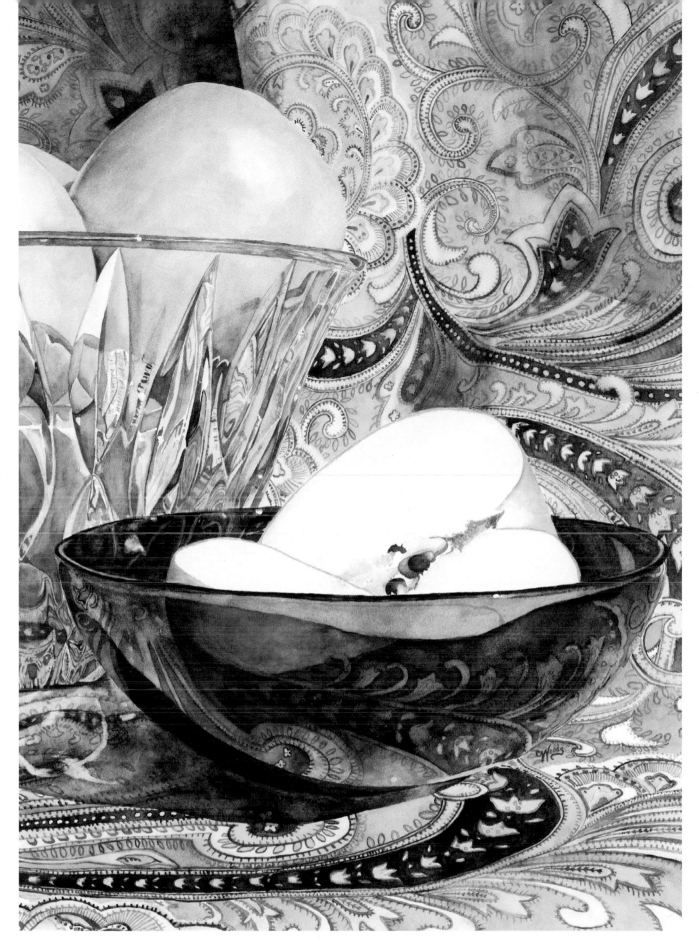

GREAT GRANNIES
Catharine Millar Woods
Transparent watercolor on 140-lb.
(300gsm) cold-pressed Arches
21" × 15" (53cm × 38cm)

INTRIGUING ABSTRACTIONS

Abstract and representational art intersect in paintings that include crystal objects. I am intrigued by the abstraction that is naturally created in the facets of crystal and cut glass. When I set up a still life, I spend several hours photographing different combinations of objects, varying the lighting conditions and the viewpoint. On my computer I view them as small thumbnails, selecting a few that catch my eye because of their overall composition. The final reference will be a photo that includes eye-catching abstract areas within the crystal facets. The challenge is to draw and paint what you really see, and not what you think *should* be there. Try turning your photo reference and your painting upside down!

 FALL MAGNOLIA
Linda Erfle
Transparent watercolor on 140-lb. (300gsm) cold-pressed Arches
18" × 24" (46cm × 61cm)

ONE'S PERSONAL ENVIRONMENT

Our magnolia tree, just off the patio and visible from the dining
room, provides beautiful, fragrant blooms in early spring that are
often the focus of my paintings. It is also stunning in fall, when the
leaves turn an incredible Quinacridone Gold set against a backdrop
of Cerulean/Cobalt Blue sky. I first captured several images with
a camera in morning light and then altered the composition in
Photoshop by adding/deleting elements to improve the composition,
creating an arrangement with pleasing shapes for the subject as well
as the negative space. The painting was completed in my studio,
begun very wet, with darks and details added as the paper dried to
barely damp.

 MANTIS WITH CHIVES
Linda Erfle
Transparent watercolor on 140-lb. (300gsm) cold-pressed Arches
20" × 13" (51cm × 33cm)

USING THE SUBJECT TO DEFINE THE COMPOSITION

The praying mantis is a common sight in the garden throughout
the summer into fall and a frequent subject for my paintings. This
camouflaged, beneficial insect is intriguing to observe in the way it
tracks you or its prey with its large compound eyes and 180-degree
turn of the head. It is the elongated form of the mantis that inspires
me, particularly because of the way it divides the background into
interesting shapes. For this particular shot I moved the mantis to the
stem of a nearby chive blossom, where it remained and allowed me
time enough to shoot its portrait, from which I did this painting.

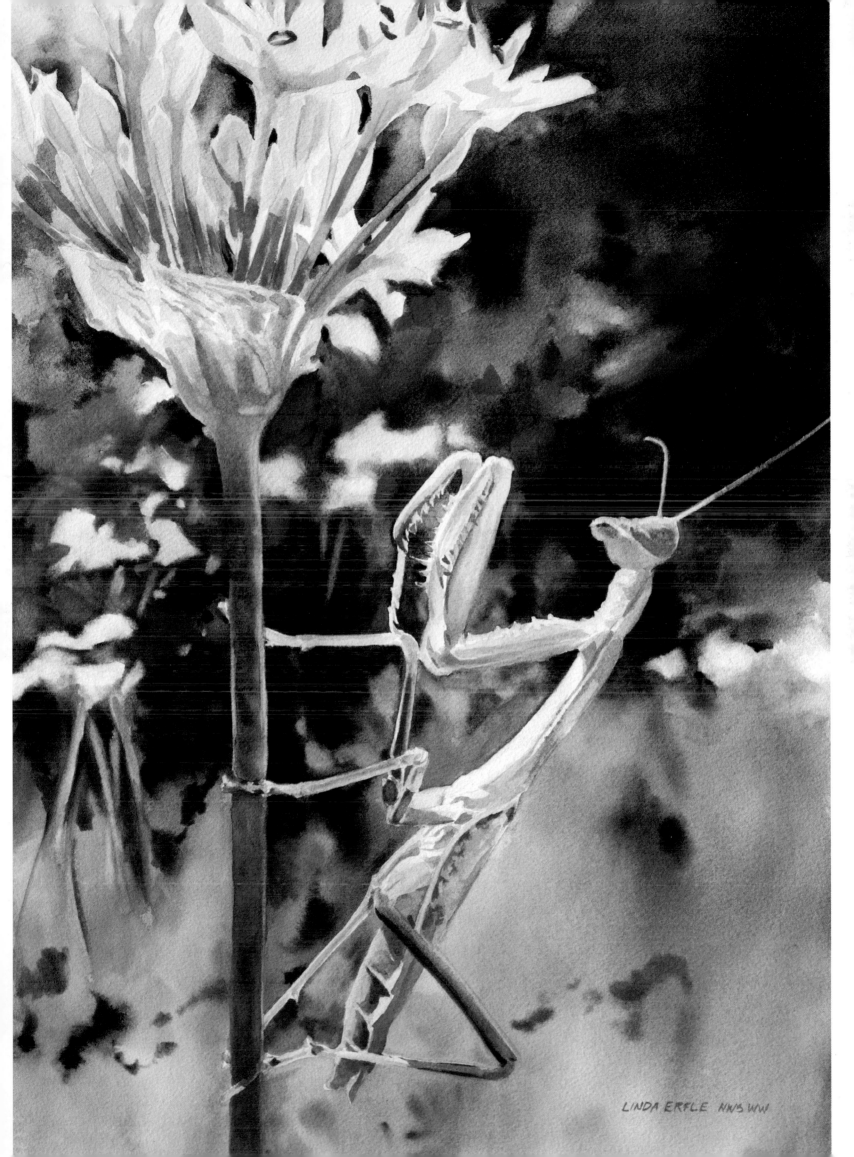

LINDA ERFLE NWS WW

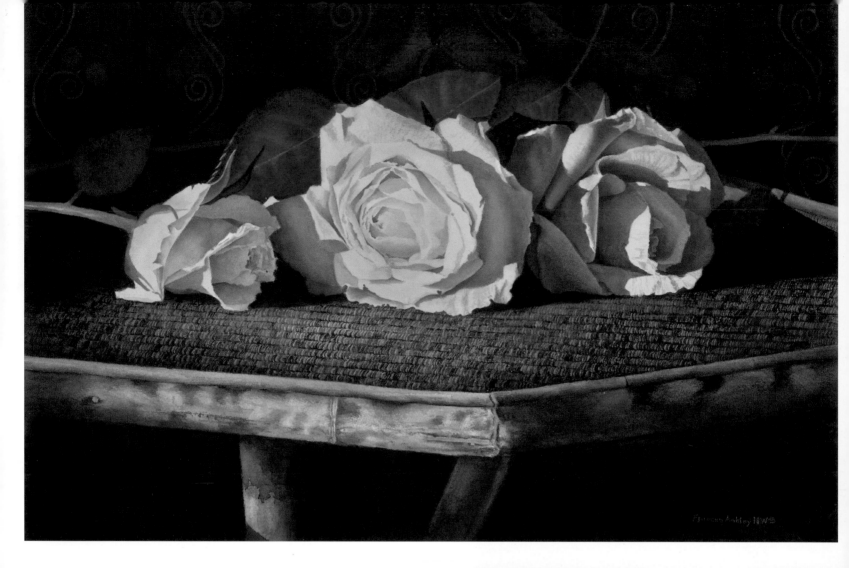

THREE ROSES
Frances Ashley
Watercolor on 300-lb. (640gsm) cold-pressed Arches watercolor paper
19" × 27" (48cm × 69cm)

GLAMOUR OF THE ROSE
I love to paint still lifes but I rarely paint flowers. However, these three white roses begged to be painted! The first step was to photograph them, paying particular attention to how the light played on the flowers. I like to deeply saturate my backgrounds with layers of paint to achieve rich darks, both lifting and applying paint.

SUMMER FIRE
Nancy Meadows Taylor
Transparent watercolor on 555-lb. (1170gsm) cold-pressed Arches
41" × 29½" (104cm × 75cm)

HONORING THE BEAUTY OF NATURE
Flowers have been a mainstay of inspiration since I began painting many years ago. The time I spend tending them in my garden yields many opportunities to observe the way light transforms an already beautiful object into something magnificent. Acknowledging that a painting can't surpass nature, my solution is to exploit the use of scale, the drama of backlighting and the randomness of surrounding color and pattern in the composition. A detailed full-scale value drawing in pencil precedes the painting process. With it I assume ownership of the image, allowing me to step away from the photograph with my personal interpretation. Problems can be worked out, but most important, the drawing lets me stay in the mood of my concept.

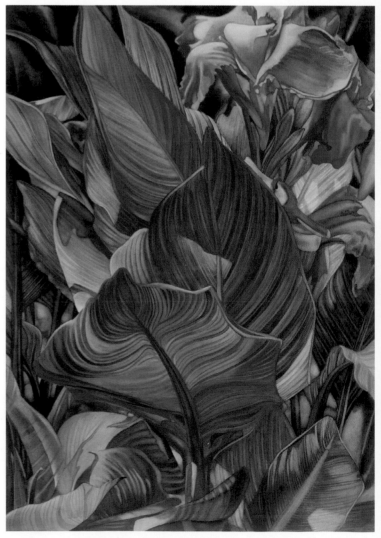

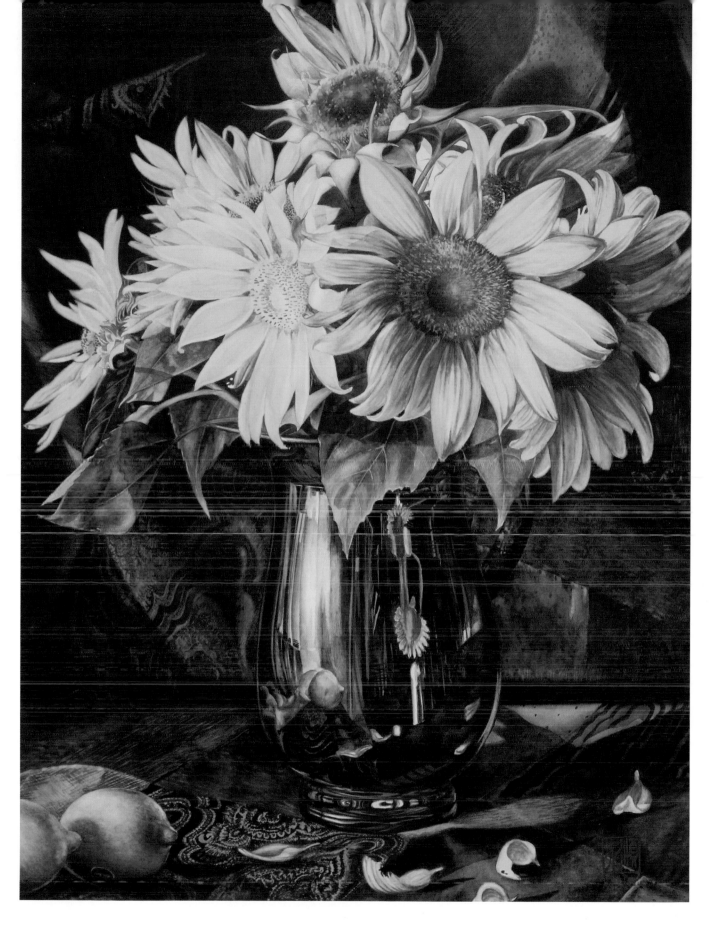

▲ SUNFLOWERS
Soon Y. Warren
Transparent watercolor on 140-lb.
(300gsm) cold-pressed Arches
30" × 22" (76cm × 56cm)

SUNFLOWER DIVAS
Layering technique in watercolor can do wonders to render realism. In *Sunflowers* the complicated dark fabric design was created with many layers of applications. First I applied several layers of light yellow and brown tones to delineate the overall value of the background from the foreground sunflowers and pitcher. Then I started to divide larger patterns of fabric by layering the color of the cloth patch. Finally, I painted the details of pattern to finish the background. After that, the process of painting the sunflowers and the reflection of fabric in the pitcher is simpler and less time-consuming. The yellow sunflowers shine out from a warm and dark background with intricate texture.

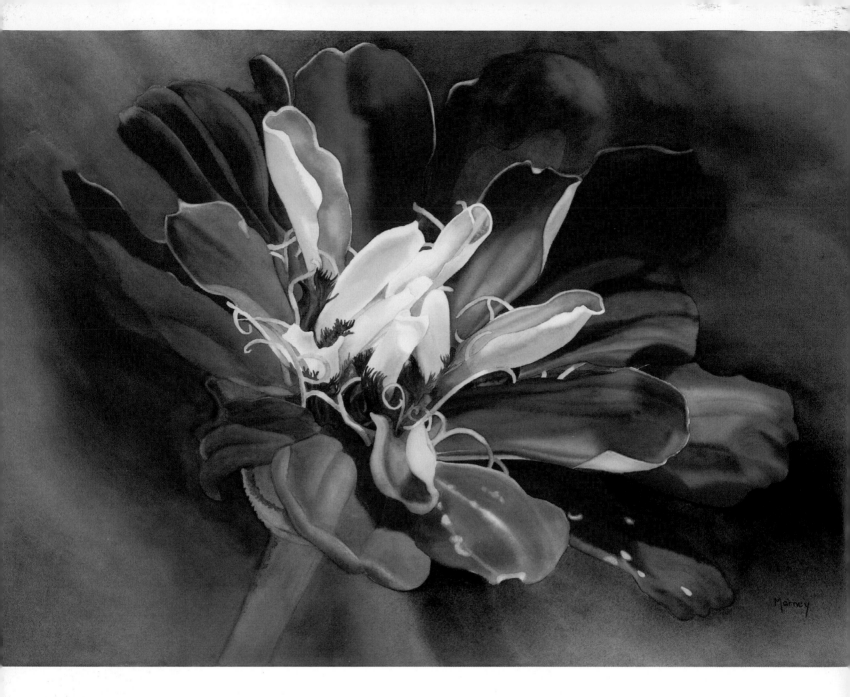

 ZINNIA

Marney Ward
Transparent watercolor on 140-lb. (300gsm) cold-pressed
Winsor & Newton
21" × 29" (53cm × 74cm)

LUSH RED ZINNIA

As a floral watercolor artist I longed to paint zinnias, but their thick, fleshy petals and saturated colors always seemed more suited to oils or acrylics. When I took this photo, I had that tingling "aha" moment: Here was my watercolor zinnia. I love combining crisp, clean edges with soft, blended ones, so the way some petals melted into the blurry red background was perfect. The center of the flower is a fusion of contrasting colors, values and textures. Unifying everything is the liquid presence of red, which bleeds from the petals into the background and seeps back over the stem like a pink veil.

 COCONUT PALM

Nancy Baldrica
Transparent watercolor on 300-lb. (640gsm)
cold-pressed Arches
30" × 22" (76cm × 56cm)

PALM PATTERNS AND TEXTURES

While on the beaches in Kailua, Hawaii, I was intrigued by the patterns, textures and vibrations happening in the coconut palm trees. As I was looking at my reference photos of the palms, I was inspired to transform the interesting variations of the green image into a kaleidoscope of color. I first poured an underpainting of primary colors onto the wet surface and let the watercolor paint itself. When it was dry, I masked out the lightest values, then painted the individual shapes using direct painting and negative painting techniques. The underpainting of color contributed to a splendid glow throughout the design.

Enjoy the excitement of creating color from a monochromatic image. —Nancy Baldrica

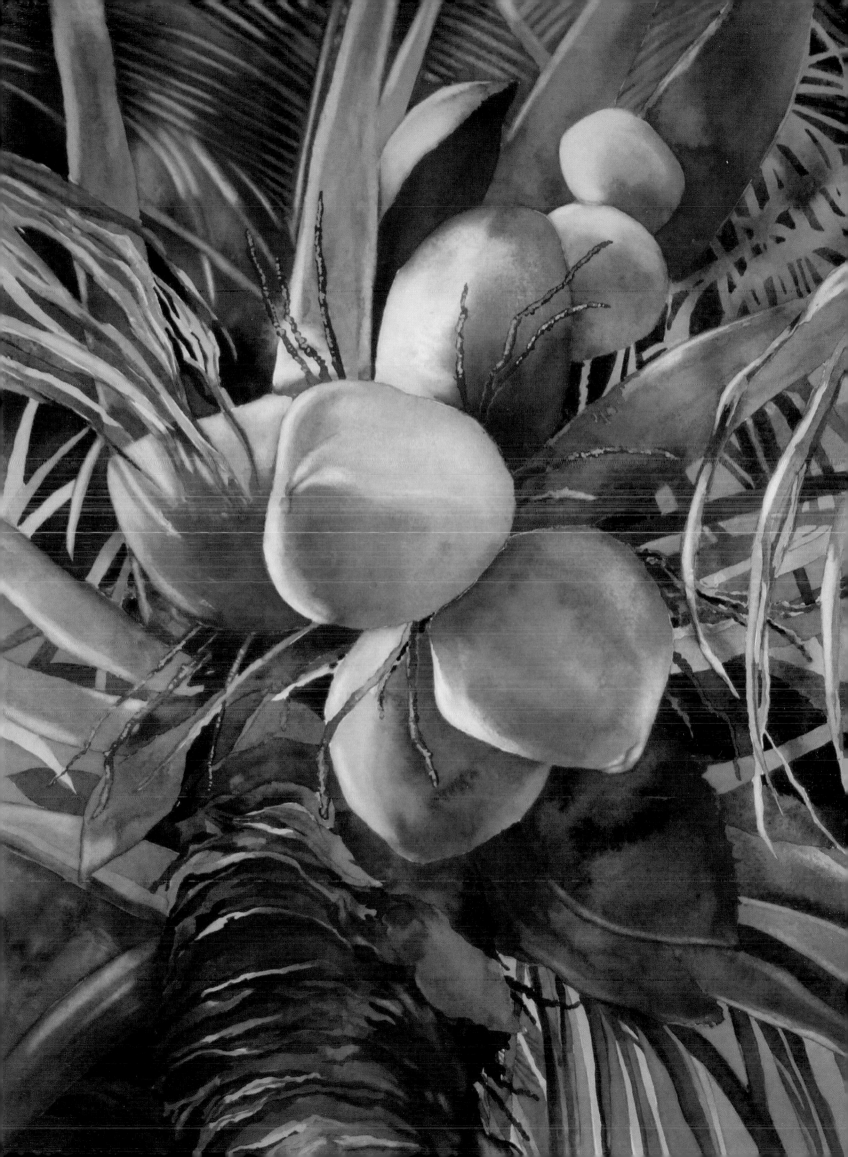

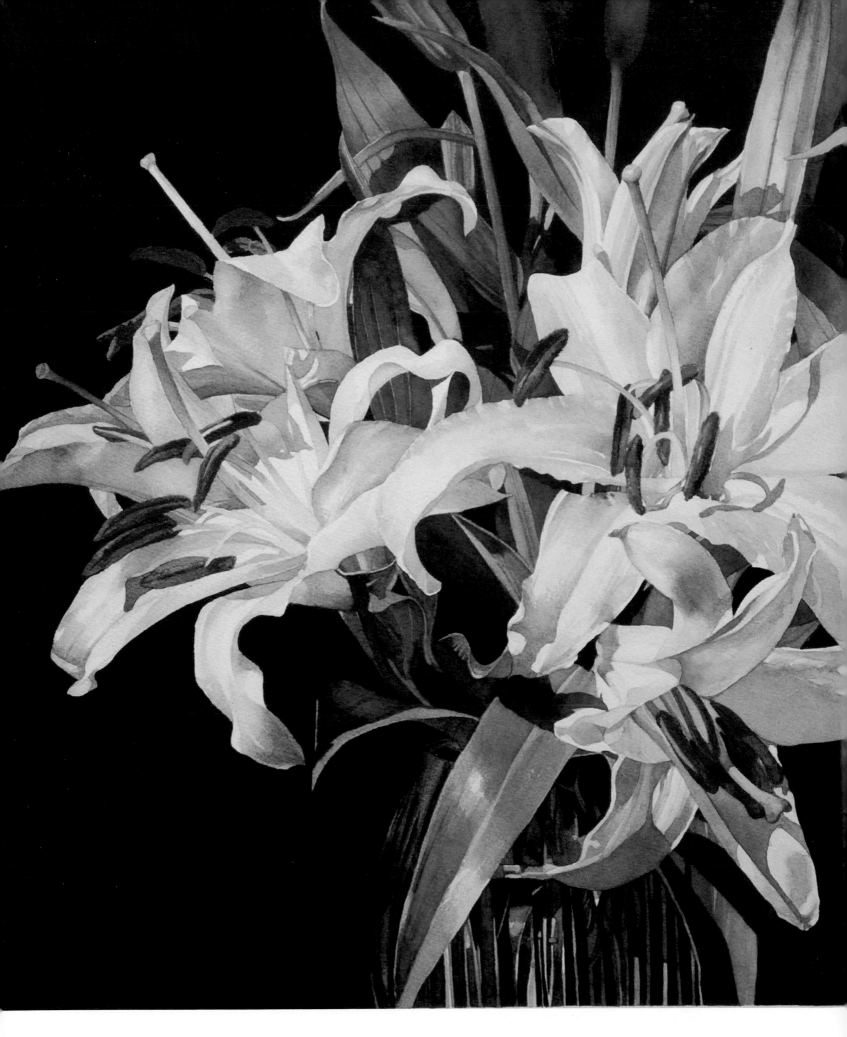

As a biologist as well as an artist, I always search for the patterns and stories behind nature's apparent chaos. —Claudia Ihl

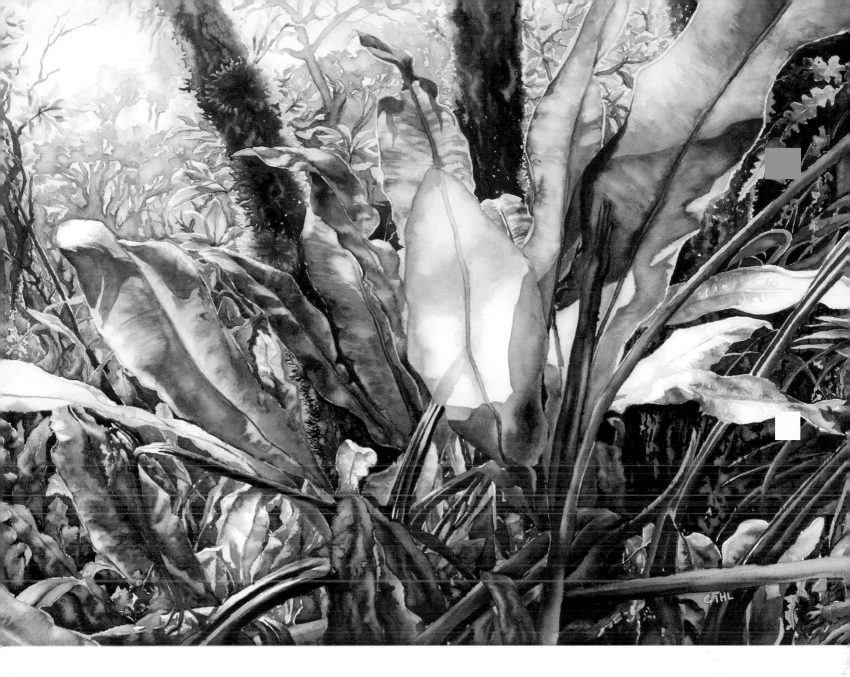

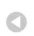

CASA BLANCA LILY
David Cox
Transparent watercolor on 300-lb. (640gsm) cold-pressed Arches
21" × 17" (53cm × 43cm)

SUNLIGHT AND SHADOWS ON FLOWERS
After forty years of architectural practice I rediscovered watercolor painting and turned to my wife's seasonal flower garden for inspirational subject matter. Observing how sunlight and shadow constantly produce complex patterns and colors is fascinating and unpredictable. I use close-up digital photography, usually against dark backgrounds and in late afternoon light, to select an image and then use the computer to further compose an 8" × 10" (20cm × 25cm) color print to work from in the studio. Lilies are a favorite subject because of the great variety of types. This painting explored the contrast of a dark background with the white lilies, bright yellow-green leaves and faceted sparkle of a glass vase.

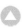

KAUAI FERNS #1
Claudia Ihl
Watercolor on 300-lb. (640gsm) cold-pressed Arches
22" × 30" (56cm × 76cm)

NATURE'S VERDANT CHAOS
These regal bird's-nest ferns grow throughout the rain forests of Kauai. The light filtering through the canopy never hits two leaves in the same way, creating a confusing but mesmerizing mosaic of colors and shadows. Nature rarely presents us with a perfect floral arrangement. In the wild, plants crowd one another in their competition for light and nutrients, and fresh young leaves grow from the decay of the old and rotten ones. I'm a biologist and an artist; while on my hikes I make quick color notes and some drawings of leaf shapes in my field watercolor book and I take many photos. At home I compose the larger painting from several photographs as well as my field book notes.

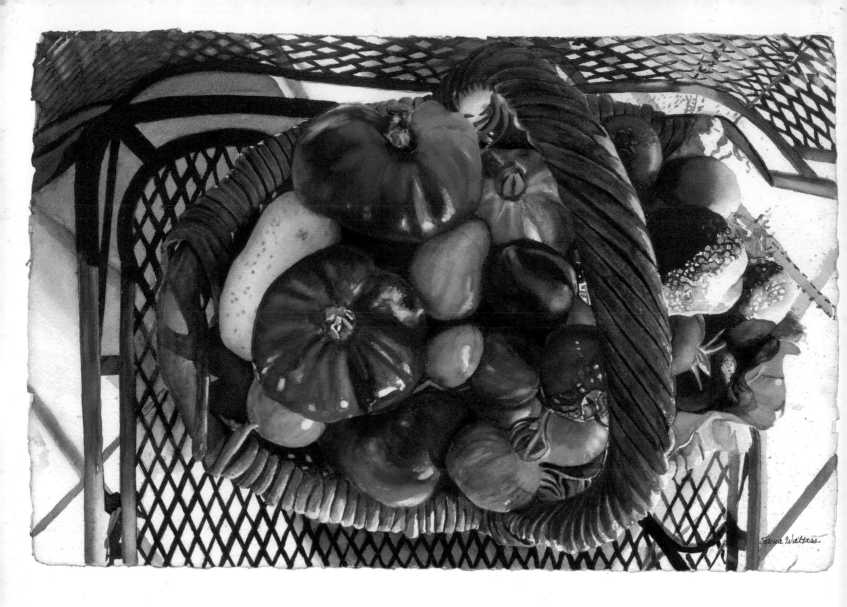

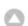
GARDEN'S BRIGHTEST GLORIES
Tania Walters
Transparent watercolor on 300-lb. (640gsm) cold-pressed Arches
15" × 22" (38cm × 56cm)

BEAUTEOUS BUMPER CROP
A late-summer bumper crop of heirloom tomatoes reduced me to pure joy. While the gazpacho, bruschetta and salads were wonderful, it was the brilliant and endless variety of colors of the tomatoes that really excited and energized me. Who could resist painting the bright sunlight yellows and greens melting into deep oranges, the brick reds, rusty browns, light whites, peaches, purples, sherbet colors and the green zebra stripes? In my studio I painted from cropped and combined photographs and from my memory. It was my attempt to capture the lush and glorious essence of summer.

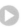
LEMONS AND GRAPES ON A QUILT
Chris Krupinski
Transparent watercolor on 300-lb. (640gsm) rough Arches
30" × 22" (76cm × 56cm)

AN OBJECT COLORED WITH MEANING
The quilt in this painting was a gift from my brother who is no longer here. Every time that I paint this quilt, it is as if he is right here with me. I never tire of painting it. My paintings are design centered. Although I paint realism, the underlying design is the motivation. In this painting the lemons act as a guide to bring the viewer's eye to the focal point—the grapes on the glass dish. The folds in the quilt also act as guides to move one through the painting. Backlighting creates a dynamic view pushing the shadows into the foreground. The busyness of the quilt with the color and the patterned squares needs the contrast of the solid shapes of the lemons for resting areas.

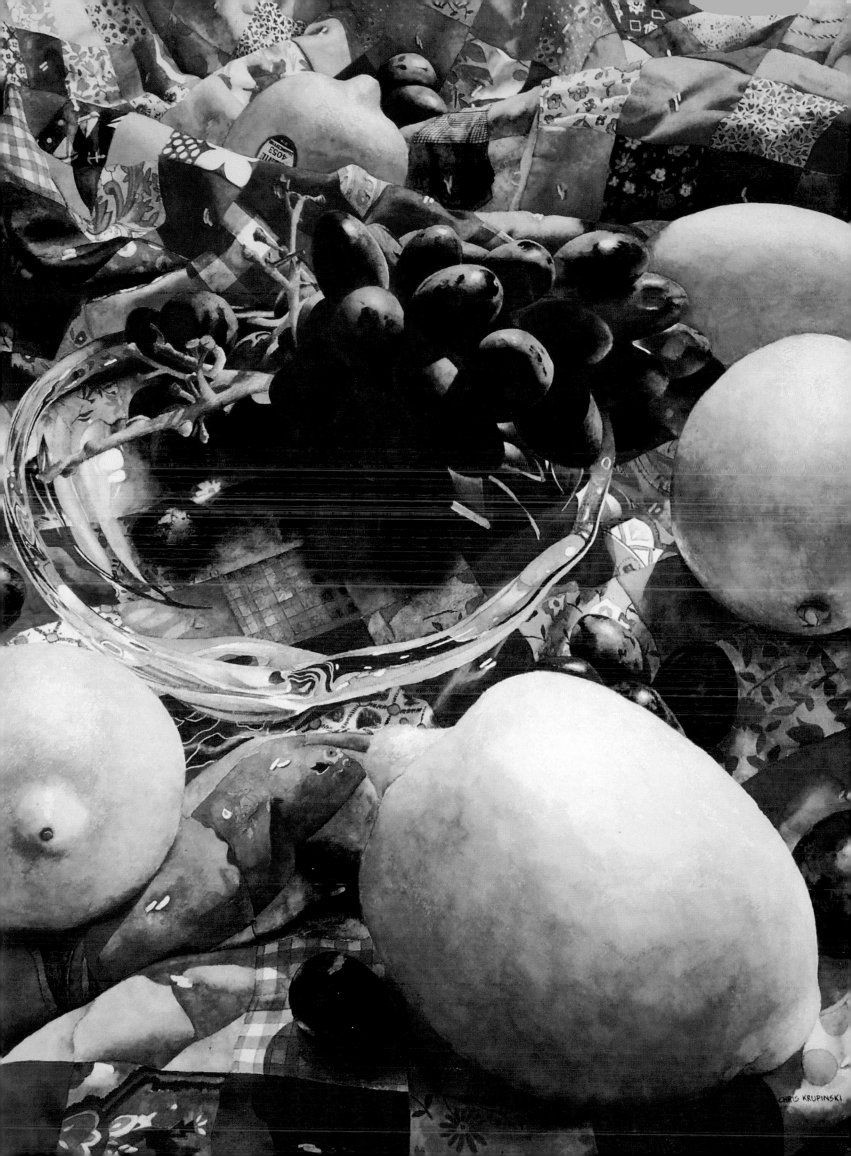

CHRIS KRUPINSKI

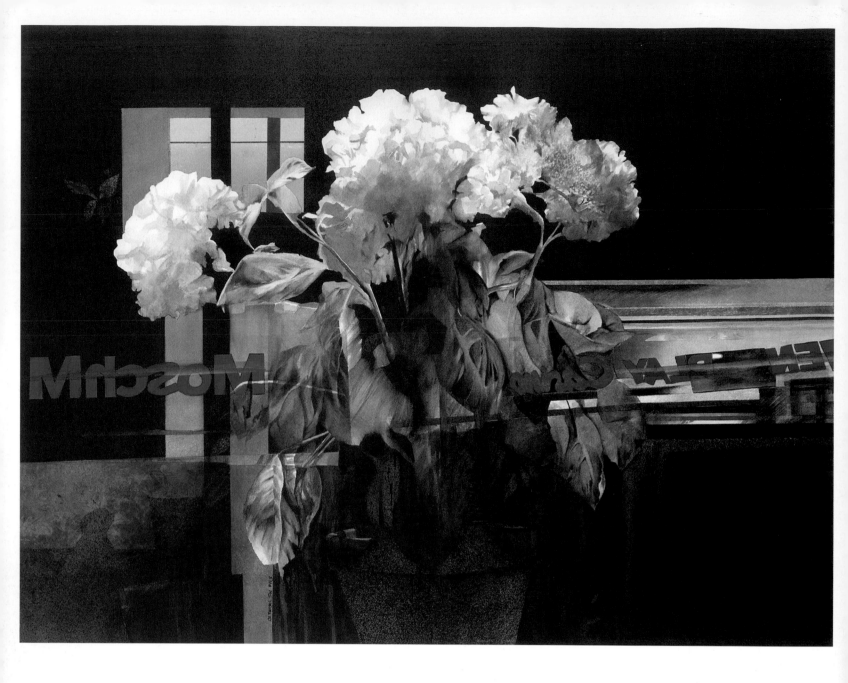

 REFLECTED FLOWERS
Cheryl A Fausel
Watercolor on 140-lb. (300gsm) cold-pressed Arches
22" × 30" (56cm × 76cm)

THE DELIGHTFUL PUZZLE OF REFLECTIONS

A photographed reflection in a window of a small town in Italy inspired this work. I love working with reflections. They combine abstraction and realism, giving a sense of reality with an abstract composition. My style of painting is like putting a puzzle together. I start with the part that I consider will be the most difficult to execute and work outward from that point. I like to bring a section of my work to the final level and use that as the critical point needed to achieve the overall success of the painting. By using reflections, I can bring in all kinds of subject matter, be it flowers, cityscapes or people, all of which interest me.

 CHINESE LANTERN
Soon Y. Warren
Transparent watercolor on 300-lb. (640gsm) cold-pressed
Winsor & Newton
30" × 22" (76cm × 56cm)

A UNIQUE AND COLORFUL OBJECT

When I spotted the bright orange Chinese lantern, a spark went off in my brain. The perfect setup came to my mind with an Ultramarine Blue crystal bowl. One sunny day I set up the complementary color combination I had envisioned. The goal of the composition was to emphasize the Chinese lantern. The first focus was an exaggerated perspective in which the lantern seedpods dominate the front part of the picture plane, decreasing the comparative size of the blue crystal bowl in the back. The second focus was to highlight the seedpods glowing from drenched sunlight. To finalize the painting I depicted the very fine details of the seedpod veins and used the cast shadows to balance the foreground. I love to combine sunny feelings with drama in the composition.

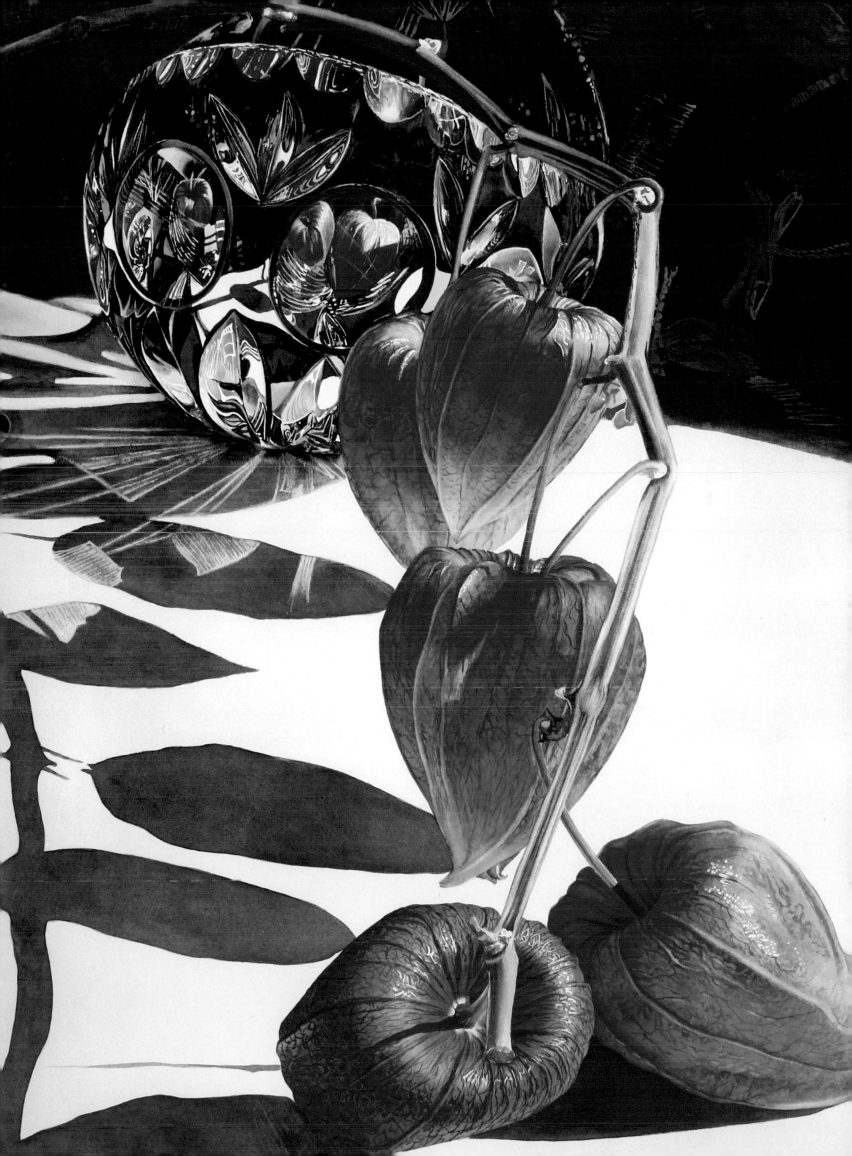

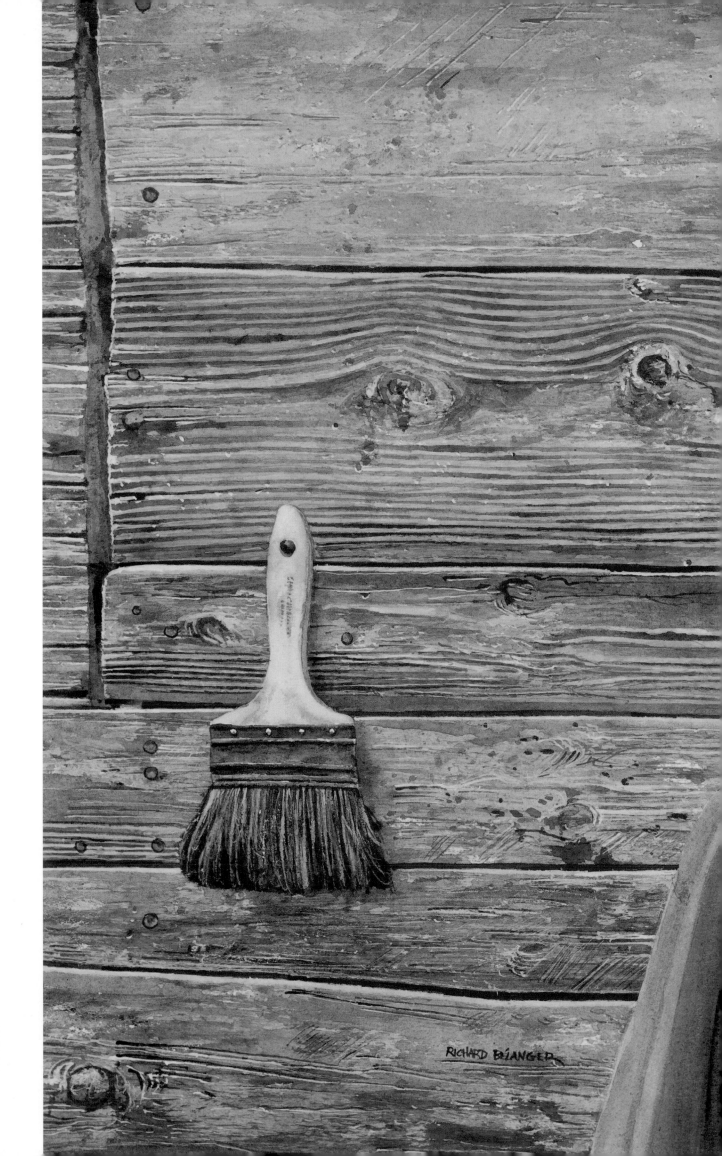

2 PORTRAITS

RICHARD BÉLANGER

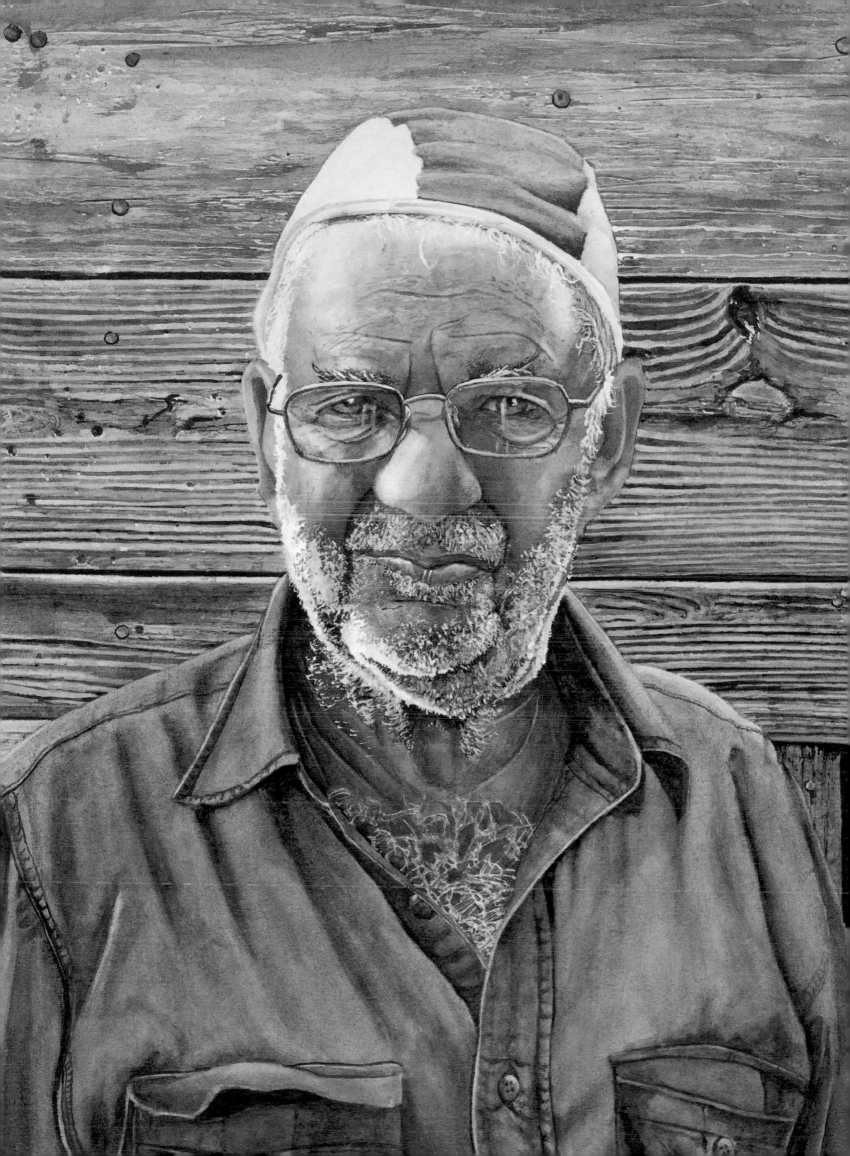

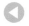

THE WELDER
Richard Bélanger
Watercolor on 4-ply smooth bristol board
20" × 30" (51cm × 76cm)

BEFRIENDING AN INTERESTING STRANGER
When something stays at the back of my mind, I know there's a painting in it. I took the same country road a few days in a row, and each time I was struck by this white clapboard house. I just had to stop and knock on the door. The owner was Leo, a friendly 80-year-old man, a retired welder who still wears his welding cap as he does his daily chores. After chatting I took some photos of him and of the shed, deciding at the same time on the size of the final painting. I masked out Leo so I could proceed with ease to use a lot of splatter and layering for the background. When this was completely dry, I lifted off color for highlights on holes, cracks and tops of wooden planks to add realism. For Leo I used a multitude of washes layered on top of one another, always keeping in mind the warm and the cool lights.

I am still visiting Leo as he always has some new things to show me. He just bought chickens as well as a dog to scare away the white-tailed deer eating up his wife's flowers and the vegetables in their garden. This year he is planning on pulling down the shed. I hope he takes his time; I have quite a few more paintings to do at his place.

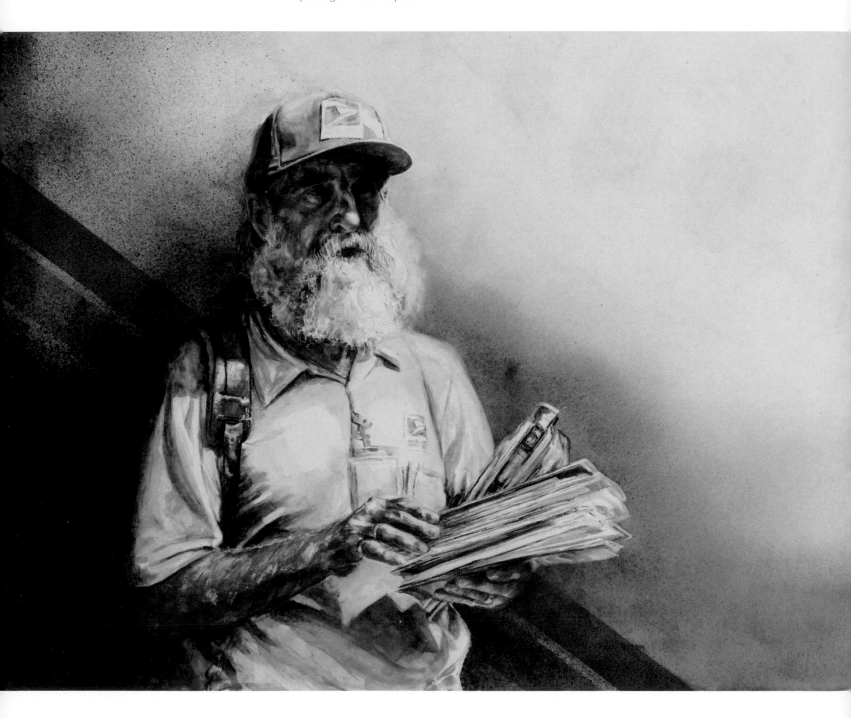

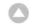

MIKE OUR MAILMAN
Kay Stern
Transparent watercolor on 300-lb. (640gsm) cold-pressed Arches
22½" × 30" (57cm × 76cm)

ADMIRATION AND GRATITUDE
That fast-moving streak of blue that rushes past our home at 9:30 A.M. every morning is Mike, our mailman. Mike swishes by with all kinds of objects pinned and clipped to his clothes and carries a satchel of letters. The background was painted with the intent of representing all the possible weather in one space. To my standard palette of Cadmium Red Deep, New Gamboge and French Ultramarine Blue, I added Horizon Blue. Many glazes, spraying and a variety of hard and soft edges bring to life our great Mike, who delivers our mail every day.

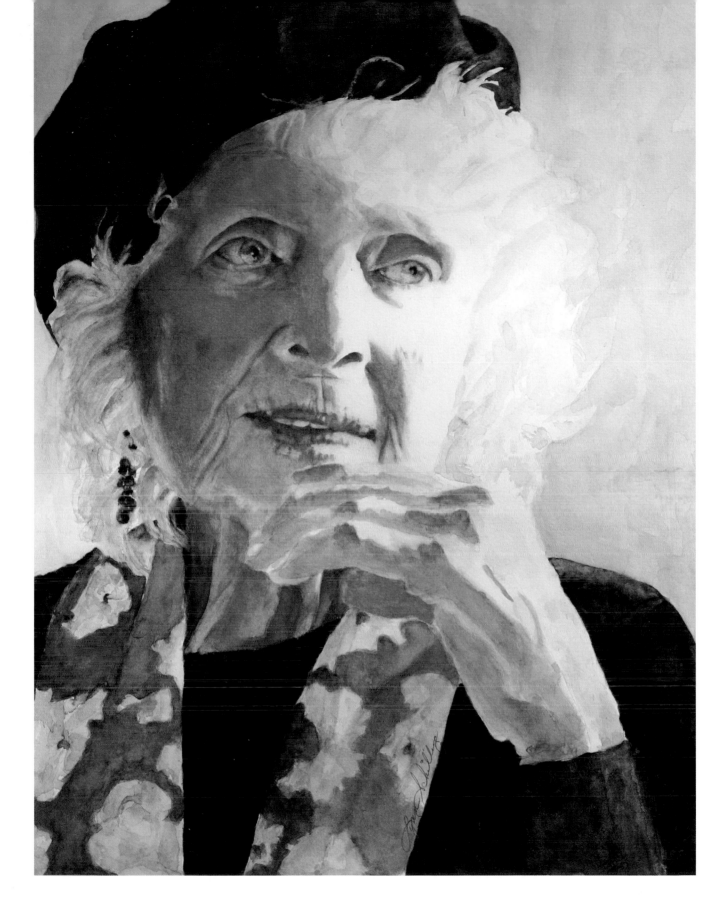

DRESSED TO THE NINES
Lynn Schilling
Transparent watercolor on 300-lb.
(640gsm) hot-pressed Arches
19½" × 14½" (50cm × 37cm)

AN INDOMITABLE SPIRIT

Marianne and I struck up an easy friendship the moment we met. When she arrived at church one Sunday wearing a black beret and chandelier earrings, I knew I had to paint her. I wondered if I could capture her indomitable spirit and sharp wit as well as her femininity and sense of style. She readily agreed to a photo shoot. The sun amiably poured through the window, warming her face against the coolness of her white hair and black attire. When Marianne saw her painting, she exclaimed "I haven't always had an easy life and you captured that in my eyes!" The ultimate award!

I am drawn to the eyes—the soul is in the eyes. —Lynn Schilling

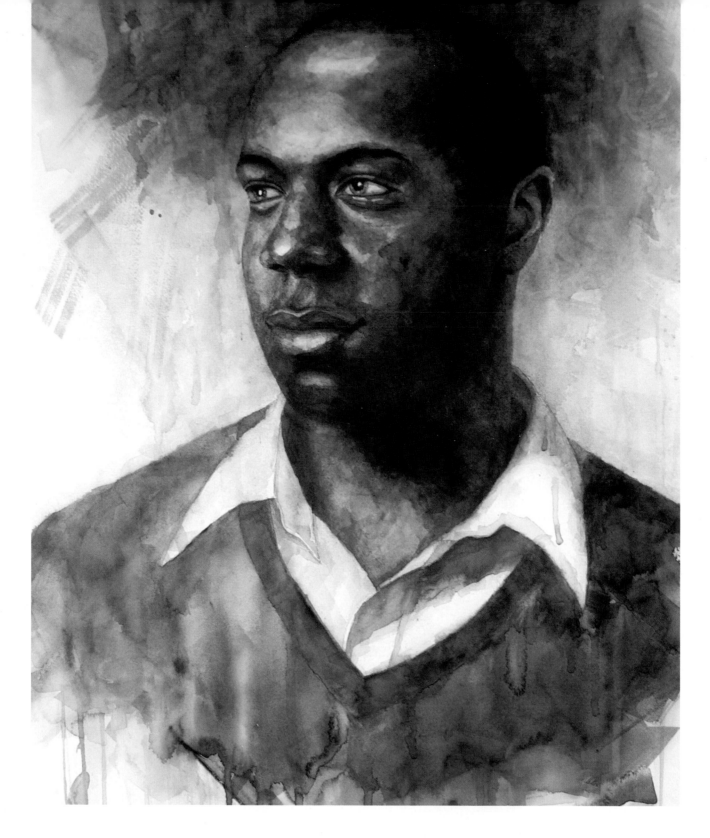

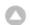 **THE EAST**
Cheng Fen Yeh
Transparent watercolor on 140-lb. (300gsm) cold-pressed Arches
23" × 18" (58cm × 46cm)

REVEALING THE PERSON
I want my portraits to display the nature of watercolor. I like the texture of the brushstrokes to show on the face. Overall, the brushstrokes come together with the subject's personality to create a full portrait. The running and dripping shapes on the shirt and background give movement and rhythm. I love the freedom of allowing the unexpected to happen. At the same time there is no room for large mistakes! I am excited as I see a portrait coming together to speak for the subject and even go beyond what is presently seen in a person's face.

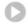 **THE SPECTATOR**
Annelein Beukenkamp
Transparent watercolor on 140-lb. (300gsm) Fabriano Artistico
19" × 13" (48cm × 33cm)

KALEIDOSCOPIC HUES
Watercolor can surprise, delight, frustrate and intimidate, but mostly it motivates me to dip into my palette of colors and interpret the world in kaleidoscopic hues. Faces are an intriguing subject, and I aim to capture a moment in time with layers of translucent paint that glow on thick pulpy paper. The natural pose of the young lady paired with the reflections of her sunglasses and the possibilities of painting her curly hair with unique colors moved me to capture this scene.

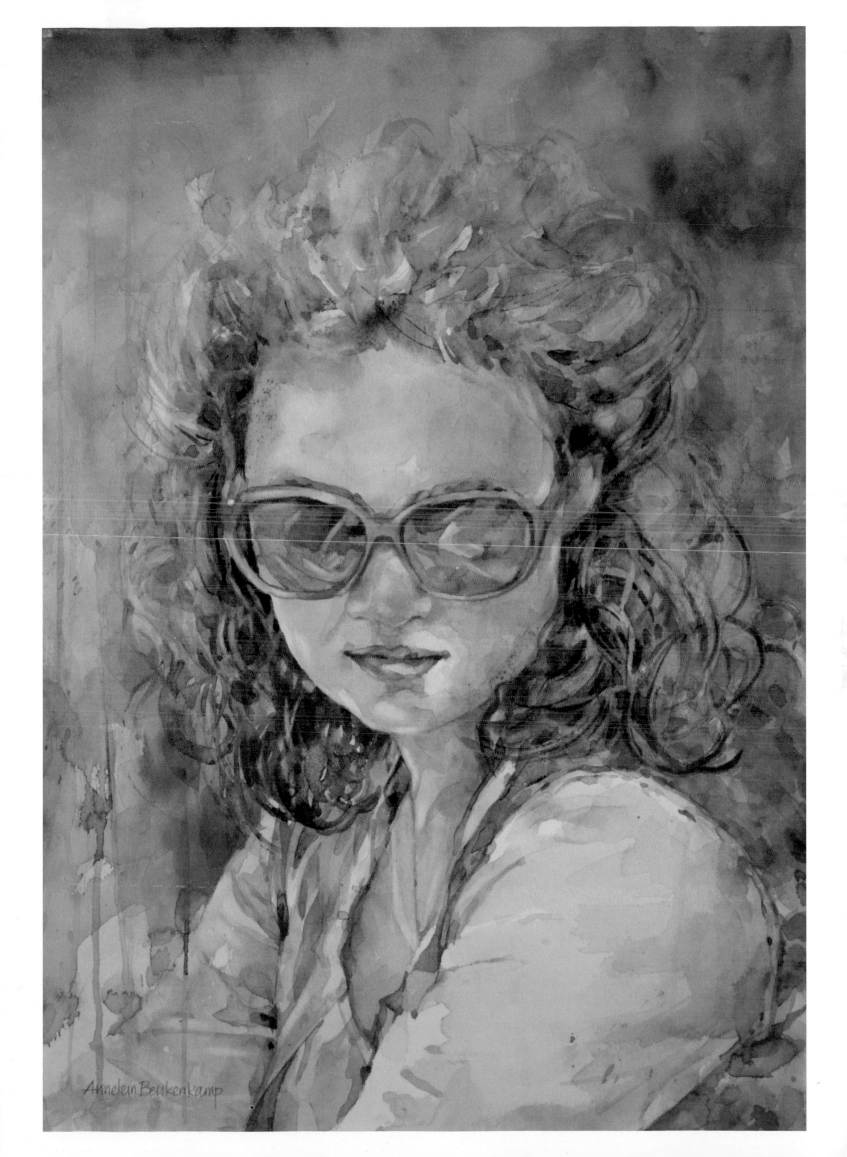

Annelein Beukenkamp

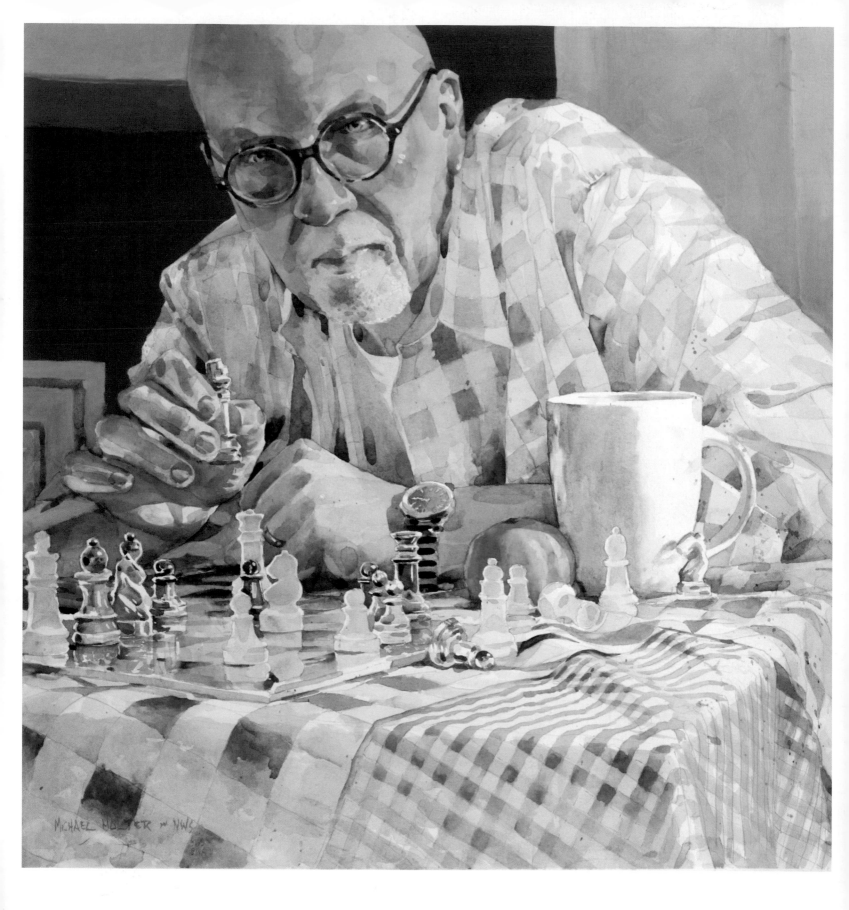

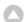

KEEPING MYSELF IN CHECK
Michael Holter
Transparent watercolor on 300-lb.
(640gsm) hot-pressed Arches
21" × 21" (53cm × 53cm)

SELF-PORTRAIT AS A STORY

I was inspired by the ageless tradition of artists painting self-portraits and decided to create a concept story that would inspire the viewer to linger with the art. I was interested in the human figure incorporated with textures, surfaces and patterns. And though I have a limited knowledge of the game of chess, I set up the chessboard like the final move of the famous "Game of the Century" won in 1956 by 13-year-old Bobby Fischer. The orange, the cup and other elements lead the eye around all of the checked patterns in the composition. I set up the camera with a timer and shot the photo myself, which perhaps added to the look of concentration. My wife says I look too serious ... but *Keeping Myself in Check* is serious business.

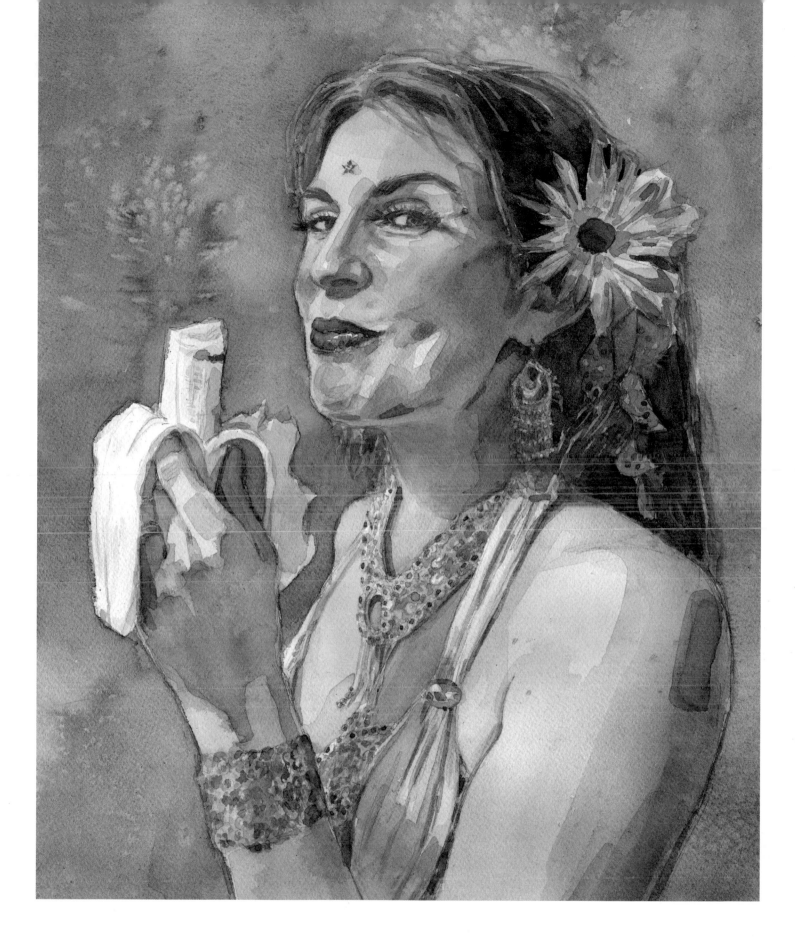

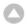

KALINDI EATING A BANANA
Joanna Barnum
Watercolor on 140-lb (300gsm) cold-pressed Arches
16" × 12" (41cm × 30cm)

WOMEN COMFORTABLE BEING THEMSELVES

I love to paint women being themselves in moments that hint at their unique personalities and stories. I usually work from photos because of the fleeting expressions they allow me to capture. In this moment I caught my friend, Kalindi, a belly dancer, showing her sense of humor while having a snack after a performance. It is important to me to capture an accurate likeness while still allowing the fluidity of the medium to express itself. In my portraits I alternate layers of cool and warm colors to build the skin tones, and try to create variety between tighter and implied detail.

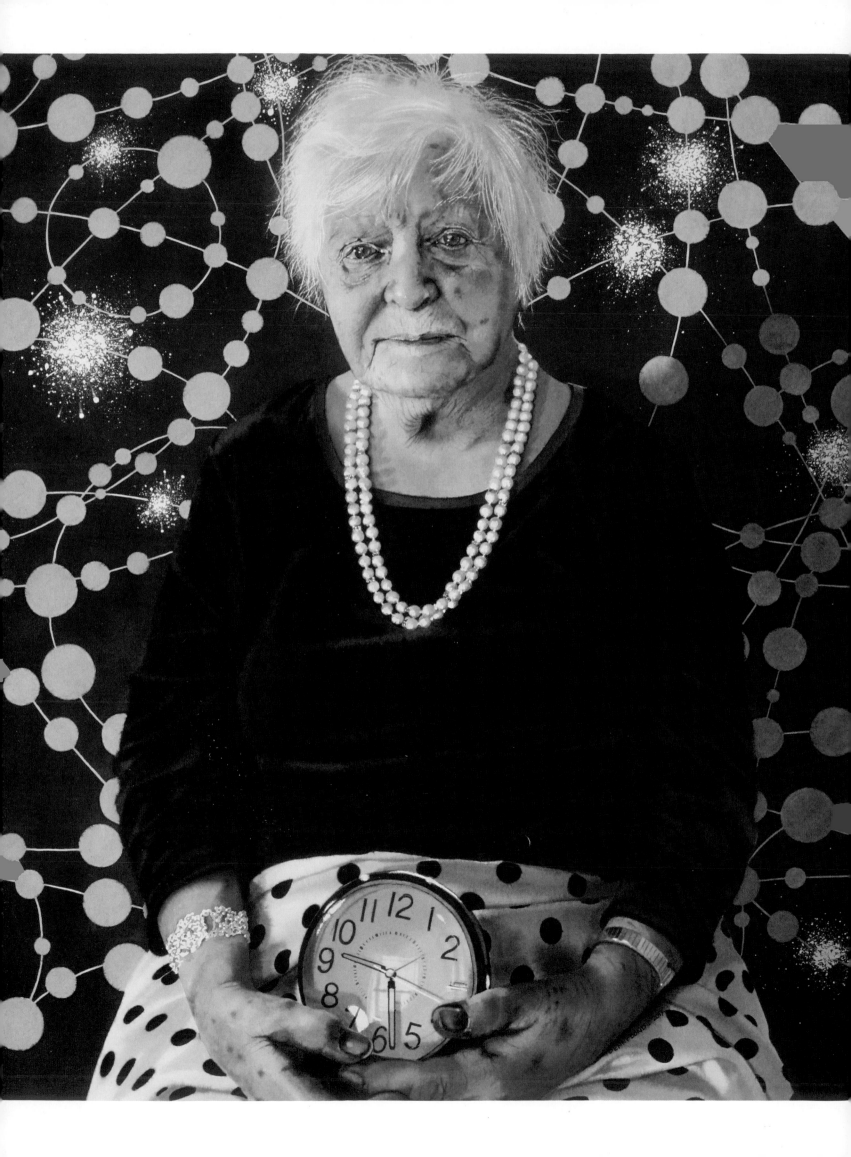

EVEN THE ANGELS CRIED
Kathleen S. Giles
Transparent watercolor on 140-lb. (300gsm) cold-pressed Arches
22" × 30" (56cm × 76cm)

A WEEPING ANGEL IN DRAMATIC LIGHT
I found this angel statue to be very moving, but I struggled with which angle to use to best portray her. I finally chose a reference that included her wings and face. I masked the sunstruck areas on her figure and then applied color through pouring and brushwork. I wanted the wet flowing watercolor to simulate her ethereal quality. I controlled the paint by wetting certain areas and then painting wet-into-wet. White objects in shadow provide an opportunity to use fun colors and allow them to swim together in a colorful puddle. I loved the emotion created by this weeping angel and felt that placing orange in her face would make the stone seem more real.

92
Denny Bond
Transparent watercolor on 140-lb. (300gsm) cold-pressed Arches
24" × 20" (61cm × 51cm)

EXPRESSING IMMINENT LOSS
I always start the composing process with my camera as I am more comfortable working within my studio. My technique involves quite a bit of layering of colors while keeping the bright whites through the use of masking fluid. As I approach the end of the painting, I use a craft knife to soften harsh white edges. The subject is my mother, who was approaching the end of her life and the beginning of a new life unknown. The exploding circles in the background suggest the dementia that clouded her memories. In her hands she holds a clock, reminding all of us how quickly time passes by.

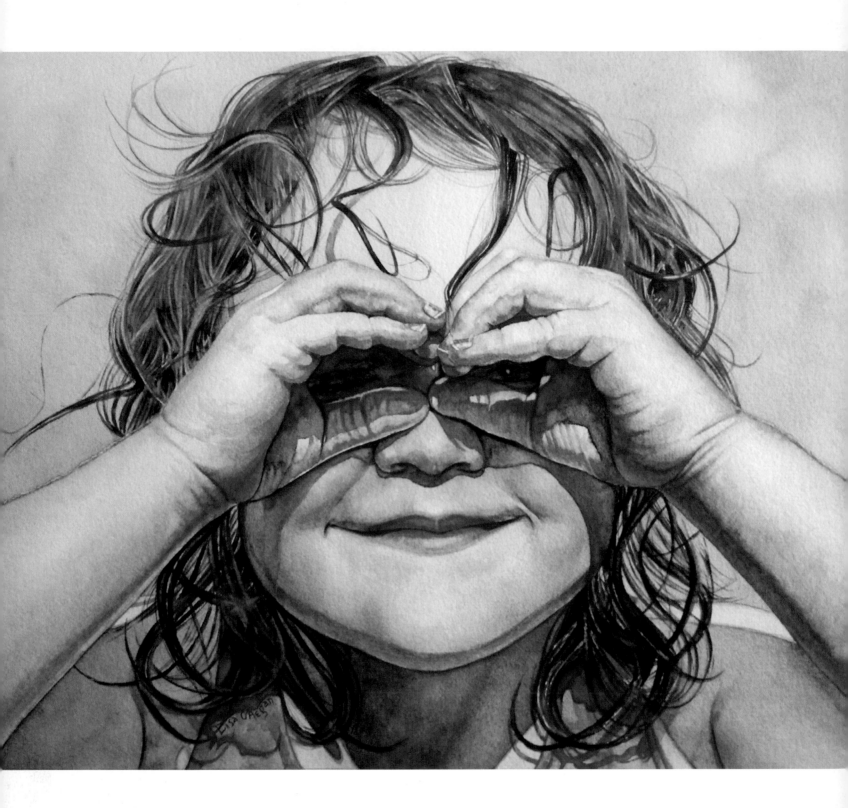

 SUNOCULARS
Lisa O'Regan
Transparent watercolor on 300-lb.
(640gsm) cold-pressed Arches
16" × 20" (41cm × 51cm)

AND OH, THAT HAIR!
My fair-skinned, light-eyed daughter Robin was constantly squinting during our outdoor photo sessions when she was younger. Striking a pose that she naturally assumed while in direct sunlight, Robin confessed to me that her eyes were closed behind her makeshift sun visor. I, too, had to squint while working from the photograph, believing that both eyes were closed, but no ... one eye was open. Robin, with her fiery red hair, has often been my painting muse, and my favorite go-to color is Burnt Sienna! Often painting my other two children as well, not to mention numerous cats, I have found that the inspiration to paint these close-to-the-heart subjects remains constant.

Paint what you love, and love what you paint!
—*Lisa O'Regan*

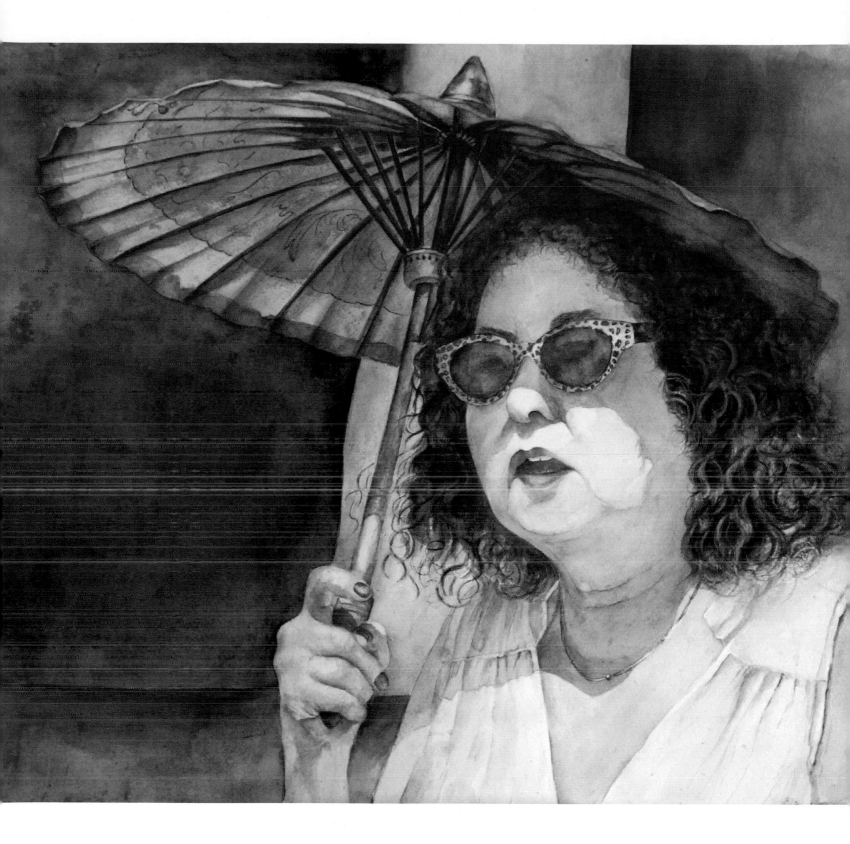

TINY UMBRELLA
Carol Baker
Transparent watercolor on 300-lb.
(640gsm) cold-pressed Arches
19" × 22" (48cm × 56cm)

UNIQUE GESTURES OF EVERYDAY LIFE

I watch for a mood, a gesture or some unique spark as people move through everyday moments of their lives. The reference for this painting was taken at an art fair. The lady, shaded by her tiny umbrella, had spotted a piece of art that she wanted to buy. I hope I caught her look of determination as she marched past me. I begin with an accurate drawing taken from, often, black-and-white photos. After loose washes of transparent watercolor, more color is glazed over these washes to find the shapes to build the image. I look for color in shadows and reflections, and color that glows through the skin. The black-and-white photo keeps me aware of the value contrasts necessary to create the form.

Be curious. Go explore. Study everything. Create your own inspiration ... then paint! —Carol Baker

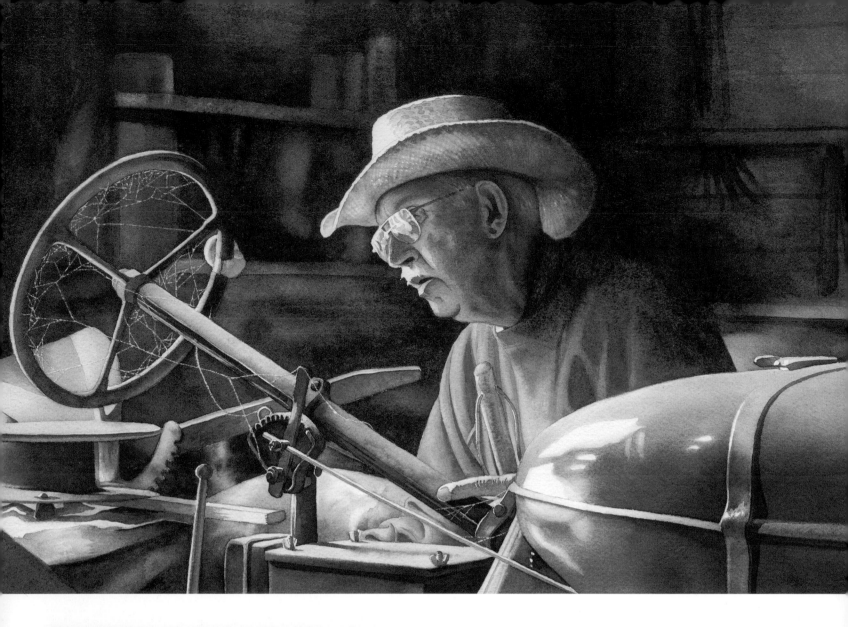

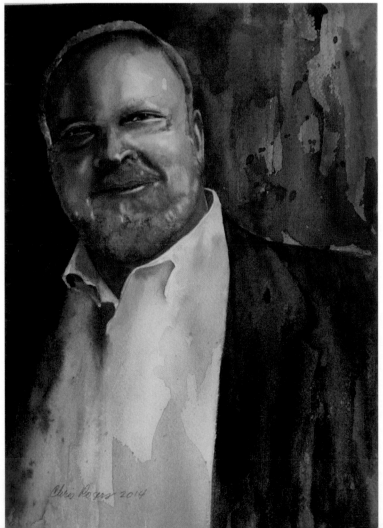

HEAD STUDY OF NELSON DEMILLE
Chris Rogers
Transparent watercolor on 300-lb. (640gsm) cold-pressed Arches
22" × 15" (56cm × 38cm)

A PARTICULAR PRESENCE
Interesting faces have always fascinated me, and I love the spontaneous way watercolor behaves on paper that results in casual authenticity. Working from several photographs of the subject, I choose the facial expression first, then the lighting, body position and clothing. My initial washes are done loosely, wet-into-wet, to block in the large shapes. To guard constantly against tightening up, I play invigorating music or a story read by an excellent voice. While painting this head study, I was inspired by my favorite Nelson DeMille novel, *The Lion*. What I strive for most is to capture an individual's presence. In the end I ask, "Can I hear the man's voice? His laugh? Can I feel what he's thinking?"

Never be afraid of color; it's the one element that changes constantly, depending on the light, and therefore allows the greatest latitude.
—Chris Rogers

 FINE-TUNING ALLIS
Judy Waller
Transparent watercolor on 140-lb. (300gsm) cold-pressed Arches
10" × 14½" (25cm × 37cm)

SPECIAL MOMENT WITH AN ICONIC GENTLEMAN
My husband and I were photographing a group of plein air painters
at Doc Bailey's Century Farm one day when Doc opened the door
to his ancient, dusty barn to proudly show us the Allis-Chalmers
tractor he had meticulously restored himself. I was inspired by the
dramatic lighting, the shiny orange surface of the tractor with its
layer of dust and cobwebs. I was also inspired by Doc himself, an
iconic First Citizen of Douglas County, Oregon. Doc is a treasure
trove of historic knowledge and entertaining stories. Excitedly
clicking away with my camera, I knew I had the makings of a great
painting. This painting inspired me to begin painting a series of
portraits of some of *The Characters in My Life Story*.

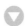 **NICE DREADS**
Sherry Phillips Carlson
Watercolor on 260-lb. (550gsm) cold-pressed Arches
18" × 18" (46cm × 46cm)

GLOW OF THE SUN ON SKIN AND HAIR
My day started with a flat. As the serviceman changed my tire, I
sat on a shaded bench watching. When he stepped into the sun,
his long dreadlocks and skin glowed with red and orange hues
complementing the dark blue of my vehicle and his uniform. I
asked his permission to take his photo. After some initial smiles, he
settled into a more natural pose. His profile and slightly open mouth
captured his nobility and friendliness. Noticing the word *Nice* on his
name tag, I smiled as I connected this with his place of employment:
Pleasant's Used Tires. The gratitude I felt for Mr. Nice and his
pleasant manner certainly lifted my spirits. He was my hero that day.

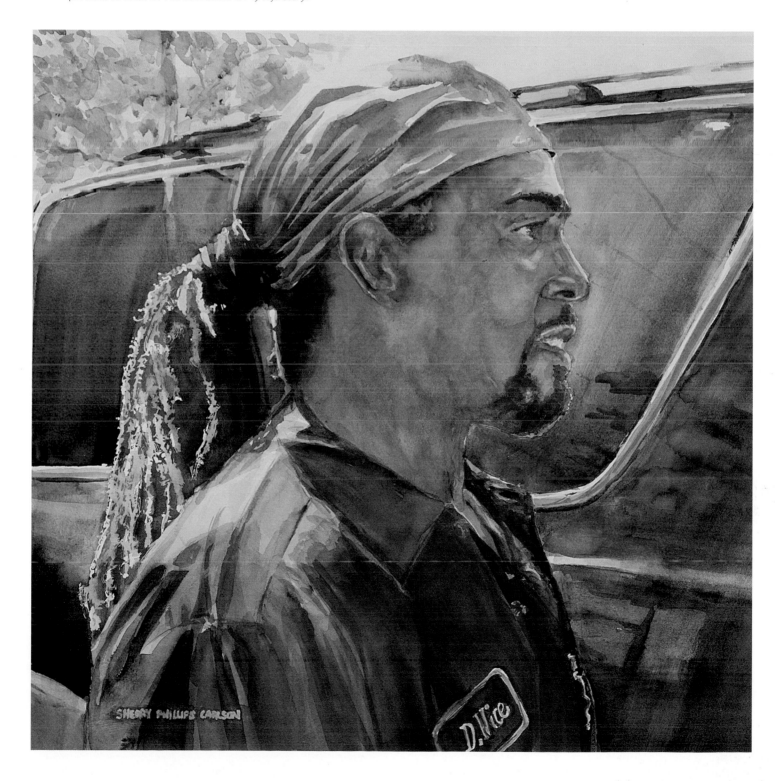

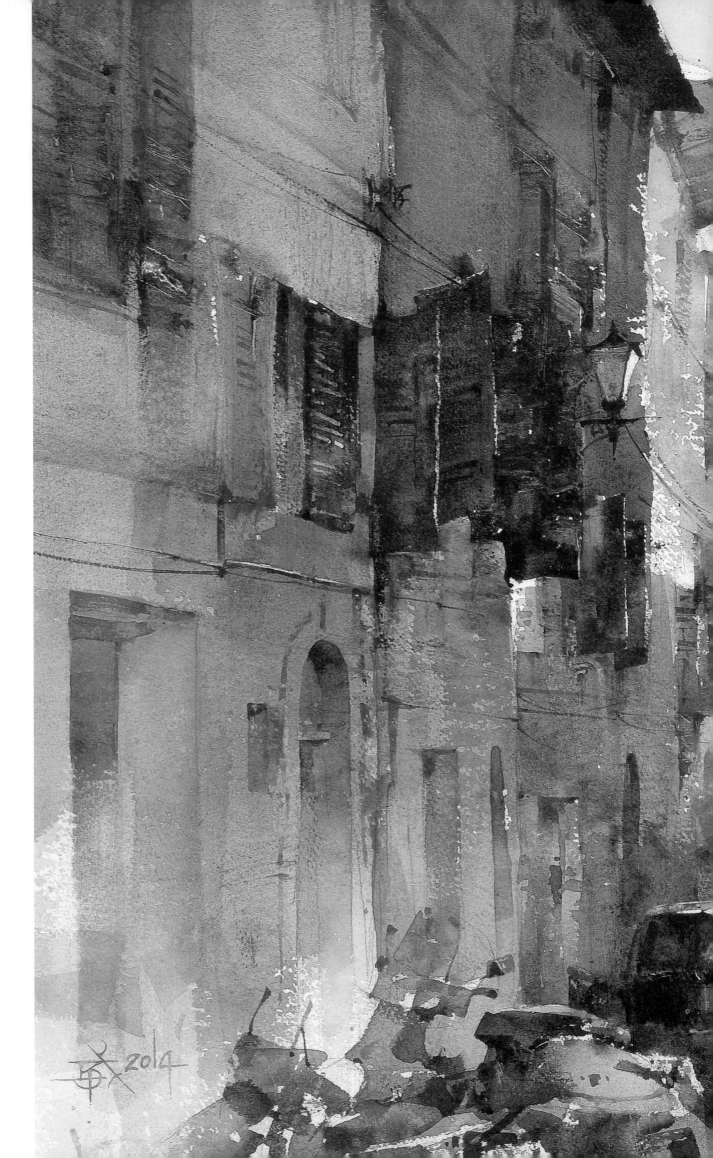

3 CITY SCENES

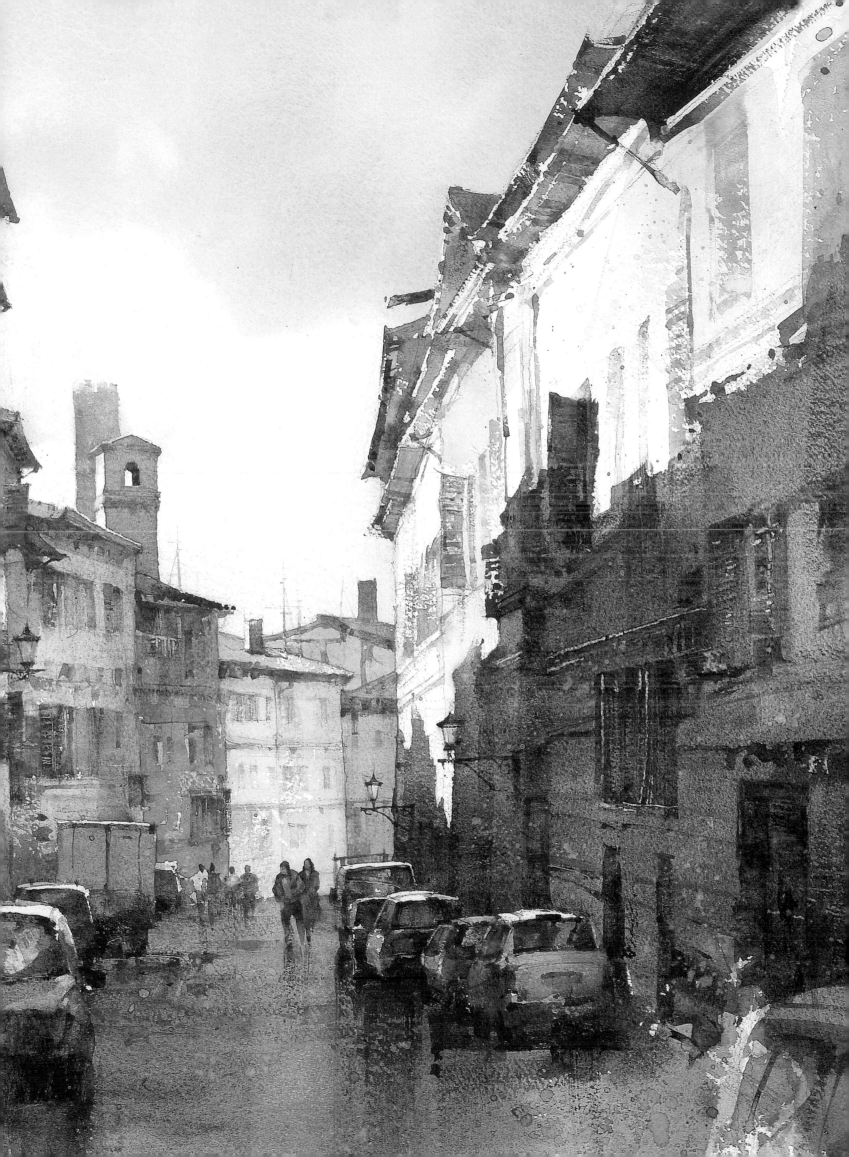

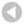

SONG OF SIENA
Chien Chung-Wei
Transparent watercolor on 300-lb.
(640gsm) rough Arches
22" × 29" (56cm × 74cm)

STUNNING FACETS OF A SCENE
Before beginning a painting from my photos, I made a quick sketch-plan, smaller than postcard size, with a soft pencil. I use only three values—and never try to depict details! What intrigued me most in this Italian scene is the light in the upper right corner and the geometric shapes of various sizes. Depicting these stunning elements became my goal. After some washes, before the surface is completely dry, I like to use scratch knives of varying sizes to scratch off the paints and get down to the white. If dry, I just dampen the area and wait a few seconds before scraping the paint from the surface.

SUNSET IN VICTORIA
Keiko Yasuoka
Transparent watercolor on 300-lb. (640gsm) cold-pressed Arches
17" × 26" (43cm × 66cm)

A MOMENTARY MIRACLE OF LIGHT
I shot a photo in Canada when my attention was riveted to the palpable dividing line between night and day at this scene. The sky radiated, experiencing day, while the buildings and streets struggled to shed the dark from the previous night. I marveled at the beautiful gradients that had slipped into the asphalt and the whisks of marmalade orange that flavored the sky. Smoothing out colors so that they appeared seamless and natural in watercolor was probably the most difficult part of this painting for me. The speckled asphalt was easier, using a speckle brush, twirling the brush and spattering frisket across the canvas. The illusion of depth was achieved by the size and quantity of the speckles.

SUNRISE: FUSHIMI INARI
Laurel Covington-Vogl
Transparent watercolor on 140-lb. (300gsm) cold-pressed Arches
24" × 17" (61cm × 43cm)

SUNLIGHT ON A SPECTACULAR SITE
Located outside of Kyoto, Fushimi Inari Shrine is a spectacular site dedicated to Inari, the kami or deity of rice and sake. A torii gate marks the entrance to a sacred space. At Fushimi Inari, there are thousands of huge vermilion torii, each an offering by a Japanese business to Inari. The wooded slope behind the main temple is a maze of paths leading to the summit. The multitude of torii line the paths and are set so close together they form tunnels. We visited in the morning when the rising sun cast a warm glow on the passages. Only a painting could convey the amazing visual impact of the radiant color. This scene provided the opportunity to use complementary colors of intense orange and blue plus accents of bright yellow and violet.

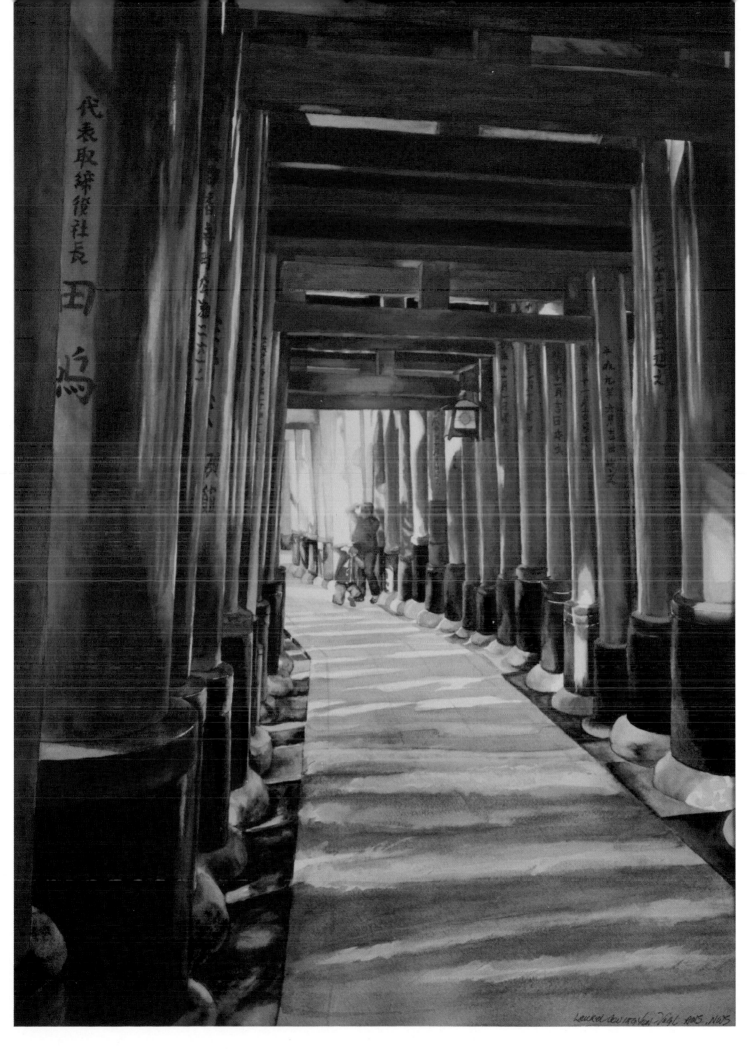

When is a painting completed? Consider what you expected to compose at the very beginning. —Chien Chung-Wei

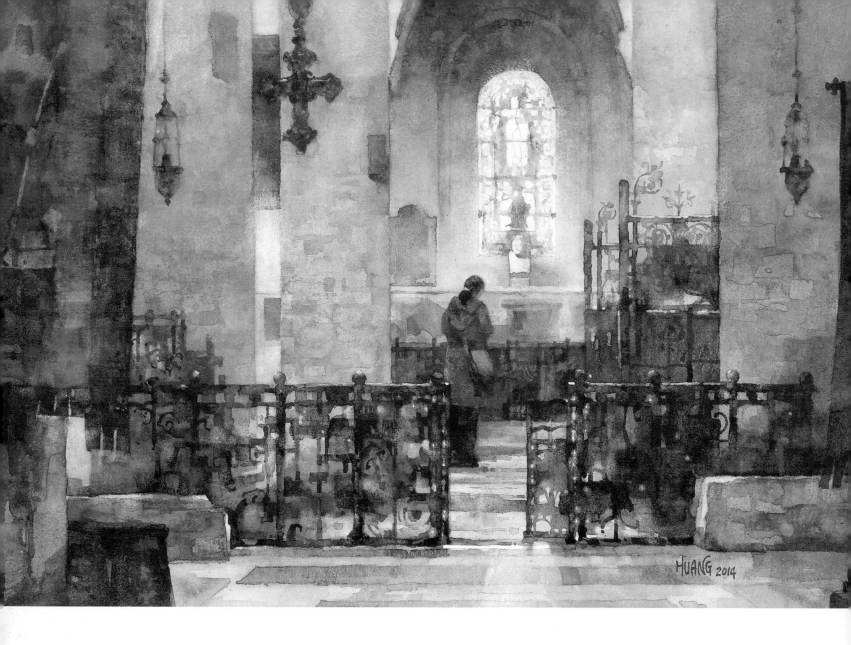

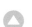 **FAITH**
Huang Hsiao-Hui
Transparent watercolor on 300-lb. (640gsm) cold-pressed Arches
14" × 20" (36cm × 51cm)

A HIDDEN MESSAGE IN NATURAL BEAUTY
When I want to express a high degree of completeness of my artwork, I'll choose to paint in the studio, and I needed to contemplate this composition more than painting quickly on site would allow. At times, as in *Faith*, I love to hide messages in my paintings. Some conceal my story of growing up, and some communicate my feelings towards how the society and civil environment have been changed. But I do not try to tell a story; my purpose is to create a scene of natural beauty to touch people. I use layering, wet-into-wet, most of the time. Sometimes I use glazing, applying layer after layer to achieve the desired effect. Gradually building up layers is very time-consuming, but the end results make it worthwhile. I don't paint a scene as it is, but rearrange objects to ensure the wholeness of an ideal composition.

Keep in mind the initial "wow" moment that made you want to create your painting all the way to the end. —Chizuru Morii Kaplan

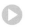 **ST. PATRICK'S, NYC**
Chizuru Morii Kaplan
Transparent watercolor with white gouache on 140-lb. (300-lb.) rough Arches
72" × 52" (183cm × 132cm)

HONORING THE EFFORTS OF UNSUNG PEOPLE
I often paint classic European buildings. I ponder the history and mythic scale of human effort that have gone into these creations over centuries. On a summer day in 2014, I passed St. Patrick's Cathedral in New York and found it covered in scaffolding, superimposing a geometric grid on top of its neo-Gothic form. Although only 135 years old—young compared to my European subjects—St. Patrick's needed restoration to reverse the effects of time and the elements. But once the work is complete, the scaffolding disappears and those people's efforts forgotten. Yet the lives of those involved behind the scene are forever infused into the history of this beautiful structure. These thoughts inspired me to create this painting.

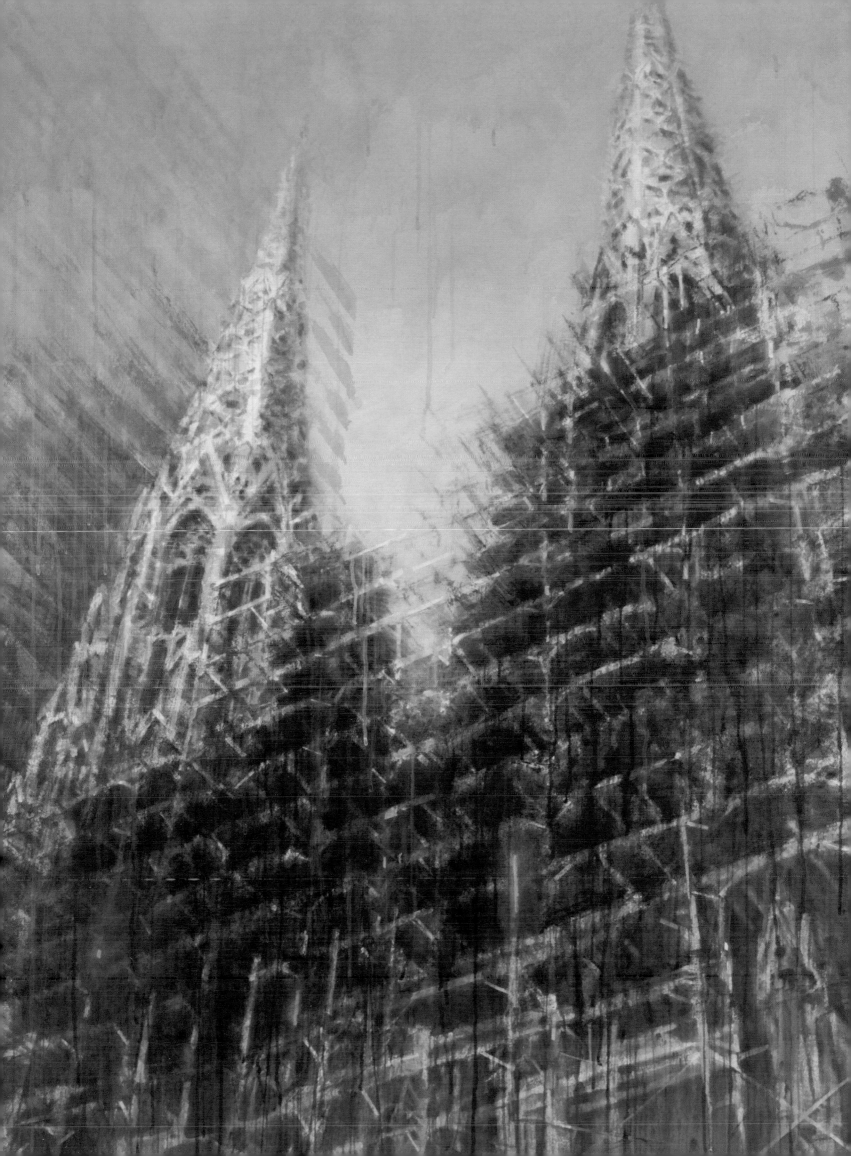

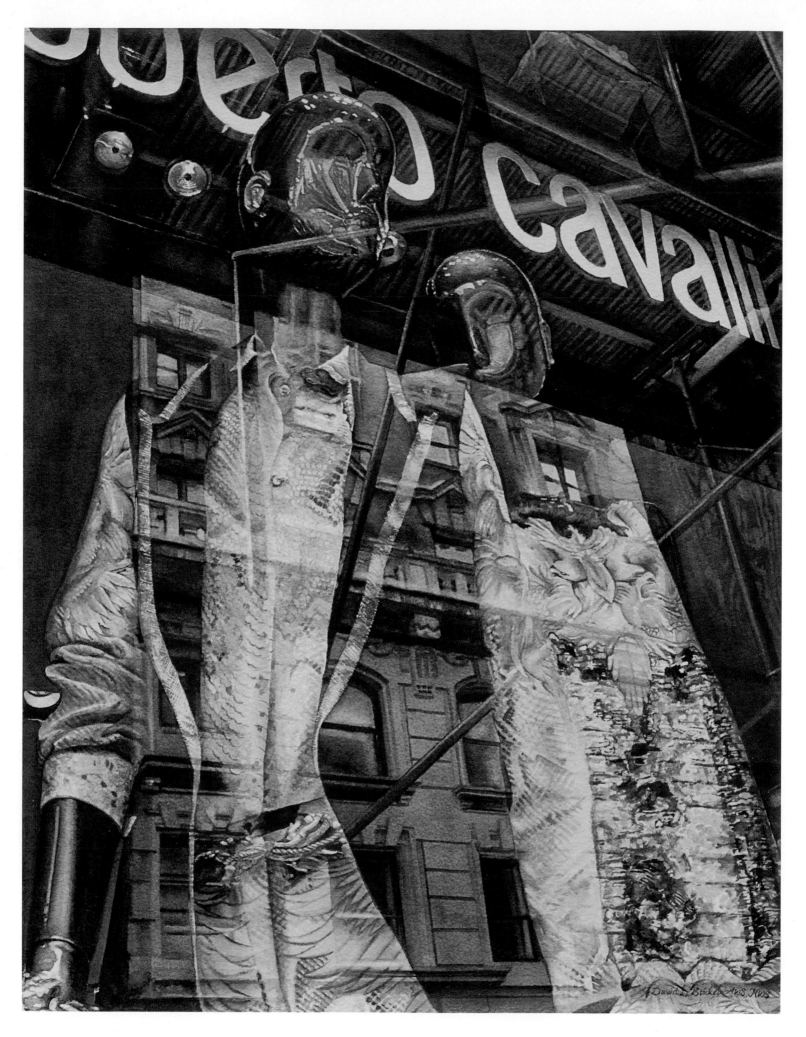

I've learned not to shy away from difficult or complex subjects because if I discipline myself and push through to the finish, it's always worth the extra effort. —David L. Stickel

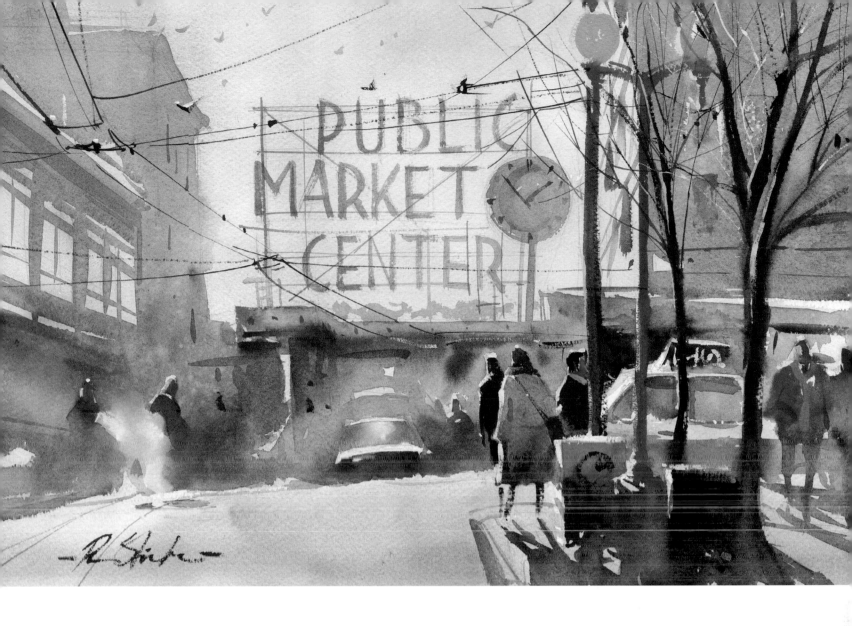

FASHION FACADE
David L. Stickel
Watercolor on 300-lb. (640gsm) cold-pressed Arches
22" × 17" (56cm × 43cm)

COMPOSITIONAL COMPLEXITY
While I was walking the streets of New York City, these mysterious mannequins reflecting the stately architecture across the street caught my compositional eye and I captured them with my camera. Later, painting in my studio, I enhanced the intrigue of the scaffolding because the lines add a contrasting dimension of movement. This type of composition inspires and challenges me to make all aspects—especially the confusion—come to life for the viewer to absorb.

MORNING MARKET, SEATTLE
Ron Stocke
Transparent watercolor on 140 lb. (300gsm) rough Saunders Waterford
14" × 21" (36cm × 53cm)

A FAVORITE PLACE SEASON TO SEASON
One of my favorite spots in Seattle is the Pike Place market. I've painted this market from every angle and in every season. This painting was done from a sketch I did on site one fall morning. I used a limited palette of Alizarin Crimson, Yellow Ochre and a touch of Cerulean Blue throughout the painting. I then created the building shapes using the same color mix. Keeping the background simple allowed me to create an exciting and dramatic foreground. The shadows and figures draw the viewer's eye to a well-placed area of dominance.

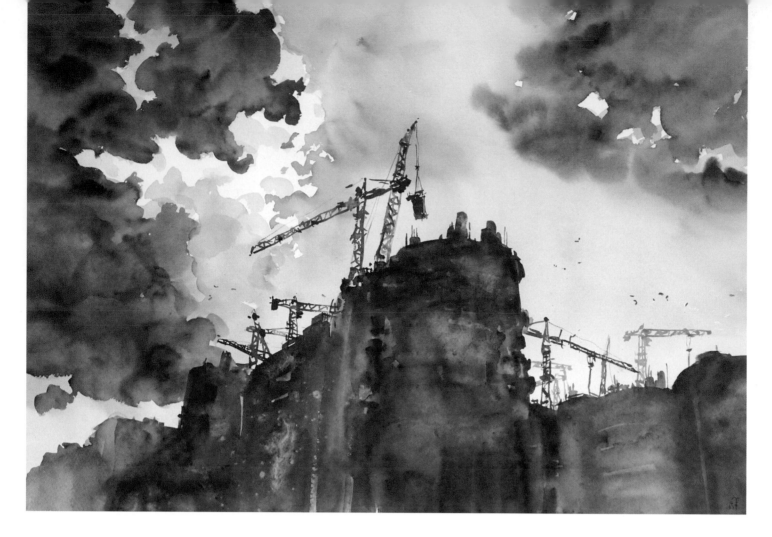

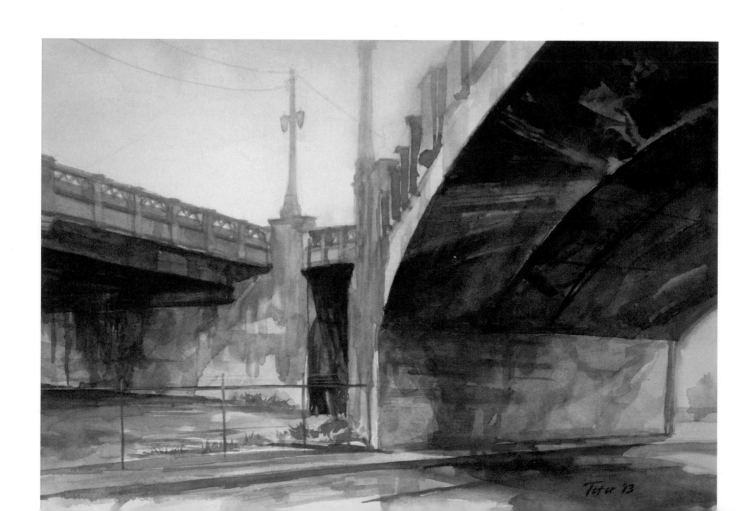

REBUILDING A NATION
Aaron Gan
Watercolor on 140-lb. (300gsm)
rough Fabriano Artistico
22" × 30" (56cm × 76cm)

HEAVEN SPEAKS IN A SPECIAL MOMENT
There was an apartment being built next to my home, and with each passing day I would see it inching higher, clouds parting as if to welcome its majestic rise. I decided to re-create that moment in my painting. I love painting with watercolor because of its fluidity and unpredictability. By learning to trust what cannot be predicted, and only when heaven shines on you, can a great painting be arrived at. To me, it is the perfect metaphor for life.

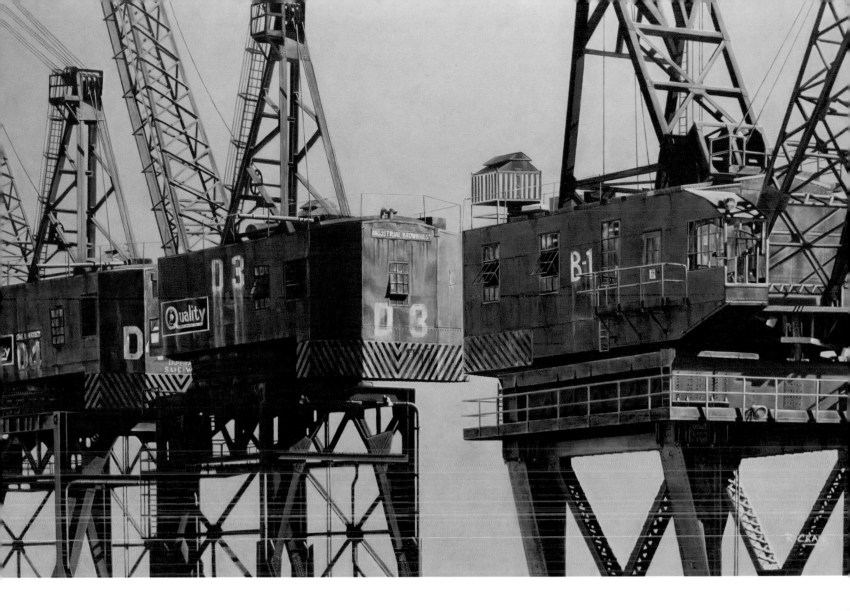

STANDS THE TIME
Ron Craig
Liquid acrylic and watercolor on Gessobord
24" × 36" (61cm × 91cm)

SECRETS OF THE PAST THAT STILL STAND
I am personally drawn to creations from our past, the lives involved, the stories told, the hidden secrets left only for one to imagine. So much of our past has been lost through the progression of time. By capturing such moments, the decay and neglect seem to slow down. With this particular painting, I wanted to honor these metal giants that, through wear and tear, have stood the test of time and continue to tell their story.

E. 4TH ST. BRIDGE
David J. Teter
Transparent watercolor on 140-lb. (300gsm) hot pressed Fabriano Artistico
10" × 15" (25cm × 38cm)

OVERLOOKED INDUSTRIAL SUBJECTS
I am endlessly inspired by industrial subjects, and I seek out the overlooked treasures in my city. The solid but well-aged E. 4th Street Bridge near downtown Los Angeles is a concrete arch bridge built in 1930. This unique and dramatic view is referred to as the "4th Street Bridge Split" where it splits south to E 4th Place. My painting is meant to be a salute to the bridge, not an architectural rendering. My approach needed to be simple and direct but solid and substantive. The undefined light of a bright overcast sky gives it a sense of historical reverence, but it is anchored in the present by adding the orange fluorescent traffic cone and post.

The harder you try to control watercolor, the less control you have. To advance, you must first retreat. To gain control, you have to first lose control. —Aaron Gan

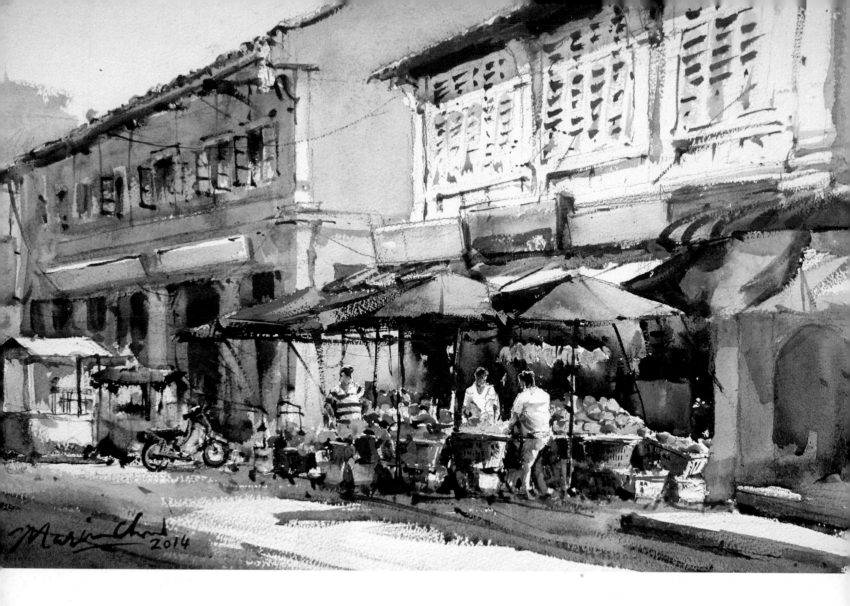

 FRUIT STALLS IN PENANG, MALAYSIA
Marvin Chew
Watercolor with gouache on 140-lb. (300gsm) rough Arches
14" × 21" (36cm × 53cm)

DISCOVERING JEWELS WHILE PAINTING PLEIN AIR
I love plein air painting. There is a magical connection with the subject that is impossible to replicate in studio. These roadside stalls are quite common throughout Southeast Asia—a rather mundane scene to most, but intriguing to me with its mismatch of colors, lines and shapes that offer interesting design possibilities. Painting outdoors, the constantly changing light and the humidity of the tropics posed many challenges for me. Thankfully, I managed to complete it in two hours and keep it fresh and spontaneous. The jewels in this piece and many of my works are in the suggested details where I added opaque colors and gouache using energetic dry brushstrokes adapted from Chinese calligraphy.

There are no shortcuts in mastering watercolor, just as there are no shortcuts when climbing a mountain.
—Marvin Chew

 TIVOLI LIGHTS
Elena Balekha
Transparent watercolor on 140-lb. (300gsm) cold-pressed Fabriano Artistico
30" × 22" (76cm × 56cm)

A MAGIC PLACE AND A MYSTERY WOMAN
The magic of this place just grabbed me and I had to paint it! Tivoli Gardens, located in Copenhagen, Denmark, is the second oldest amusement park in Europe. It is a very unusual and beautiful place, full of magic and surprises. I was particularly fascinated by the unusual lanterns at the entrance alley. They create a fairy tale, out-of-this-world atmosphere, especially at sunset! Soft warm light flooded the scene silhouetting the lanterns against the dark foliage of trees. A mystery woman walked into the gardens to enjoy its magic and peace just as I was photographing the scene.

I was thinking about the magic of the place while painting it. —Elena Balekha

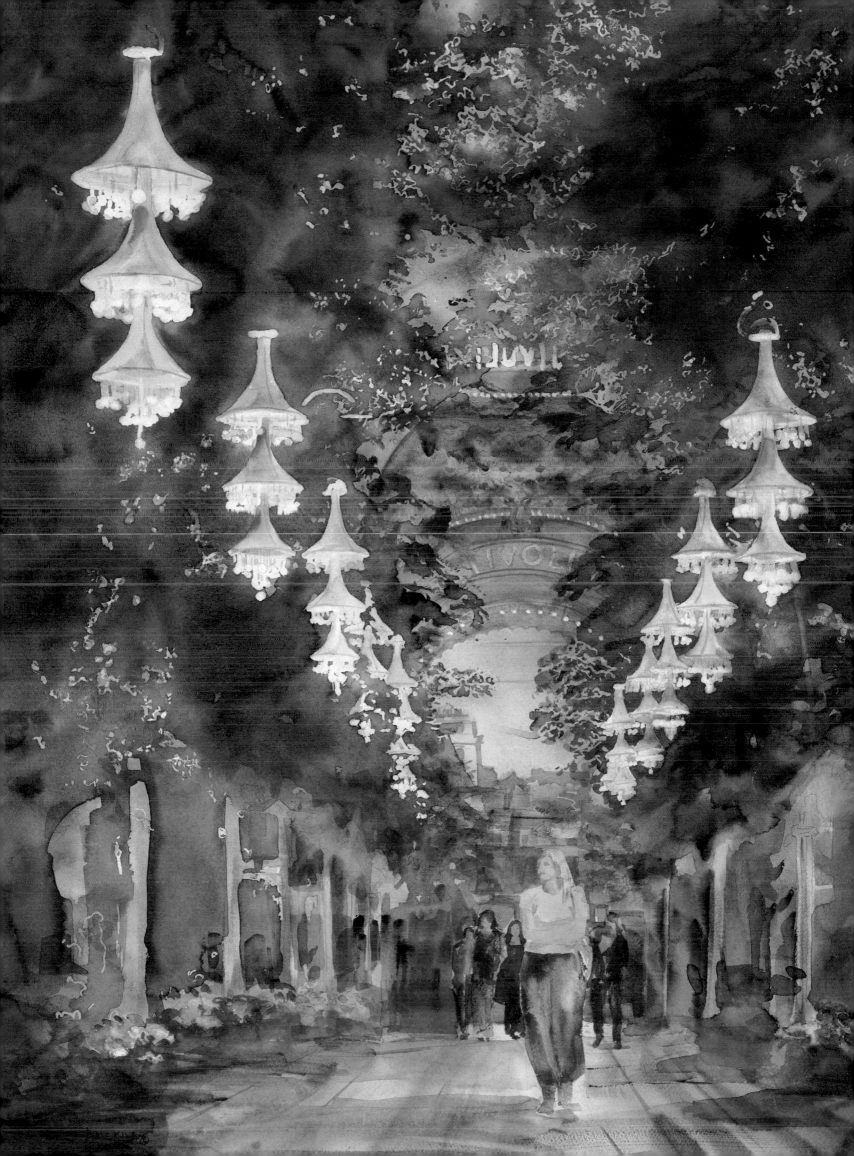

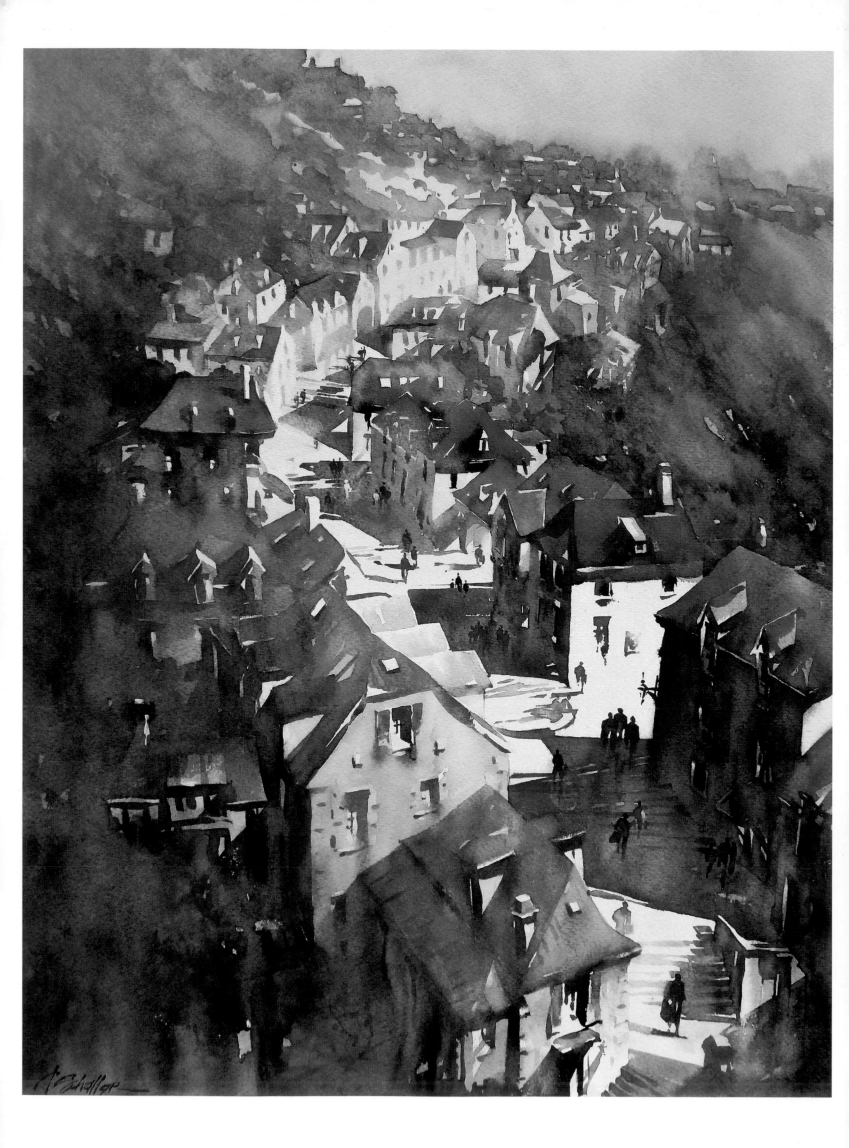

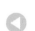

STEPS OF ROCAMADOUR
Thomas W Schaller
Watercolor on paper
30" × 22" (76cm × 56cm)

HARMONY OF MAN AND NATURE
There are times when the emotional power of a place actually exceeds your wildest expectation. The medieval town of Rocamadour in France's Dordogne region was a place I have wanted to see since I was a child. When I was lucky enough to be teaching there recently, I was anything but disappointed. The place seems to have sprouted organically out of the misty forests and craggy rock cliffs to which it clings. The architecture of man and the architecture of nature are entwined and seem at once improbable, yet inevitable—in complete harmony. That is the story I tried to tell in my painting. The path of light that winds through the forest magically reveals the beautiful town to which it is inextricably linked.

CHIT CHAT NO. 2
Tan Suz Chiang
Transparent watercolor on 140-lb. (300gsm) cold-pressed Saunders Waterford
17" × 17½" (30cm × 45cm)

HOLDING ONTO A FADING PAST
In Asia, we are confronted with the need to modernize and develop our country to cope with the economic demands of a developing nation. This is at the expense of losing our culture and wonderful memories. Watercolor painting is my way to capture the fading image of places I love. My works are a combination of my experiences, research, imagination and experiment, a blend of both Western and Eastern influences. One of my preferred techniques is to vary the direction of my brushstrokes to create the sense of energy and expression. I use broad strokes and shades of color to create the general environment of the painting, then bolder strokes and lines to highlight certain areas that are carefully planned and never frivolous.

We live in a hectic world driven by materialism; I hope that my works bring us back to what is beautiful and inspire us to go back to nature and live life to the fullest. —Tan Suz Chiang

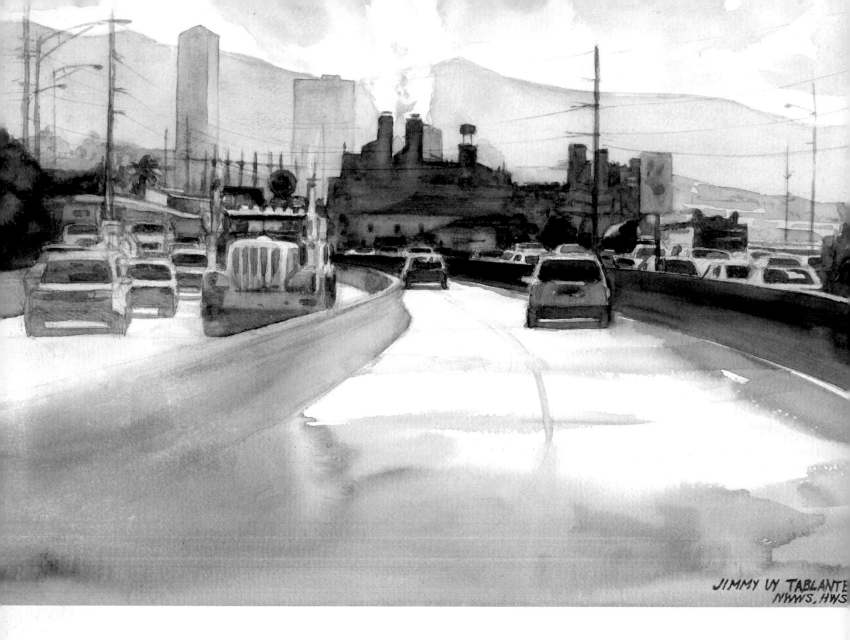

JIMMY UY TABLANTE
NWWS, HWS

 EARLY MORNING DRIVE
Jimmy Tablante
Transparent watercolor on 140-lb. (300gsm) cold-pressed Arches
11" × 15" (28cm × 38cm)

MOMENTARY DRAMATIC SHADOWS

As an architectural designer and a watercolor artist, I am always on the lookout for dramatic perspectives. Riding in a car on the H-1 Freeway near Pearl City in Oahu, I was struck by the shape and shadows of the Hawaiian Electric Building. The smoke stack, lit up by the morning sun, created a dramatic image of strong dark shadows contrasted with bright bursts of morning light. Excited to paint this gorgeous subject, I quickly captured a shot with my phone camera. Later I rendered an almost monochromatic re-creation of the image.

 AT THE OPERA
Nadine Charlsen
Watercolor on 150-lb. (315gsm) Khadi handmade paper
39" × 26" (99cm × 66cm)

ARCHITECTURE OF BYGONE SPLENDOR

I went to Paris to explore the wonders of the iconic city. Walking into the Paris Opera to admire the architecture, the monumental grand staircase beaconed me to photograph it for a painting. The environment and structure create every kind of dramatic contrast: light/dark, smooth/rough, color and value. Working large-scale allows me to explore subjects with areas of detail and textures using drips and puddles, and the handmade heavyweight paper allows me to scrub and scratch and repaint over and over. I want my viewer to experience and feel the moment as I did.

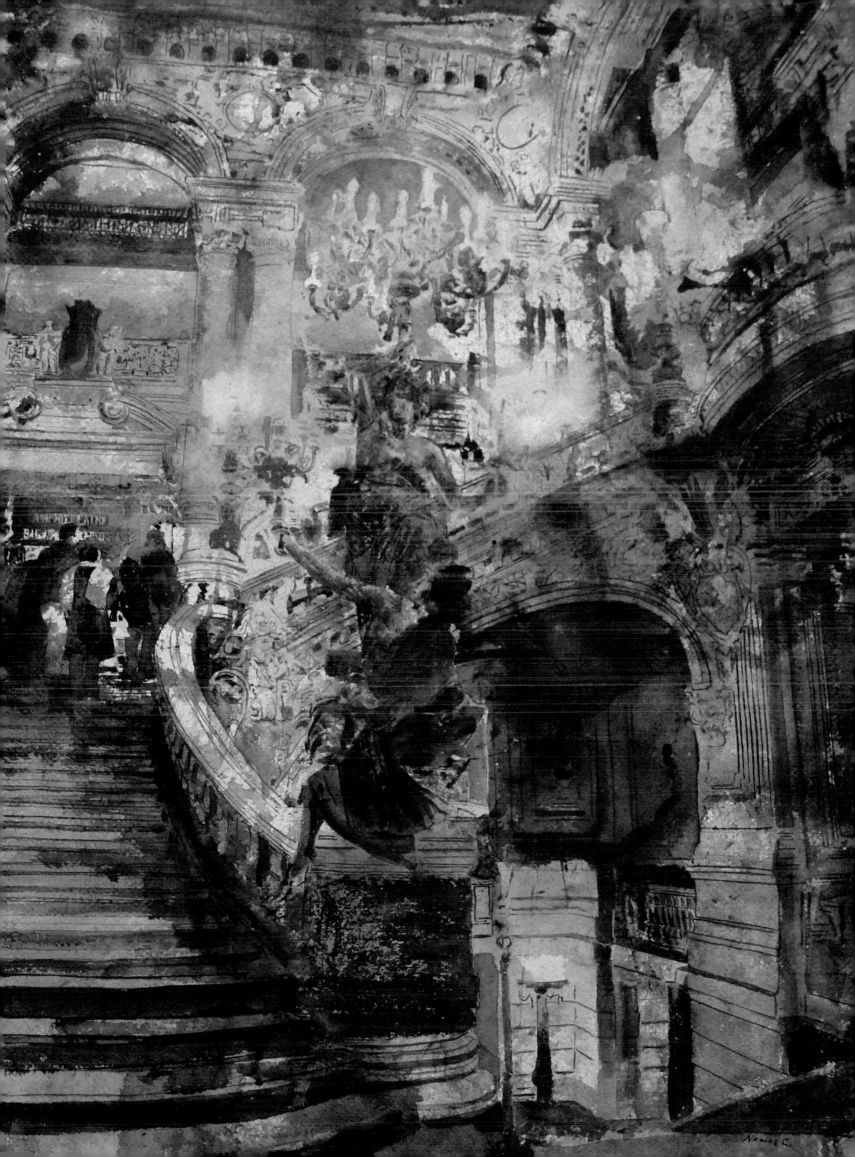

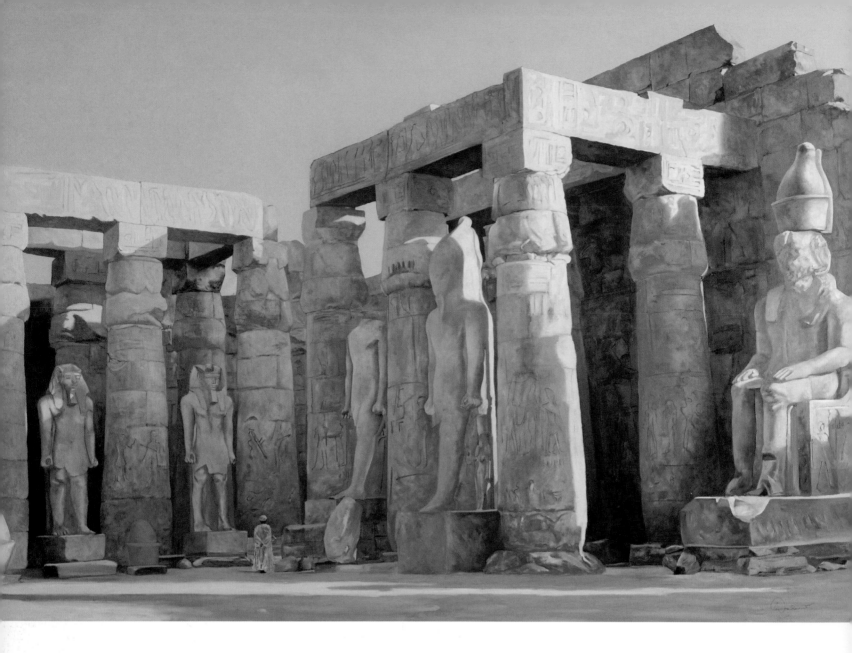

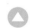 **TEMPLE OF KARNAK**
Thomas Valenti
Transparent watercolor with gouache accents on 260-lb. (550gsm)
cold-pressed Arches
25" × 40" (64cm × 102cm)

SHROUDED MYSTERIES OF THE PAST
Though my main source of painting inspiration is New York City
street scenes, I am quite intrigued by ancient civilizations and their
ability to erect massive monuments without the aid of modern tools
and technology. The ancient Egyptians were especially adept in
creating magnificent edifices whose building methods continue to
be shrouded in mystery. I was drawn to the size and scope of the
columns and statuary at the Temple of Karnak, and added the figure
to illustrate these proportions. After taking extensive measurements
from my photographic reference, I drew directly on the paper. In
certain areas I mixed gouache into my colors to give more body to
the paint. My watercolor palette consists of only seven colors; no
more than three to four colors are used in any given painting.

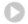 **POLITECHNIOU STREET, THESSALONIKI**
Daniel Napp
Watercolor on 140-lb. (300gsm) cold-pressed Saunders Waterford
15½" × 12" (39cm × 30cm)

UNEXPECTED MUSE ON A GRAY DAY
During a painting week in Thessaloniki I planned to paint plein air
watercolors at the harbor. But a rainy day destroyed my plans. So
I decided to relax on my roofed hotel balcony. After a couple of
minutes staring at the busy crossing, I finally realized: I have some
work to do!

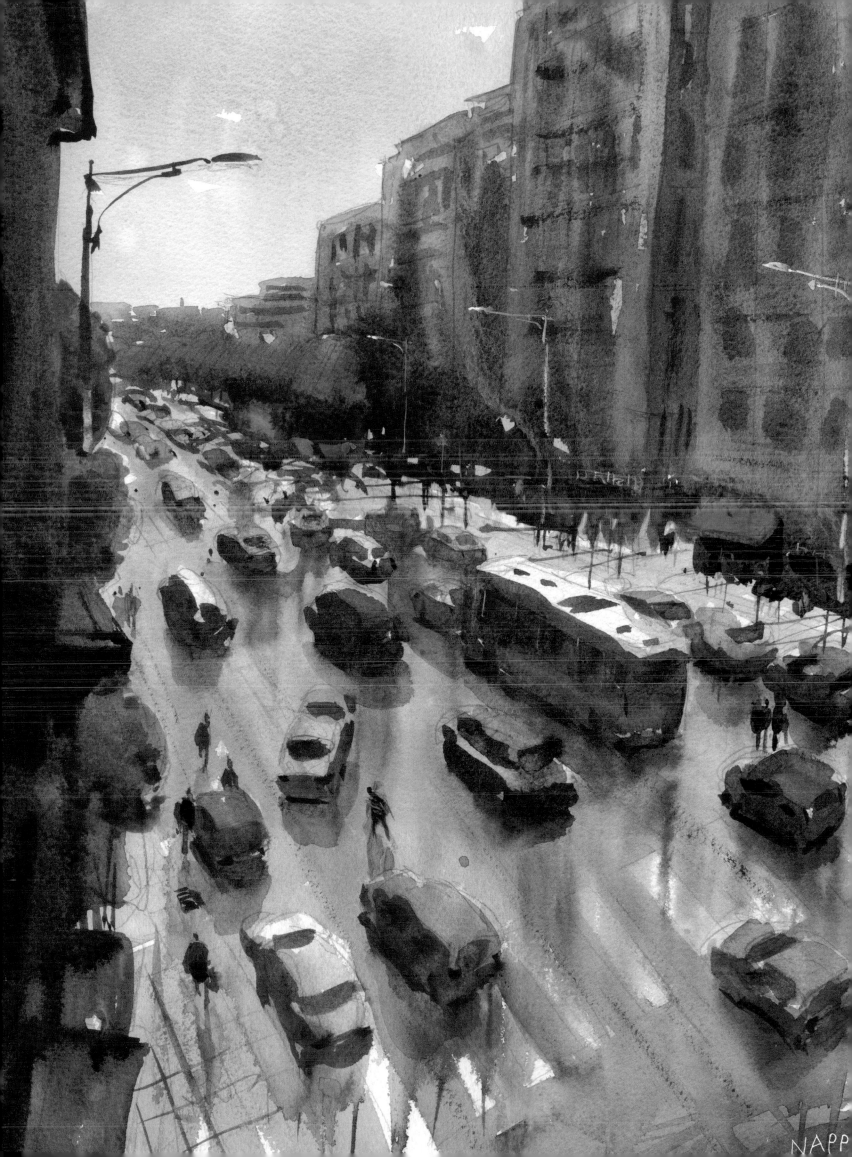

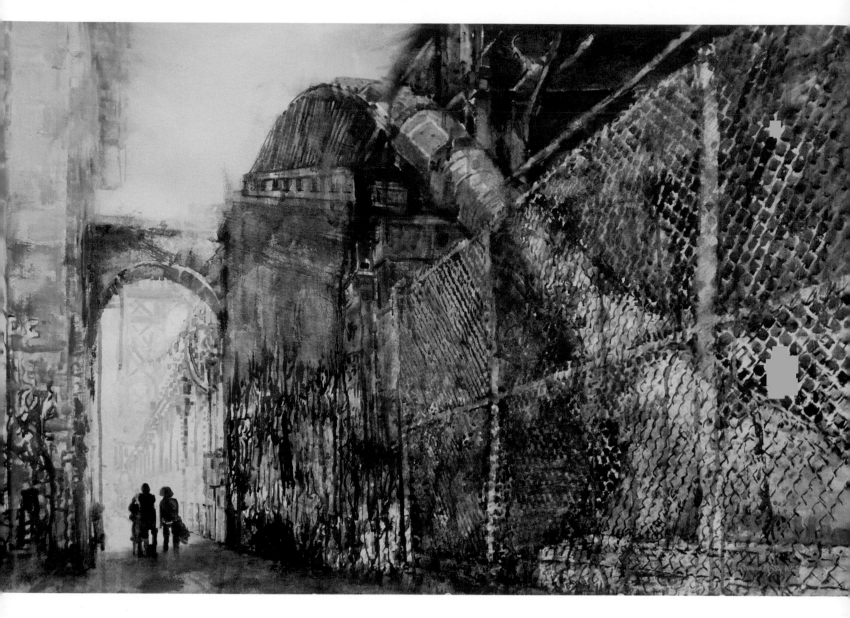

FAMILY WALK – MANHATTAN BRIDGE

Antonio Masi

Transparent watercolor with body color
on 300-lb. (640gsm) rough Arches
30" × 40" (76cm × 102cm)

TEXTURAL MAZE

This work was created from sketches, photos and memory. The approach I took was to use many glazes to build up areas with thick paint. It was a sun-bleached day and what attracted me to the scene was its multiple textures that almost numbed the senses. The flow of light on the forms gave them a jewellike quality. The simplicity of the silhouettes contrasted by the intricate lacework of the steel fence and diffused light enveloped everything—an elusive moment.

Life is art. Art is life. —*Antonio Masi*

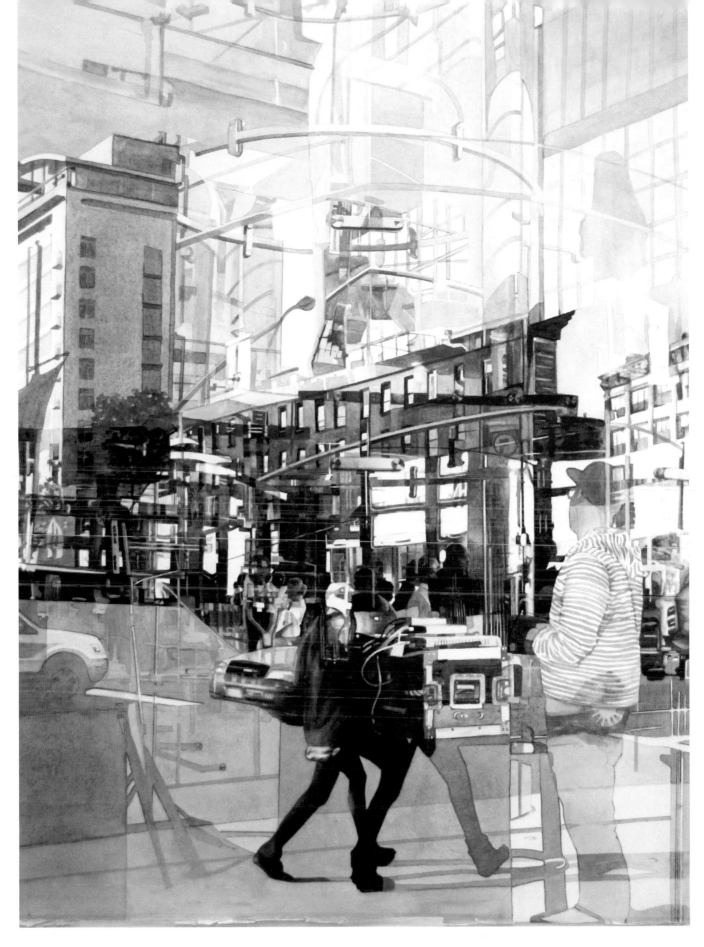

APPLE NYC – INSIDE AND OUT
Robin Erickson
Transparent watercolor on 300-lb.
(640gsm) hot-pressed Fabriano Artistico
30" × 20" (76cm × 51cm)

FINDING THE MAGIC IN PLAIN SIGHT
We urbanites often pass through our surroundings without seeing what is all around us. My aim is to help viewers see the magic that can be right in plain sight. I compose with my camera lens, using photographs of reflections to create my paintings. I find a store window with interesting shapes, colors or potentially relevant text. I then wait until the right person, vehicle or bicycle appears and snap the shutter. This image was created at the Apple store on 14th Street in New York City, which is a beautiful glass edifice. From the printed photo, I trace the image, editing as I go, and then put it carefully onto my paper using graphite transfer paper.

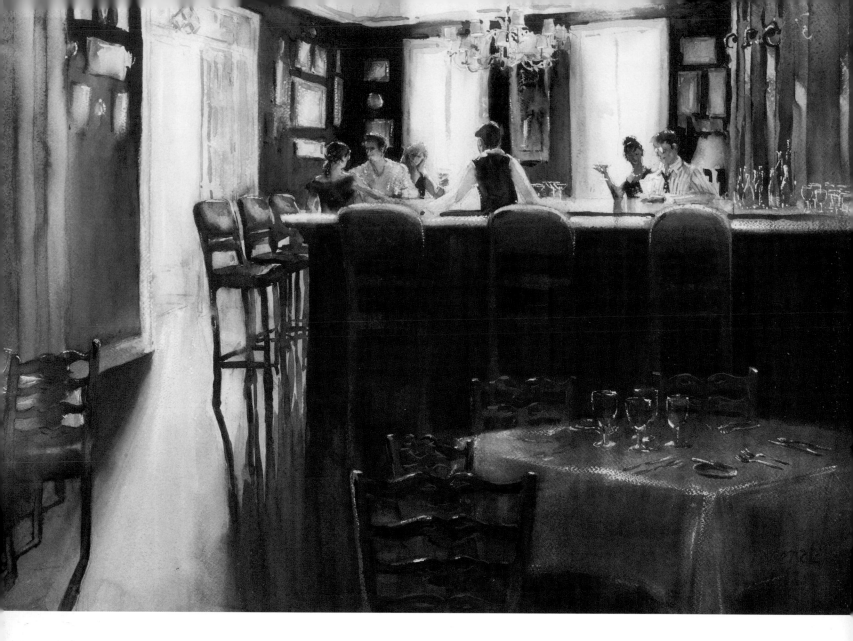

 HAPPY HOUR AT THE EBBITT ROOM
Marie Natale
Watercolor on 140-lb. (300gsm) rough Fabriano Artistico
20" × 30" (51cm × 76cm)

BEAUTY IN BACKLIGHTING
Backlighting fascinates me! While awaiting dinner I was struck by
the ambient glow flooding through windows and doorways, creating
long reflections and sparkles on any surface it touched, while rich
darks created lost edges. My painting approach is this: Keep it simple,
capture the essence of the scene and complete in these five stages:

• Composition. The Rule of Thirds is always a good start.
• Draw simple, convincing and interesting shapes.
• Paint first layer top to bottom in lightest values, mingling colors as a
 varied wash; connect everything; hold on to some white paper.
• Add midtones. Consciously save a percentage of the first wash
 and whites.
• Pull painting together by adding dark values; darks create the
 magic of the painting. Add sparkle using touches of white where
 needed.

 VIEW OF VENICE WITHIN VENICE
Luis F. Perez
Transparent watercolor on 300-lb. (640gsm) cold-pressed Fabriano
Artistico
30" × 22" (76cm × 56cm)

LOST AND FOUND IN VENICE
While touring Venice, Italy, I came upon this little scene: two folding
chairs and a painting on an easel in between. I took a photo. A year
later, I used the image as a demonstration for my students, and I
became caught up with its possibilities: varied textures, pushing
color limits, large format and the intriguing feature of viewing a
Venice scene within a Venice scene. My process was simple and
methodical, starting with the chairs, painting and easel, and finishing
with the large door and upper wall.

*Understanding the personality of your colors is very helpful for achieving the
final result you want. Is the color transparent or opaque? Does it stain? Can it
be lifted? Is it grainy or textured when it dries?* —Luis F. Perez

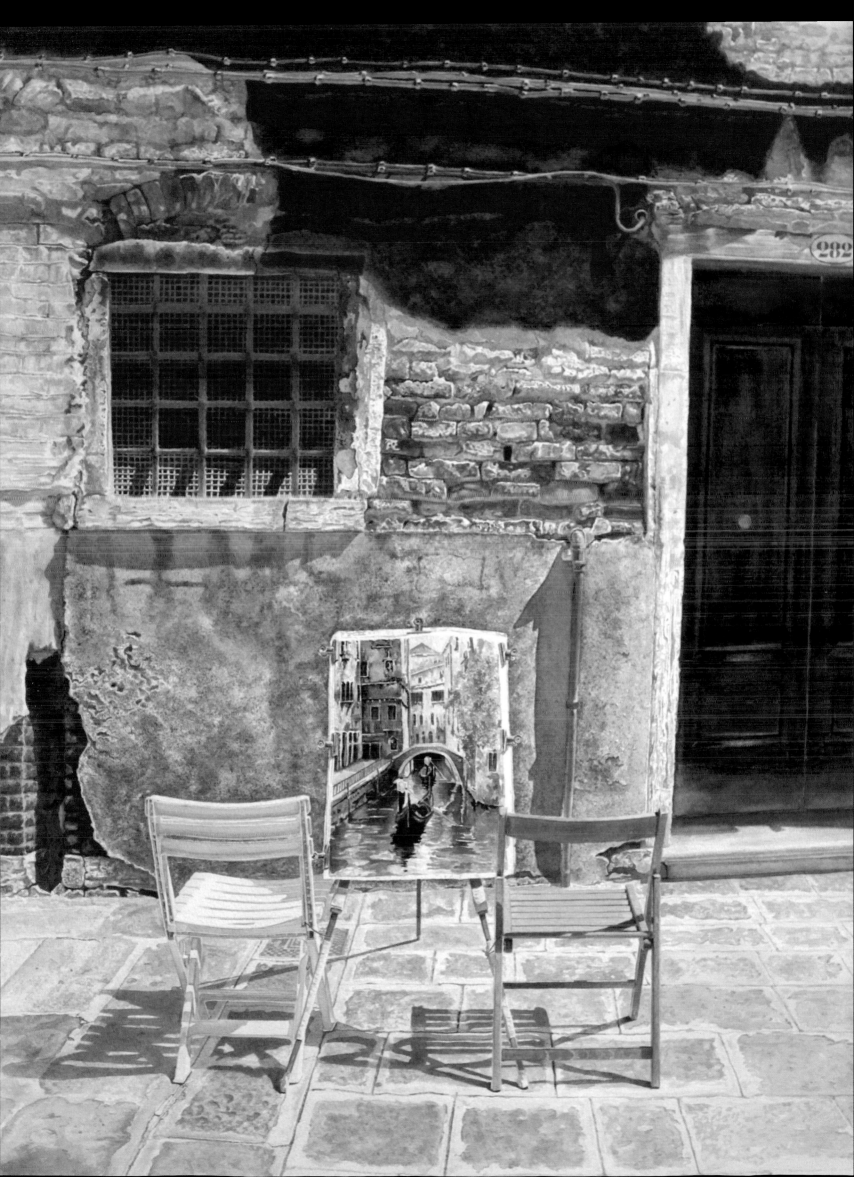

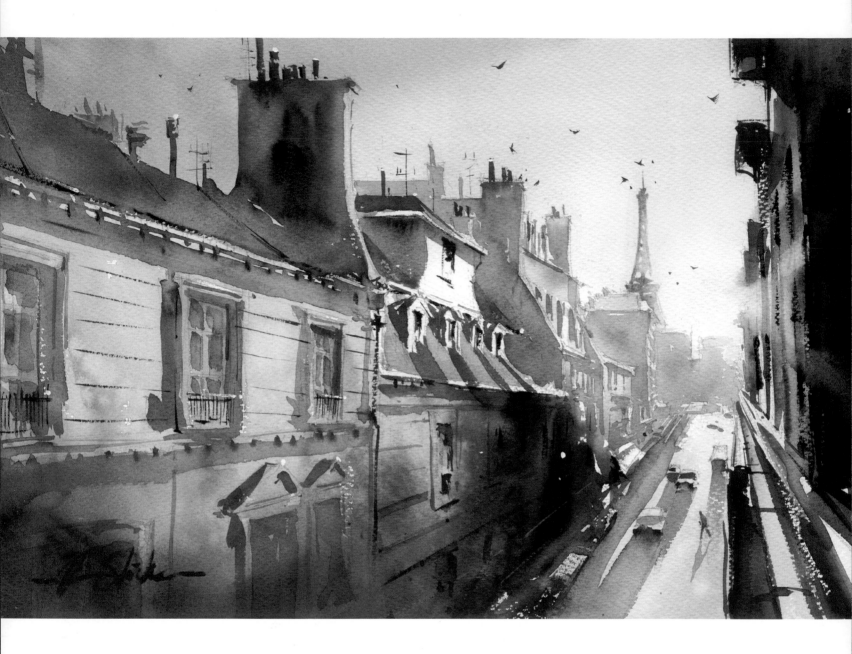

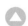 **PARIS LIGHT**
Ron Stocke
Transparent watercolor on 140-lb.
(300gsm) cold-pressed Saunders
Waterford
14" × 21" (36cm × 53cm)

THAT PARISIAN GLOW
I started by drawing a forced perspective view of a Paris street, taking liberties with some of the
buildings and monuments. A strong drawing is the foundation of all of my paintings. I sometimes draw
a more complete rendering of my subject but paint only what I need. The same goes with color. Often
the paintings with a simpler color palette make the most impact. This painting was done with five
colors: Yellow Ochre, Burnt Sienna, Ultramarine Blue and Dioxazine Purple with Cadmium Red Light
for accents.

*Draw as much as you want but paint only what
you need.* —Ron Stocke

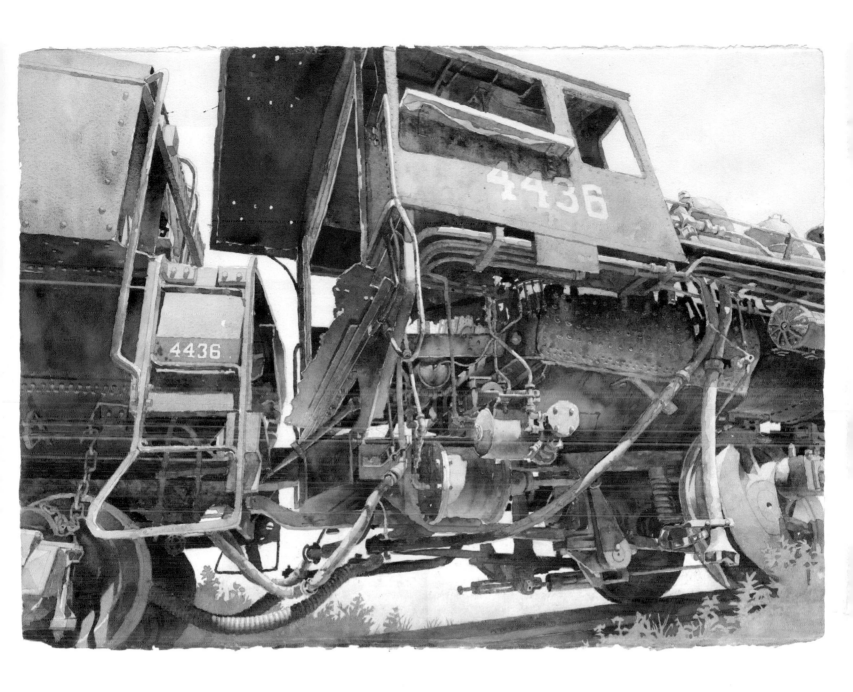

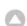 **ENGINE 4436-CAB**
Peter V Jablokow
Transparent watercolor on 300-lb.
(640gsm) hot-pressed Arches
22" × 30" (56cm × 76cm)

CAPTIVATING MACHINERY
The looming weight of this steam engine in Ogden, Utah, is what inspired me. I'm more interested in the dramatic angles, shapes and textures surrounding me when I walk up close (and maybe climb up) to an object than a static overall portrait. When I find something that captivates me, I take hundreds of pictures on a sunny day from every possible angle. When I get home, I view the images to see if one grabs me. I often don't find any, even if I love what I'm photographing. I really have to love both the subject and the composition, or it's not worth the many hours of work. In this case, I found what I was looking for.

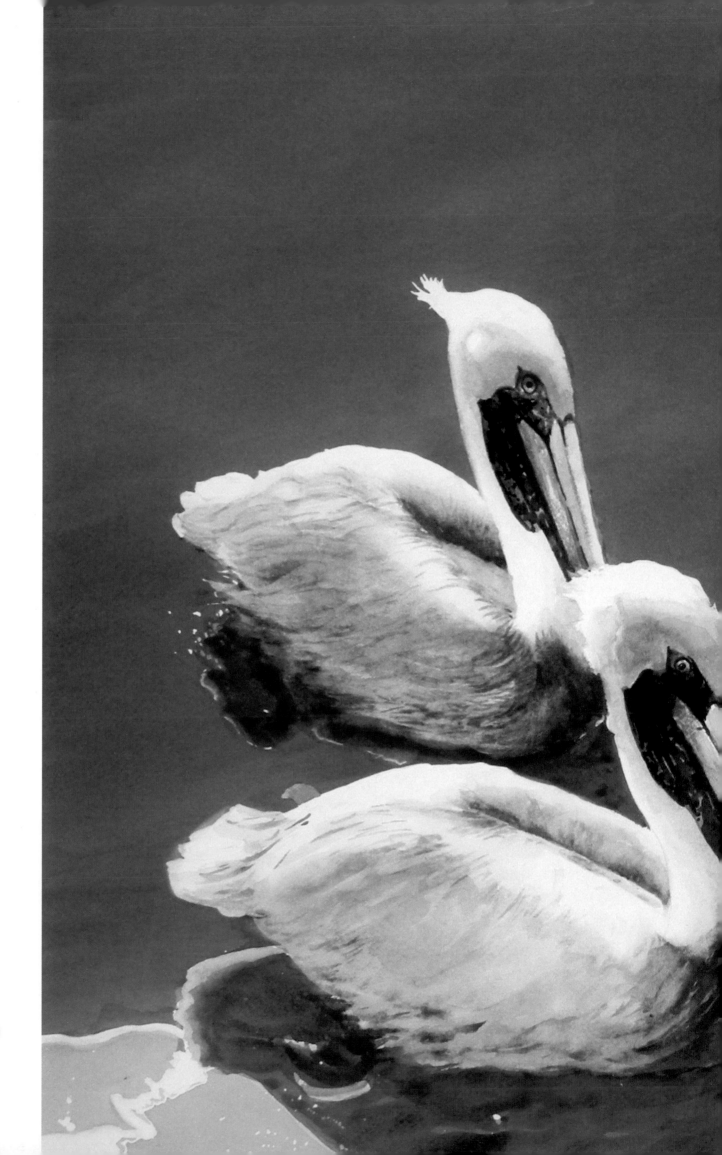

4 ANIMALS

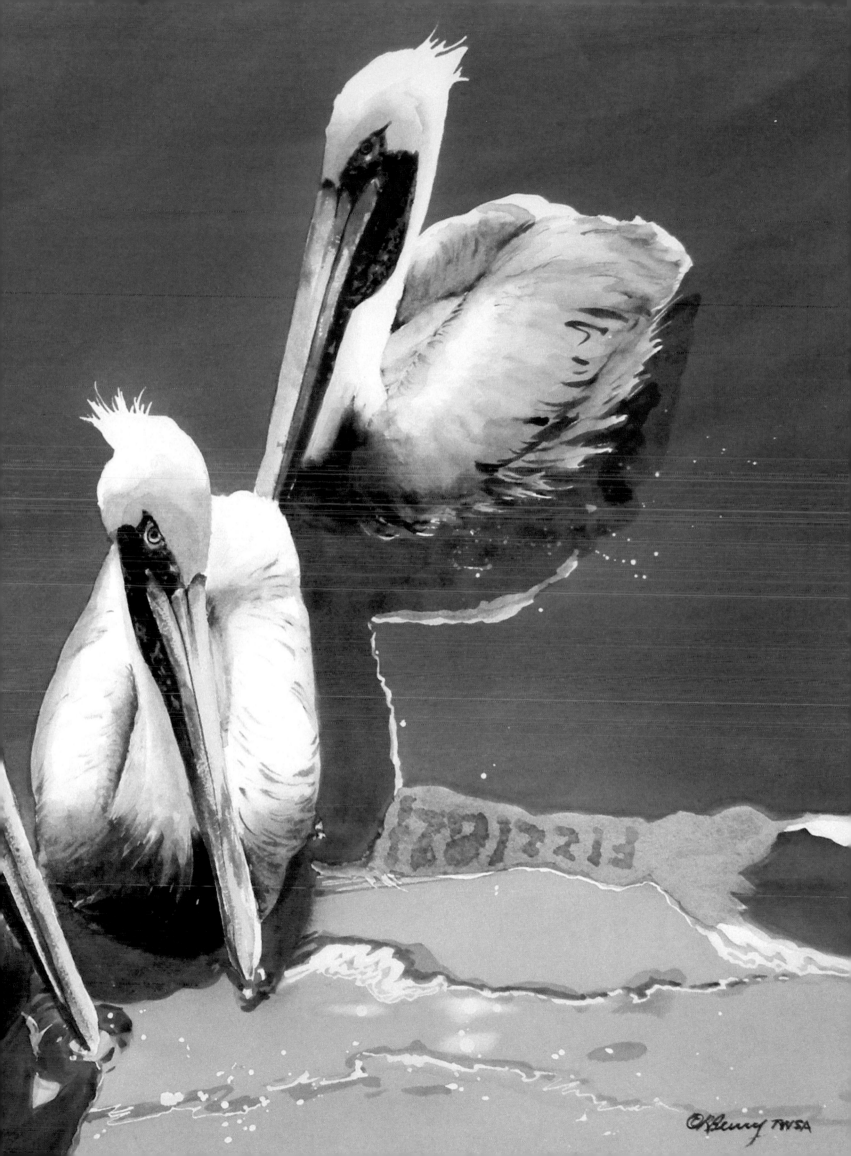

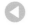

THE GATHERING
Robin Berry
Transparent watercolor on 140-lb.
(300gsm) cold-pressed Arches
20" × 28" (51cm × 71cm)

LIFETIME LOVE OF BIRDS
Birds have been a lifetime love and the most inspiring subject for me. This painting of a gathering of brown pelicans expresses the immediacy of a thrilling moment. I took many photos at the time. Later I opened the photos in Photoshop and rearranged the composition until it felt natural to me and reflected the experience that had inspired me. In addition to the birds, two elements present in all the photos excited me: the unusual color of the water, which I mixed to match exactly, and the blue reflection of the sky in the foreground. Before I started, the birds were masked so that the water and sky reflection could be painted smoothly. When dry, the masking was removed and the pelicans completed.

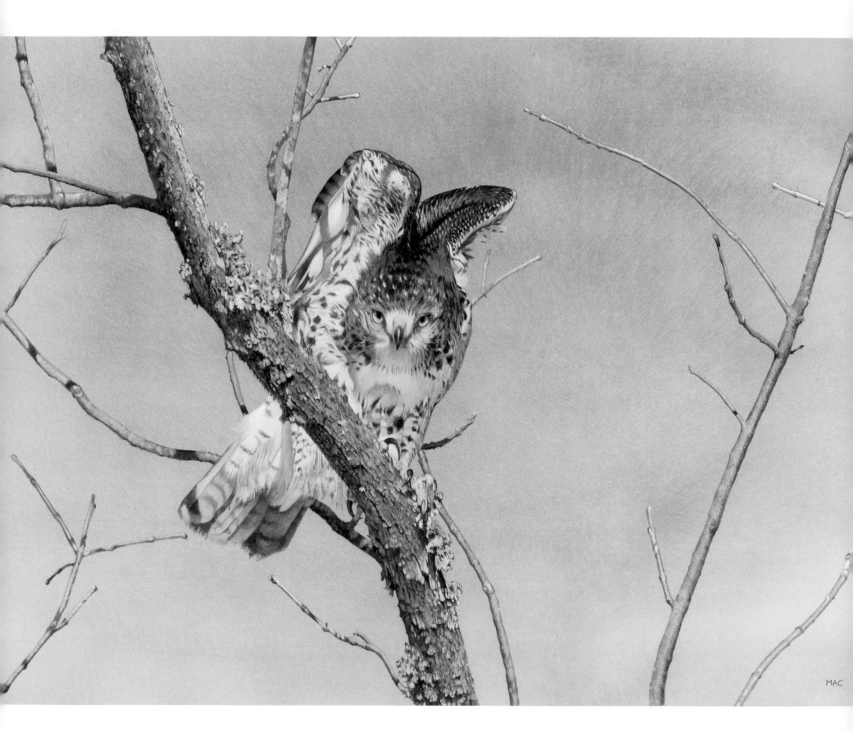

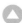

EAGER TO LAUNCH
Mark A. Collins
Transparent watercolor and
gouache on 140-lb. (300gsm) cold-
pressed Arches
19" × 26" (48cm × 66cm)

SPIRIT OF THE WILD
A friend notified me that a juvenile red-tailed hawk had established hunting grounds in a suburban field. Despite the brisk January weather, I headed out the next clear day and was rewarded with a dramatic sighting—the glowing white chest and raised wings of the hawk against a cloudless cerulean sky. The bird commanded attention in this rarefied air. To capture the drama of the moment, I knew the color of the pure winter-blue sky would have to be perfect without blemishes, streaks or blossoming. I spent a whole day painting blue skies with transparent watercolor on various brands and textures of watercolor paper until satisfied. Using gouache to paint the bird, I was careful to let the blue shine through in parts of the branches and bird. Positioning the hawk to engage directly with the viewer suggests imminent movement and an eagerness to launch.

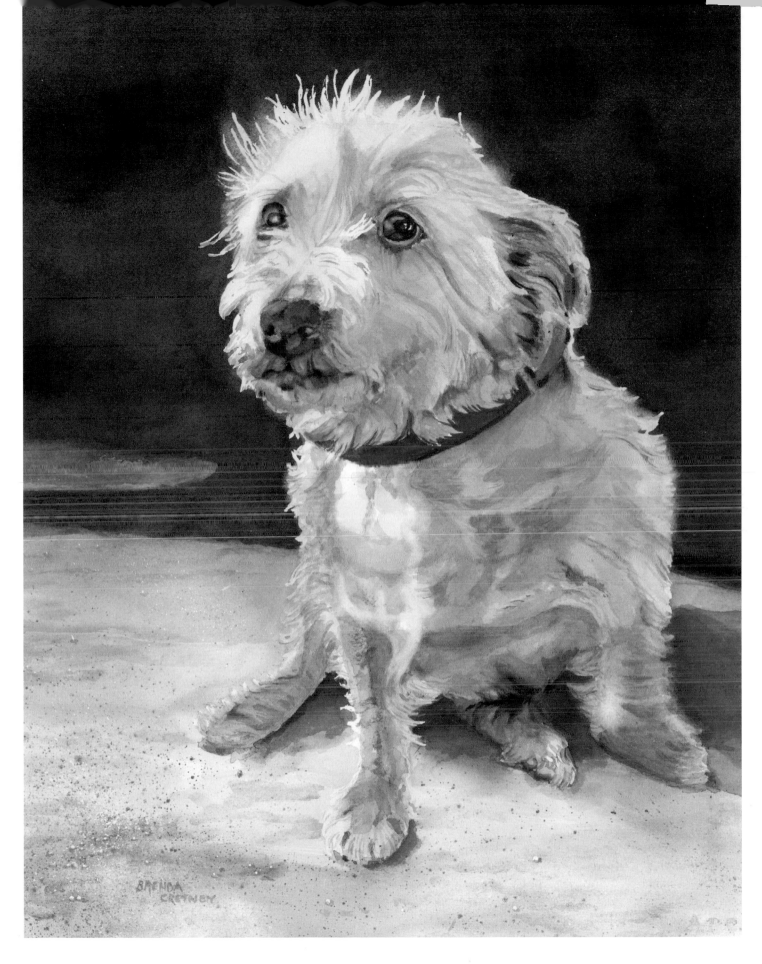

SHY PENNY

Brenda Cretney

Transparent watercolor on 140-lb.
(300gsm) cold-pressed Arches
19" × 14" (48cm × 36cm)

UNEXPECTED MODEL ENCOUNTERED AT AN EVENT

One of the events that I use for inspiration is the Walnut Hill Farm Driving Competition. The horses and carriages are magnificent. People are dressed in costume and elegant hats. And there is a parade of pure breed and rare breed dogs. After taking photos of many spectacular dogs, I saw Penny sitting under her owner's chair trying to be invisible. She allowed me to take her picture but didn't seem to feel it was a safe thing to do. I later used that photo and my memory of the little waif of a dog to do this painting. The success of an animal painting depends on getting the eyes right. At least one of your photographs has to show you the shapes and the colors of the eyes. I want my paintings to convey how much I like my subjects.

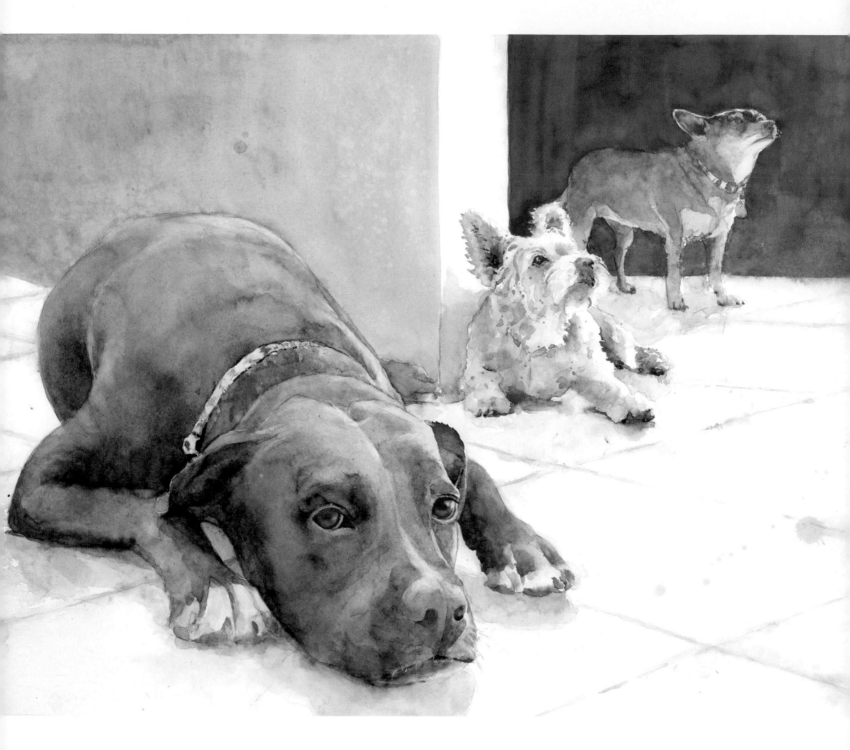

 SO EASILY DISTRACTED
Kim Johnson
Transparent watercolor on 300-lb.
(640gsm) hot-pressed Fabriano Artistico
18" × 22" (46cm × 56cm)

MEETING A COMPOSITIONAL CHALLENGE
A client with two small active dogs and one large easy-going dog commissioned this painting. I took a few photos. In each of the photos the smaller dogs were actively watching the people around them while the large black dog was indifferent. To bring out the unique character of each pet, I had to combine three photos though this can be somewhat challenging when it comes to perspective and lighting. I painted on hot-pressed paper to keep the colors alive and vivid. A variety of pigments were used to get good darks including Ultramarine Blue, Carmine, Burnt Sienna and Mineral Violet. I let the mixing happen on the paper to keep the pigment looking fresh.

Inspiration: When it hits, don't wait to put it together, go with your gut and paint it! —Kim Johnson

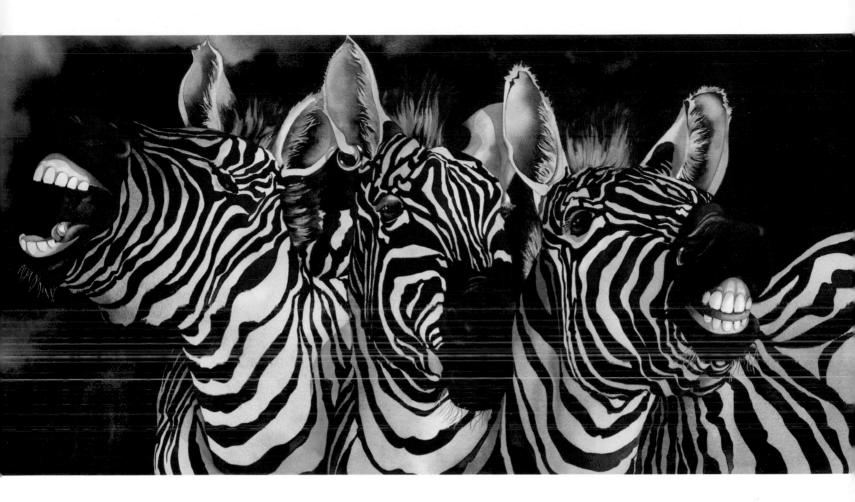

THE RING BEARERS

Nancy Collins

Transparent watercolor on 300-lb.
(640gsm) cold-pressed Arches
21" × 43½" (53cm × 110cm)

RAMPING UP THE COLOR

Painting ordinary subjects with unusual colors and hidden objects brings fun and surprise to my work. I love visiting and photographing the zebras near my home and kept wondering how color would change the appearance of these beautiful yet awkward creatures. I always mix my watercolors on the paper, not in the palette. While it is risky, it sure makes it exciting and fresh. That is how I changed these zebras' attire from prison garb to party time. And who would ever expect to find a nose ring on a zebra?

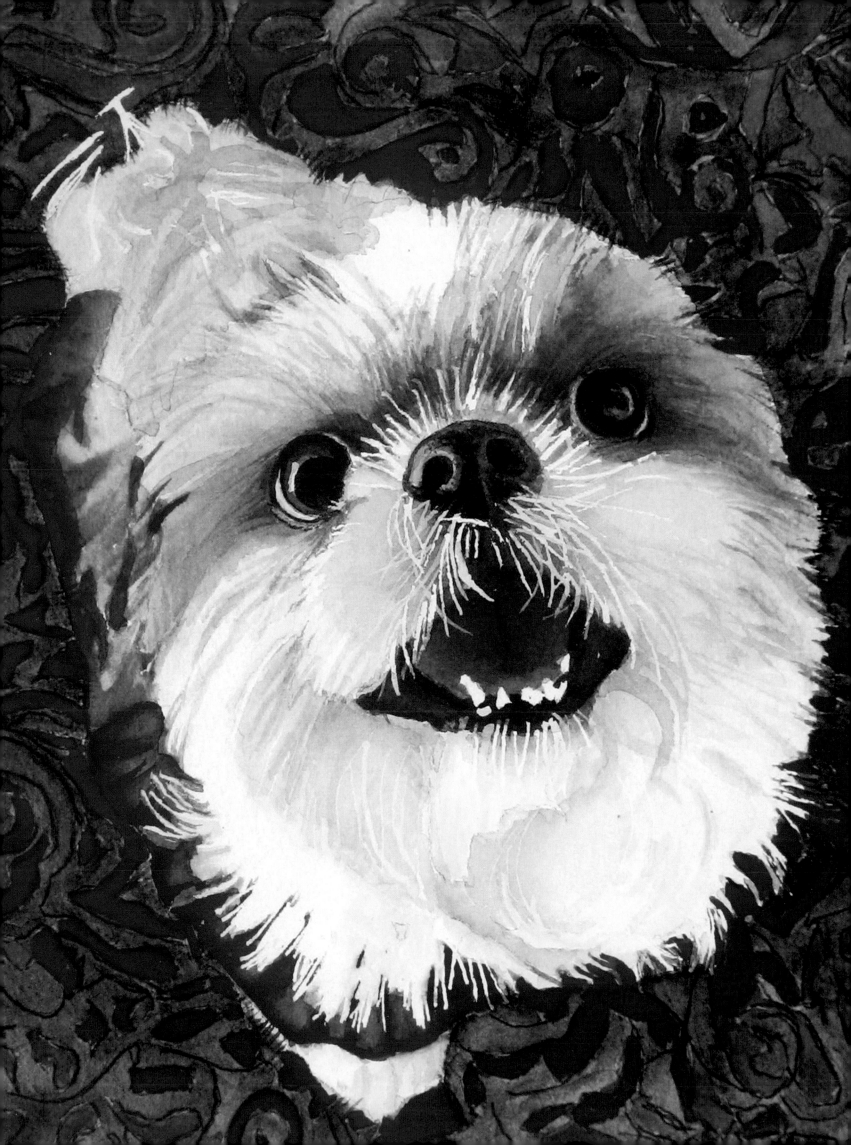

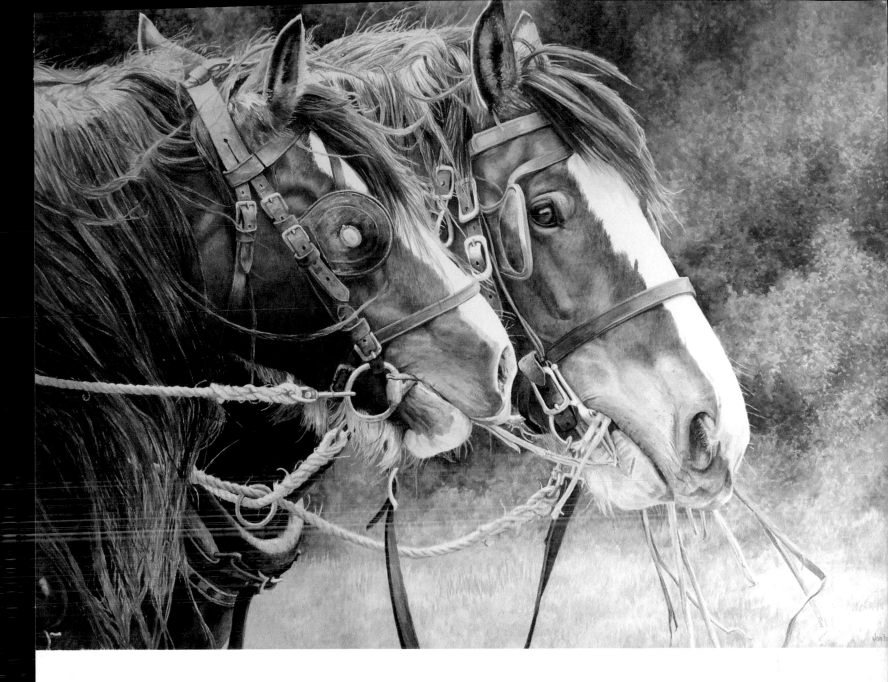

SHARED GRASS
Jan Long
Watercolor on 140-lb. (300gsm) cold-pressed Arches
22" × 30" (56cm × 76cm)

ENDURING APPRECIATION FOR HORSES
Horses have been a part of my life since childhood and are a favorite subject. Every move shows muscle, and every action, especially caught in the light, can make a great painting. Horses have mates and they enjoy being close together. I draw with HB graphite, then begin with some washes in selected areas. I build up many layers, carefully painting around all the lights and whites—I never use masking or white paint. Often the fine point of the brush is used like a pencil for the hairs. It is a very slow and difficult process, but so enjoyable. I leave to you the question of what will happen to the grass.

MIMI
Mid Martinez
Transparent watercolor on 300-lb. (640gsm) cold-pressed Arches
11¼" × 10" (29cm × 25cm)

BACKGROUND LAUNCHES THE PAINTING
I started painting Mimi, a Shih Tzu, from an email sent to me by a close friend who had adopted her from a rescue group. Mimi's enthusiastic attitude and sparkling eyes inspired me to paint her. She appeared to be smiling eagerly, yet the gold-color rug she was sitting on seemed to make her disappear. I decided to paint the dog and then consider the rug/background. After Mimi was painted, I drew into the background several shapes similar to the pattern on the original rug, then applied bright colors into the shapes. This brought the dog into view as if she were springing forward saying, "I can fly, I can fly."

The challenge and fun of painting is to be patient in the beginning, not to rush, and in the end I will have something worthwhile. —Mid Martinez

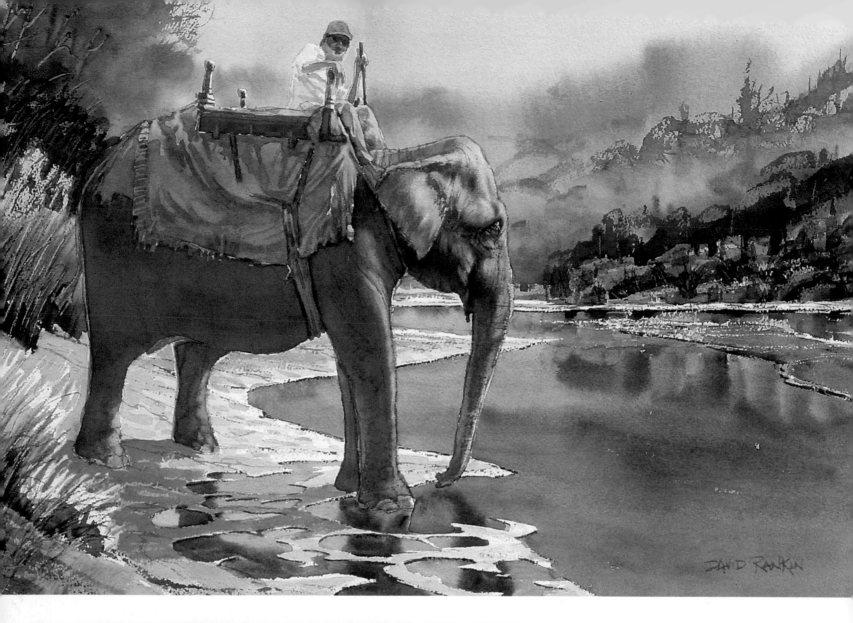

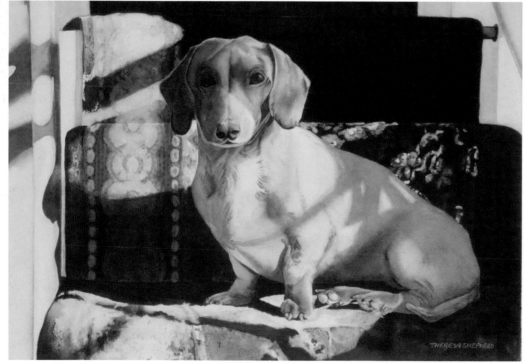

BADGER HOUND
Theresa Shepherd
Transparent watercolor on 300-lb.
(640gsm) cold-pressed Arches
21" × 25" (53cm × 64cm)

A SPECIAL CANINE SOUL
Badger Hound is my daughter's
dachshund and was painted from
several of my reference photos. She was
captured sitting quietly on a stairwell
while other dogs were running about.
It is her temperament to find a special
spot and sit quietly. I used masking
fluid to mask out the entire dog while I
painted the background. Once the mask
was lifted, I painted her eyes, trying to
capture her true nature. Looking into an
animal's eyes always draws me nearer
for a closer look, and I feel a tremendous
desire to paint them.

*An animal's eyes have the power to speak a
great language.* —Martin Buber

ARUNDHATI AT THE GANGES

David Rankin

Transparent watercolor on 140-lb. (300gsm) rough Arches

18" × 26" (46cm × 66cm)

A SINGULAR EXPERIENCE WITH A ROYAL SUBJECT

Arundhati was the Queen of Indian elephants until her untimely death at the age of eighty. During her long life in the Indian Forest Service she had been used to carry presidents, kings and queens, rajas, movie stars, world leaders and many of India's most regal dignitaries out into the jungles of North India. For many decades she was the single most famous and treasured elephant in all of India. Back in May 2007, Arundhati carried my team and me as we began my Artists for Conservation Flag Expedition #2 in the Ganges Himalayas. We spent several days exploring the North Indian elephant forests of Rajaji National Park—from Arundhati's back—and were honored to meet her. However, a month or so later we read the sad news that she had broken her front leg and died. It was very odd for me as I had spent quite a lot of time sketching her in my journal. I then did this painting to honor her as the queen of India's elephants.

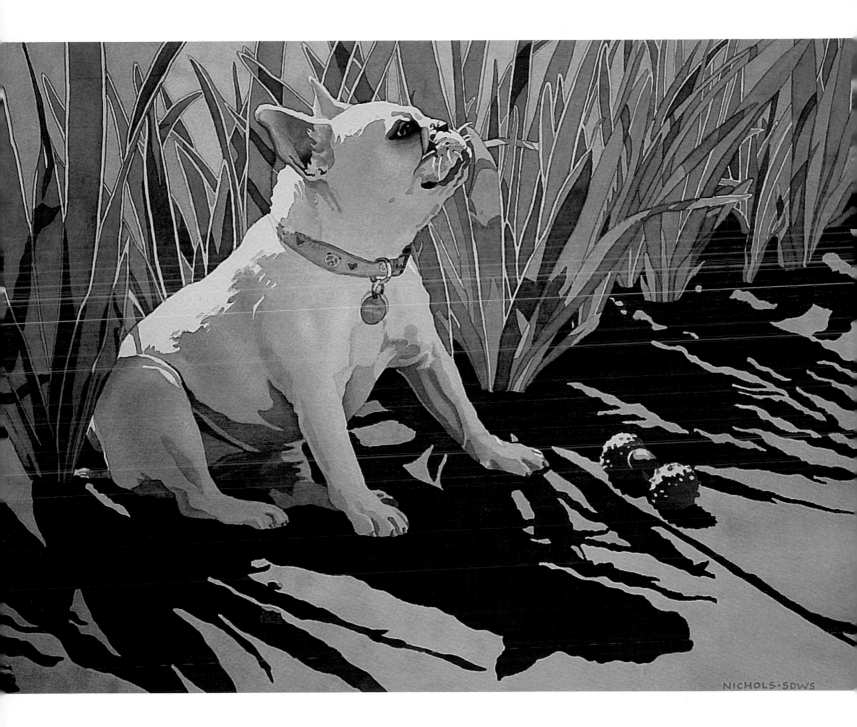

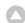

QUORRA AMONGST THE GLADIOLAS

r. mike nichols

Transparent watercolor on 300-lb. (640gsm) cold-pressed Fabriano Artistico

11" × 15" (28cm × 38cm)

LIGHT AND SHADOW ON A BELOVED CREATURE

In 2014 we adopted a lively French bulldog named Quorra. As with any new child we took numerous photos. Subjects with wonderful light and shadow patterns always catch my eye, and I loved the way the sun was playing across her head and back and creating interesting shadows. Our first Frenchie, Lilly, was a constant source of inspiration, and Quorra is proving to be the same. Capturing the essence of her playful spirit is both a joy and a challenge.

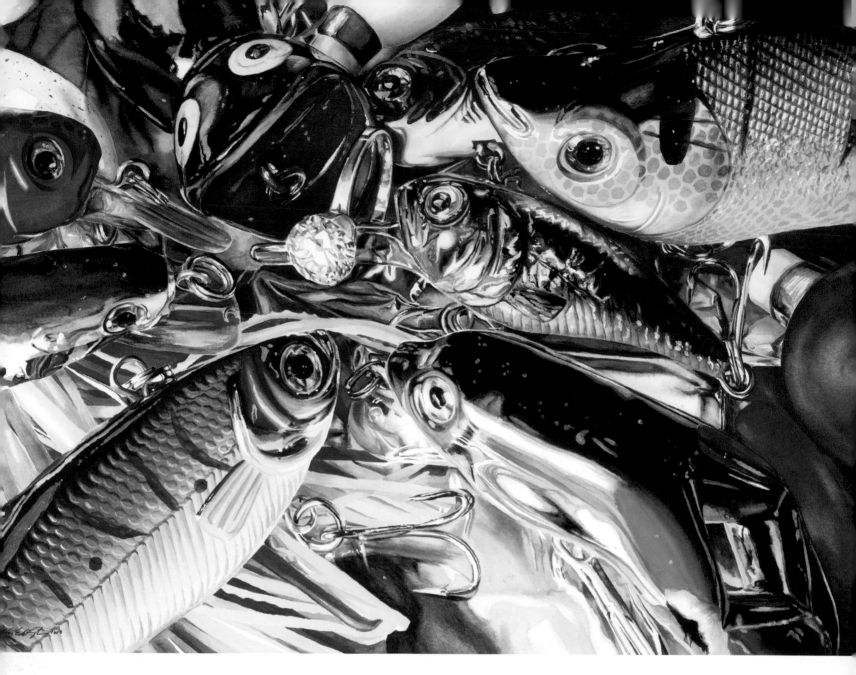

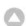 **HOOKED**
Kelly Eddington
Transparent watercolor on 140-lb.
(300gsm) cold-pressed Arches
18" × 24" (46cm × 61cm)

THE LURE OF AN ORIGINAL SUBJECT

Coming up with an original idea for a still life is difficult, especially when your contemporaries seem to own subjects like crystal vases, canning jars or rusty old tools. I keep a running list of subjects I've never seen other painters tackle, and "fishing lures with jewelry" was one of them. When I arranged the lures on a piece of aluminum foil, they slid around and knocked each other over. I added a jumbo (fake) diamond ring into the mix to create a sort of feeding frenzy, lit everything carefully, and took dozens of reference photos. I live with a couple of cats who would have loved nothing more than to knock this delicate still life off my work table, so photos were the only option. It was a joy to paint the lures' shiny, nonsensical colors, goofy faces and impossible hooks.

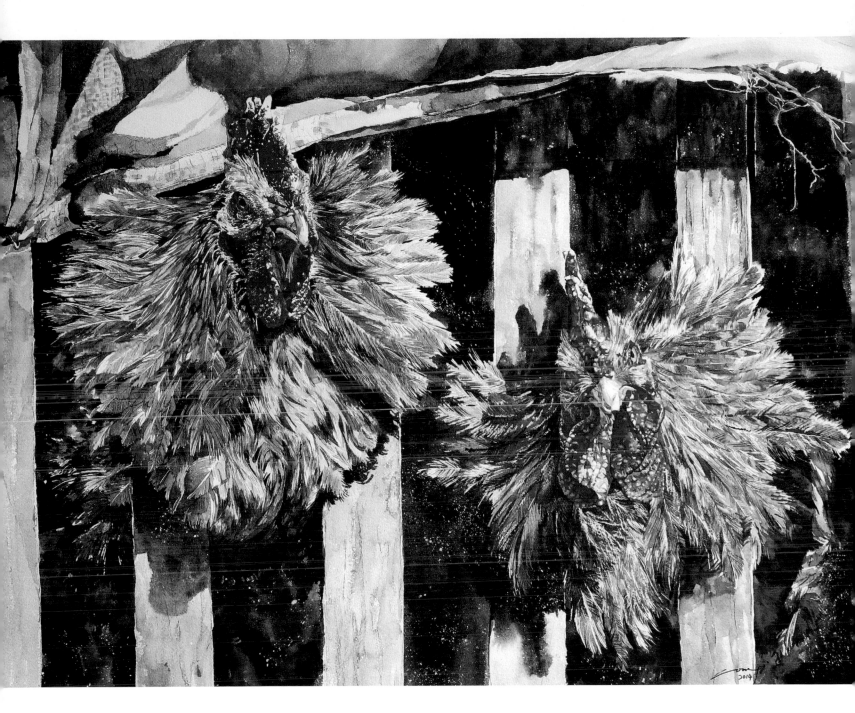

THINK & THOUGHT
Ooi Aik Ceong
Transparent watercolor on 140-lb.
(300gsm) cold-pressed Arches
22" × 30" (56cm × 76cm)

UNUSUAL ANIMAL SETTING IN STRONG LIGHT
Visual arts should be able to communicate a message by a mixture of techniques and subject matter. Light and shadow are also critical for creating strong feeling in a painting. In *Think & Thought* both chickens were rendered individually to give a better focal point to the painting. Indigo was heavily applied to the background with loose yet controlled strokes to form the important darkest value.

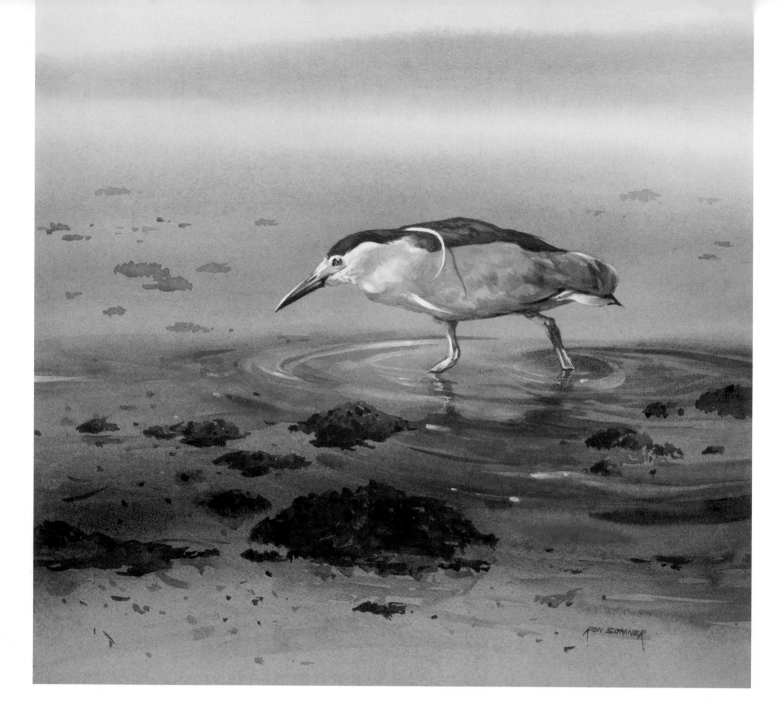

 NIGHT HERON
Ron Sumner
Transparent watercolor on 140-lb. (300gsm) rough Arches
16¼" × 18" (41cm × 46cm)

BIRDING OUT THE CAR WINDOW
Even as a kid I was always fascinated with watching birds: seeing
them fly gracefully through the air, chasing other birds, finding
their food and picking up scraps of grass and small branches to
construct their nests. Birds are very challenging; you must keep
them anatomically correct while recording gesture, colors, plumage
and form. *Night Heron* was painted in my studio from a photo I
took from my car window while driving along the water's edge of
Bodega Bay, California. It was noon and fortunately the bird stayed
motionless for the picture. The weather was overcast, eliminating
any dark shadows, thereby allowing great detail in the photo. The
watercolor is a combination of two techniques: wet-into-wet for
the background (allowing the painting to dry overnight) and then
multiple wash overlays to render the bird.

 EXTENDED LUNCH BREAK
Theresa Shepherd
Transparent watercolor on 300-lb. (640gsm) cold-pressed Arches
28" × 20" (71cm × 51cm)

ENJOYING NATURE'S COMICAL CREATURES
Extended Lunch Break was painted from one of many photos I have
taken at the Metro Richmond Zoo near my home in Virginia. Instead
of masking the whites I saved the paper-white and found this was a
nice way of capturing the subtle blending of spots and fur. I started
with very light washes and glazed areas until I got the value I was
looking for. Watching animals is one of my life's passions. Giraffes
have such funny eating habits and I love the way they just go about
their eating ritual without caring who watches them.

Animals are such agreeable friends—they
ask no questions, they pass no criticisms.
—George Eliot

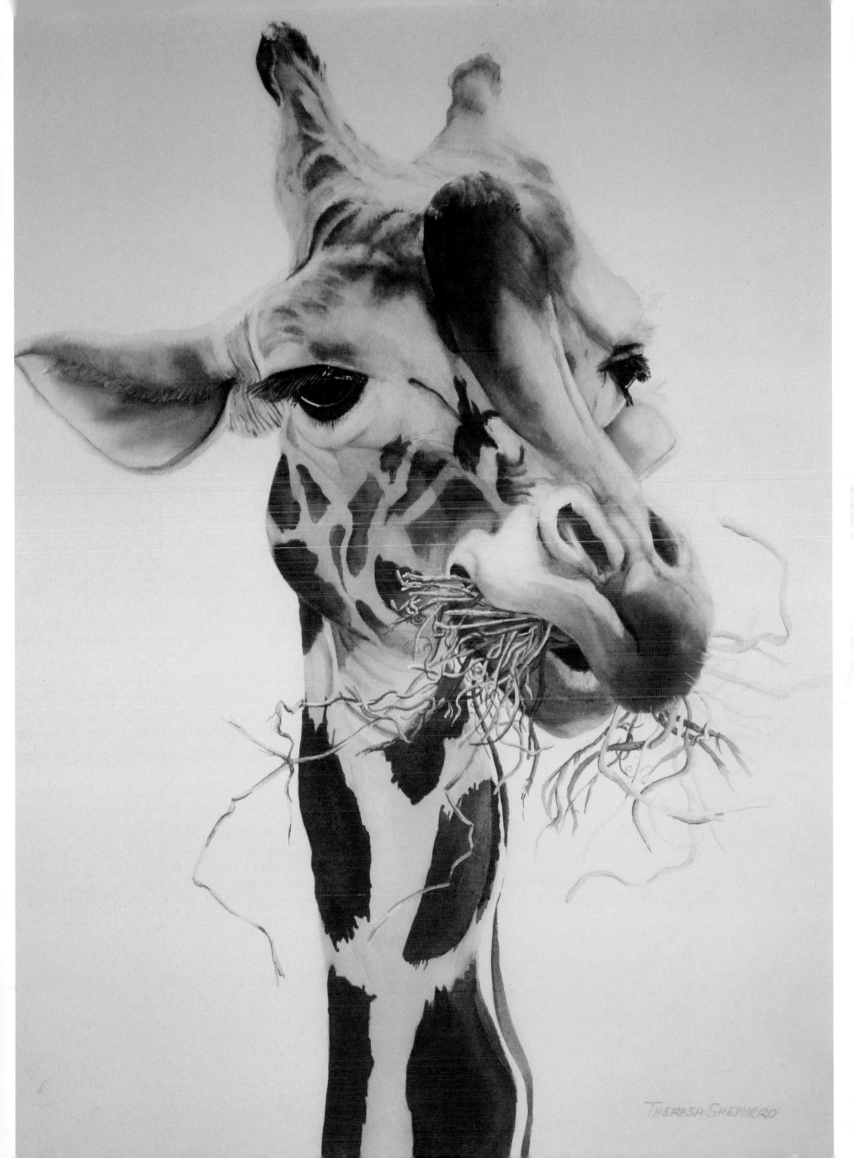

Theresa Shepherd

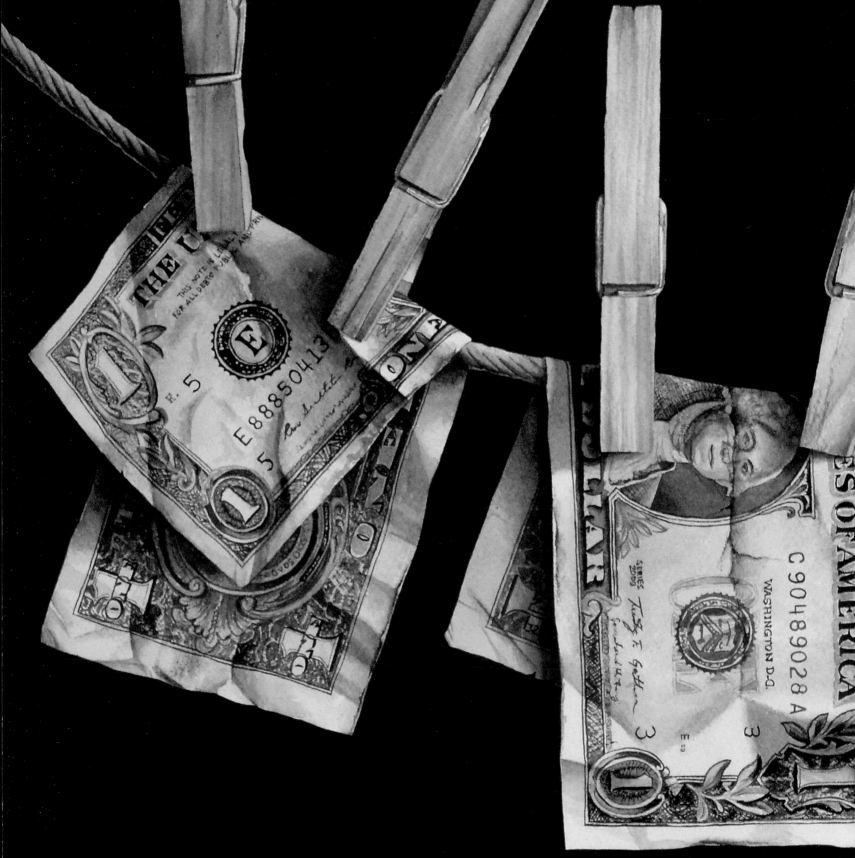

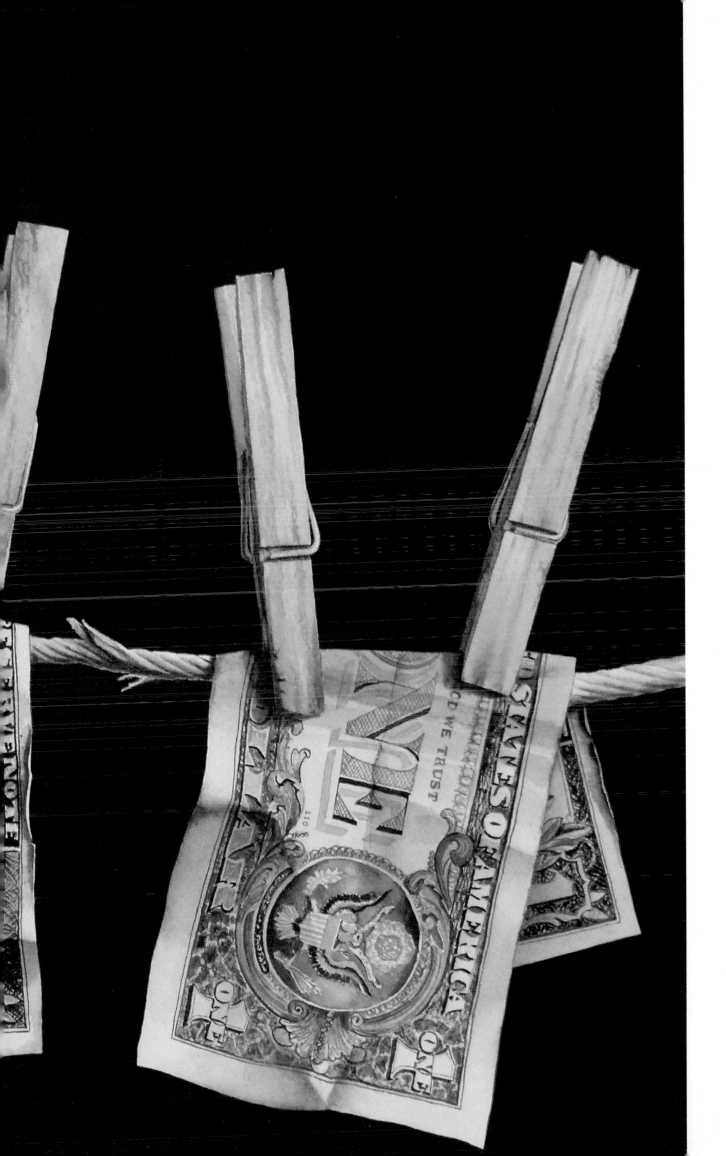

MONEY LAUNDERING
Lynn D. Pratt
Watercolor on 300-lb. (640gsm)
cold-pressed Arches
15" × 21" (38cm × 53cm)

WATCH YOUR CHILDREN FOR PUNNY INSPIRATION
My children's fascination with money inspired me to do this painting. They like to take it out and count it over and over again. It often ends up in pockets, going through the laundry. I set up the scene of money drying on a clothesline in my studio with this in mind. I take hundreds of photos of each setup, varying the lighting and angle until I am perfectly happy with the result. I then edit with Photoshop, usually combining many images for a single painting. This way I find the perfect wrinkle in a dollar bill or the best clothespin. Then I can sit at my desk and paint whenever I have time, which I find very helpful with young children.

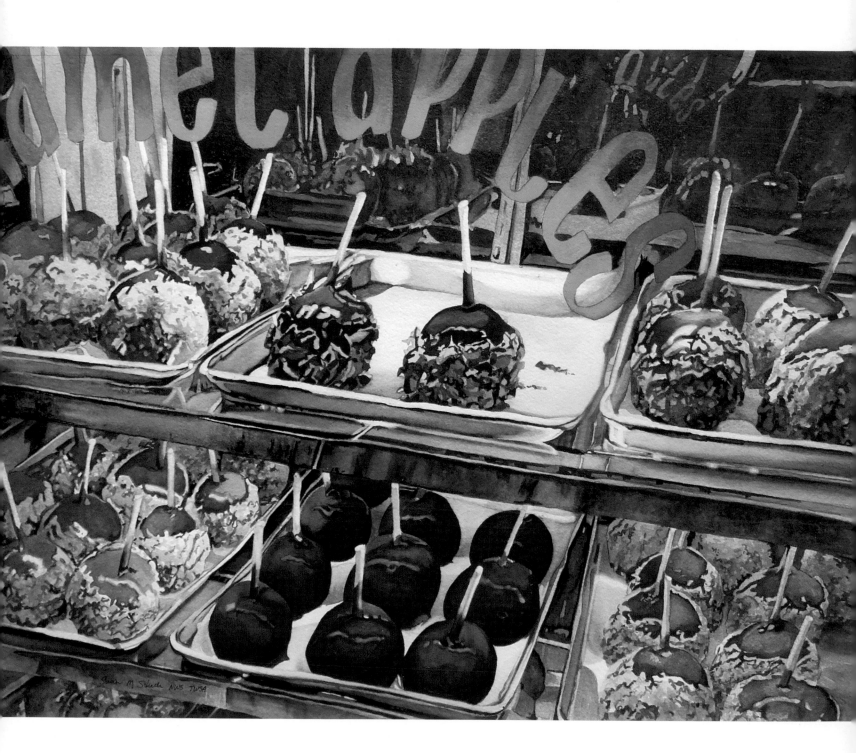

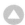

AN APPLE A DAY
Susan M. Stuller
Transparent watercolor on 300-lb.
(640gsm) Arches
21" × 29" (53cm × 74cm)

APPEALING PERCEPTIONS ON THE ROAD
On many of my travels I photo random things that strike my fancy. Once home I reflect and think, *Now why did I take this!?* My painting *An Apple a Day* started this way. The photo was intriguing but there wasn't enough color or light for me. I decided to think outside of the box, starting with a value study to build in more light. Next came changing some of the caramel apples to candy red. This also gave me a nice tension between the red of the apples and the green lettering on the window. The key to painting reds is to build up slowly using different glazes of New Gamboge, Permanent Red and Alizarin Crimson.

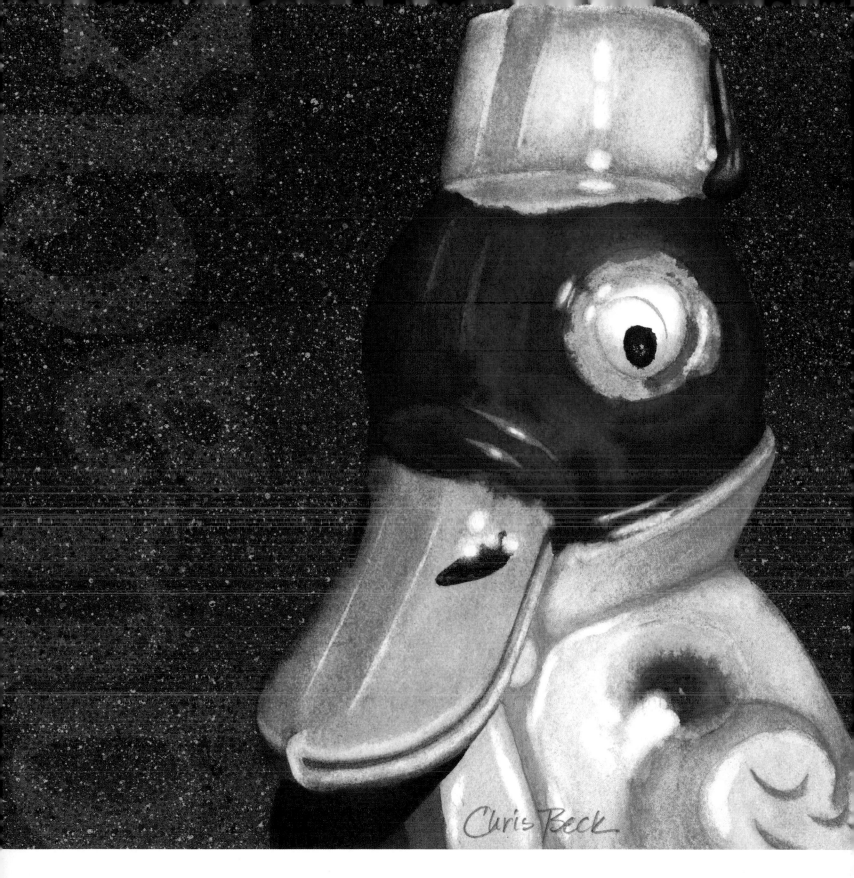

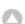 **QUACK**
Chris Beck
Transparent watercolor and
gouache on 140-lb. (300gsm)
cold-pressed Winsor & Newton
9" × 9" (23cm × 23cm)

CRAZY COLLECTIONS
Funky vintage saltshakers took over my life about seven years ago, although it started long before that when my husband suggested I collect "odd ducks" (after finding a single, very ordinary duck saltshaker in an antique shop). This truly odd duck is one of the sillier ones in my collection and one of my favorite demo subjects. Because I create step-by-step versions of a final painting for my demos, I end up with multiple copies of each demo painting. I decided to play with this one by stamping *quack* on it with gouache and then spattering various colors of gouache on the background and text to integrate them and add liveliness.

THANKSGIVING
Sean Barrett
Transparent watercolor on 156-lb. (330gsm) rough-pressed Arches
18" × 35" (46cm × 89cm)

REFLECTIONS ON MEMORIES
Reflective surfaces, especially silver, are a challenge to paint. More than the objects themselves, one is rendering their surroundings in reflections. As I was working on *Thanksgiving*, the painting gradually revealed the nuances of the room in which the photo was taken; this helped me to better understand the spatial relationships I was dealing with. Besides being eating utensils, the silverware itself is a reflection of my memories of past holidays celebrated with family and friends. There was always such a sense of anticipation, warmth and comfort whenever the table was set and it was nearing time to eat.

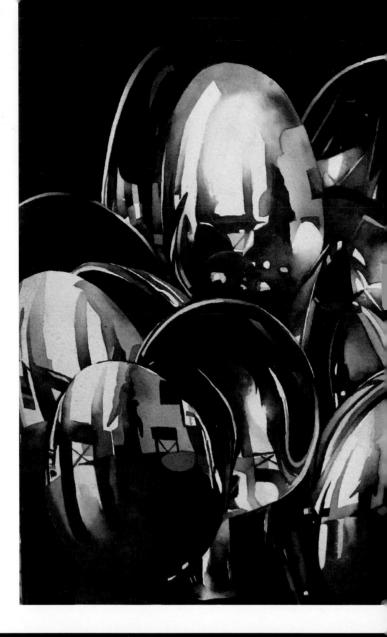

LADY CHURCHILL CIGARS
Laurin McCracken
Transparent watercolor on 300-lb. (640gsm) soft-pressed Fabriano Artistico
18" × 38" (46cm × 97cm)

COMPLEX TEXTURAL NOSTALGIC OBJECTS
This is an image in my *Objects on a Shelf* series that is meant to evoke memories or nostalgia in the viewer. Here I combined a few tins purchased years ago with various size canning jars and lids. These objects allowed me to advance the craft of painting realism in watercolor.

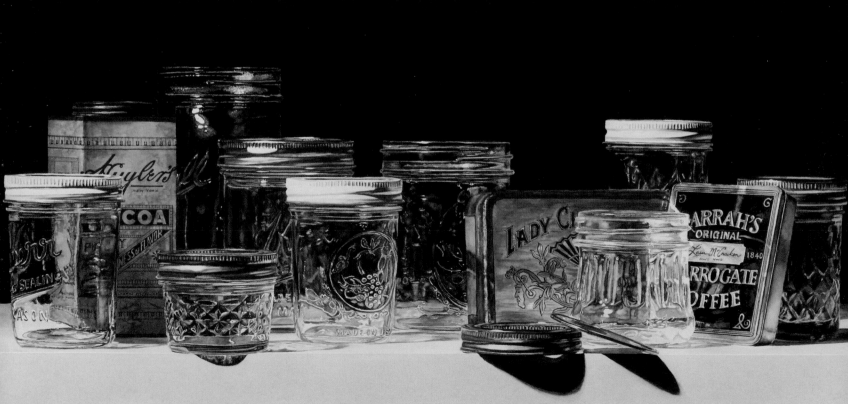

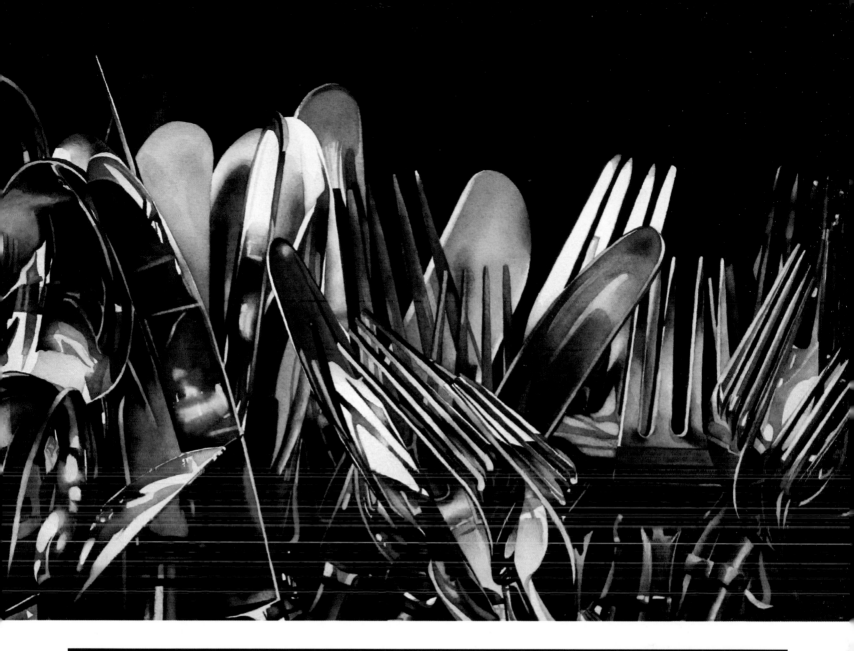

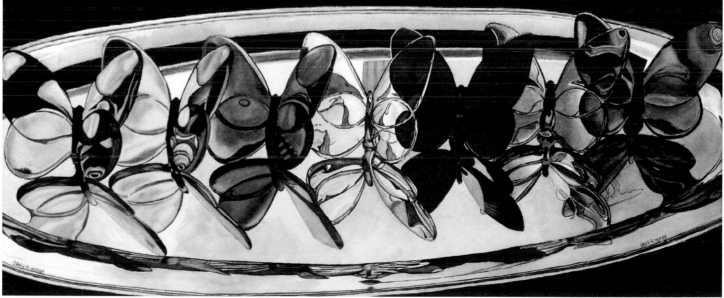

LUCKY BUTTERFLIES
Sally R. Webb
Transparent watercolor on 300-lb.
(640gsm) cold-pressed Arches
10" × 24" (25cm × 61cm)

SIGNIFICANT SENTIMENTAL OBJECTS

Butterflies are fascinating to me and I have a butterfly garden. On my 70th birthday, my husband gave me twelve Baccarat crystal butterflies, each one a different color. I decided to paint some of them, placing them on a silver tray by the kitchen window using natural light, which showed their beautiful reflections. I let colors mix on the paper by layering one color over another to keep them as clear and transparent as possible. It has taken me a while to define myself as an artist. After trying botanicals, landscapes, birds, etc., I found my comfort zone was in detailed, colorful, realistic renderings of still life whether glass, fruits, vegetables or flowers.

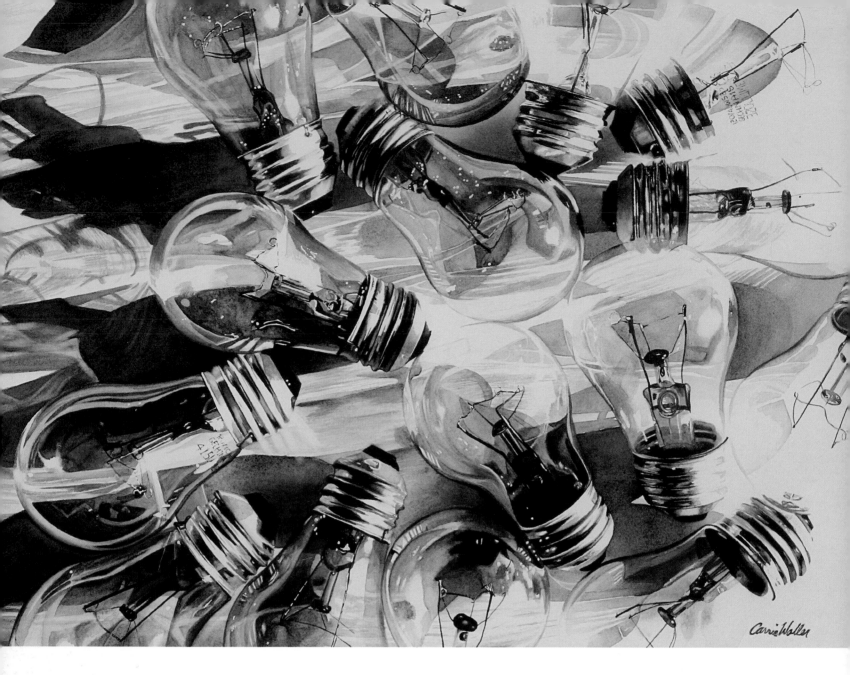

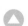 **BANNED**
Carrie Waller
Watercolor on 260-lb. (550gsm) cold-pressed Arches
18" × 24" (46cm × 61cm)

COMEBACK TO ODD CURRENT EVENTS
Banned was conceptualized in response to the government ban of incandescent lightbulbs. These had become a valuable asset and I wanted to immortalize them in watercolor. I set my still life up in strong sunlight. Some lightbulbs were tinted blue and threw a blue stream of light through the composition. I took 100 photos and chose this composition as my first in a painting series. Using homemade transfer paper, I transferred my completed drawing to my watercolor paper. I then started on the right side and completed one section at a time, painting in a puzzle piece fashion, using a palette consisting of Daniel Smith's Payne's Grey, Ultramarine Blue, Quinacridone Purple, Quinacridone Gold and an Indigo/Sepia mixture for my darks.

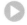 **TEA AND SUSHI**
Evelyn Dunphy
Transparent watercolor on 140-lb. (300gsm) cold-pressed Arches
30" × 22" (76cm × 56cm)

HAVING FUN WHILE CELEBRATING GIFTS
This painting was truly a gift! I purchased the teacups while visiting Japan, but the iron teapot was a gift from my daughter-in-law, as well as the apron and chopsticks. It began as a simple still life for a class. As I had only one teapot, apron and teacup, I drew each item in duplicate to create an interesting combination. The painting is a double vision of my original setup. I cut out paper shapes of the plates, teapot and chopsticks, changing the sizes until they made a visually pleasing composition. Then on my watercolor paper I used warm and cool graded washes with value changes and wet-into-wet passages for a painterly effect. The black apron was one wash of Phthalo Blue (Red Shade), Phthalo Green and Alizarin Crimson.

A still life is a snapshot of our lives.
—Evelyn Dunphy

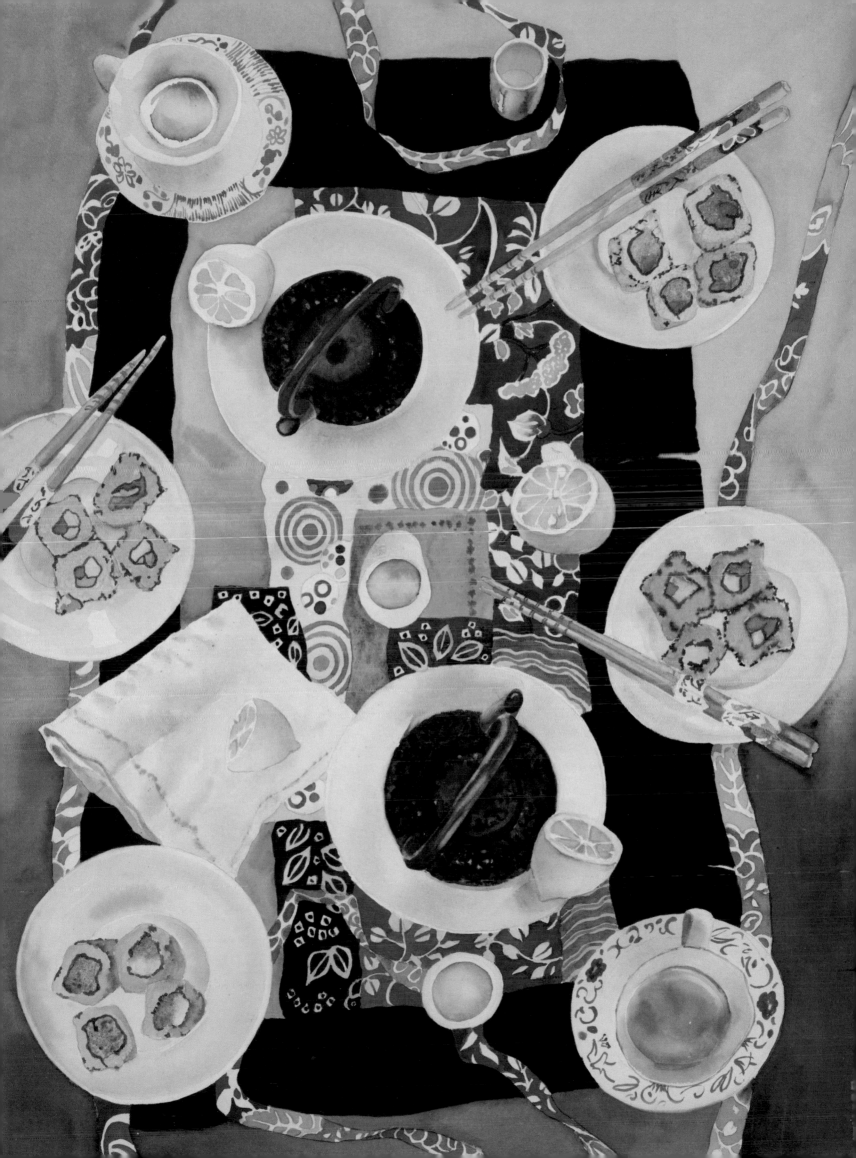

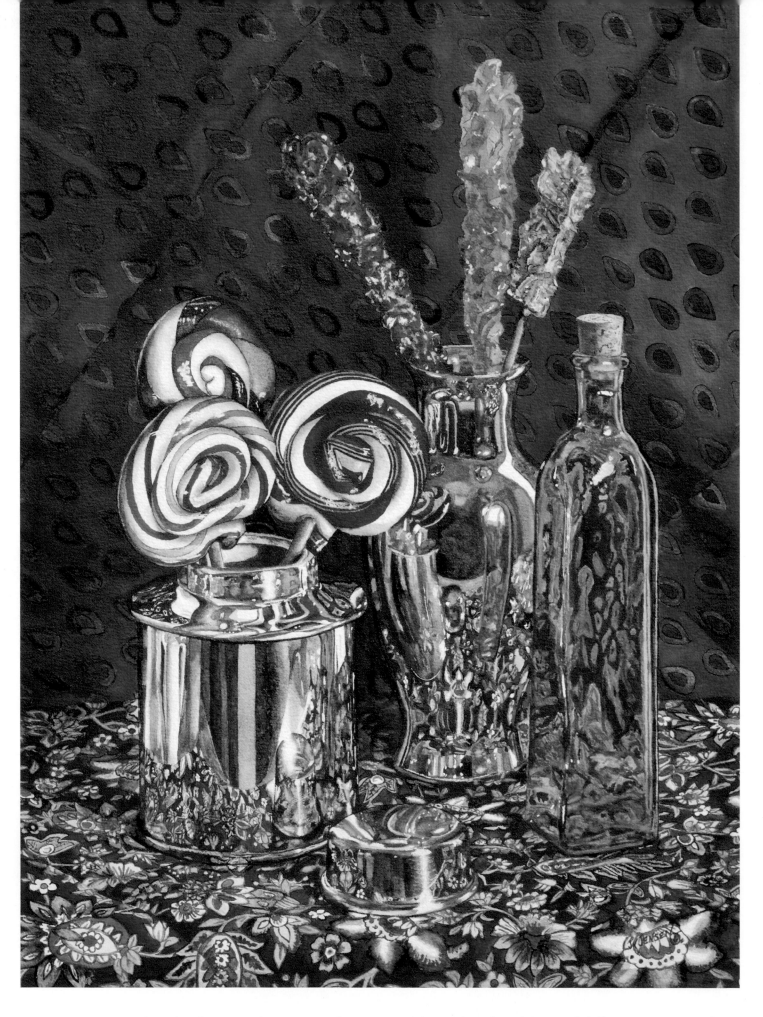

Inspiration requires gestation, so as ideas develop, it's useful for an artist to be patient and welcoming. —Joyce K. Jensen

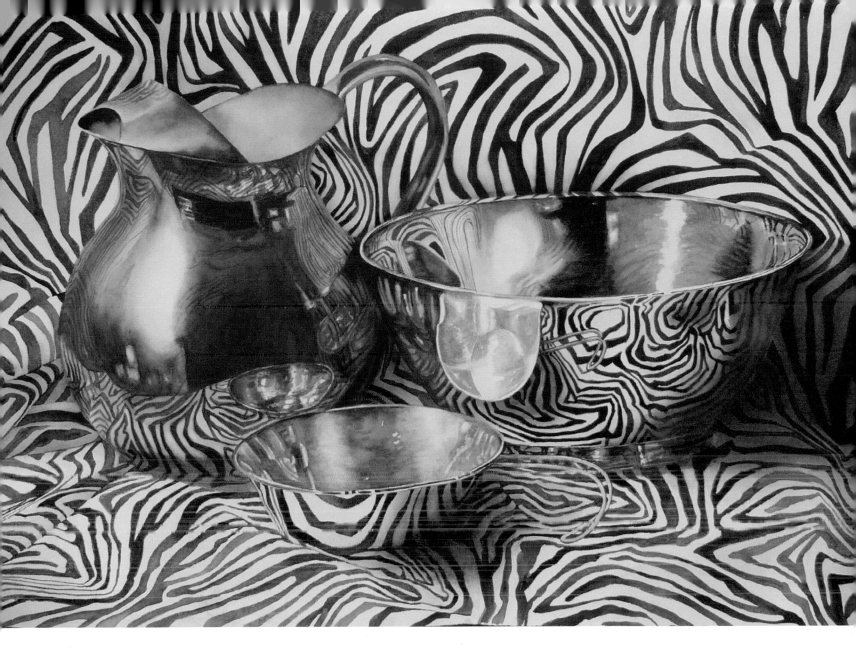

TOO MANY STRIPES
Luanne Stone
Transparent watercolor on 140-lb. (300gsm) cold-pressed Arches
13" × 20" (33cm × 51cm)

REFLECTIONS, REFLECTIONS
Shiny glass, metal and water always attract me. I start a still life with quite a few photographs and use them to create a detailed drawing. Then I mask out the whitest highlights and paint the shadows with large washes. With those steps done, I mix a strong dark to paint most of the background stripes as a gauge for my darkest darks. The copper pitcher is a mix of Quinacridone Gold, Burnt Sienna and red. The same dark mixture is used in all dark areas. I followed the photo closely to be sure to get the reflections where they made sense to the forms, but a lot of the small details were made up as I went along. This is where the fun comes in!

STILL LIFE WITH TEA CADDY
Joyce K. Jensen
Transparent and opaque watercolor on 140-lb. (300gsm) cold-pressed Arches
28" × 20" (71cm × 51cm)

REFLECTIVE OBJECT INSPIRES RIOT OF COLOR
This painting comes as close to realizing my inner vision as any I've ever done. I chose a simple, classic composition to bring order to the riotous colors of a spring garden. As often happens, the inspiration was an object I reacted to intuitively—in this case, the silver tea caddy. I love painting reflections, especially reflections in silver. When I discovered the tea caddy in a shop, I kept picking it up and turning it over in my hands. The lid, shoulders and cylinder offered intriguing possibilities for a variety of reflections, which are realized here.

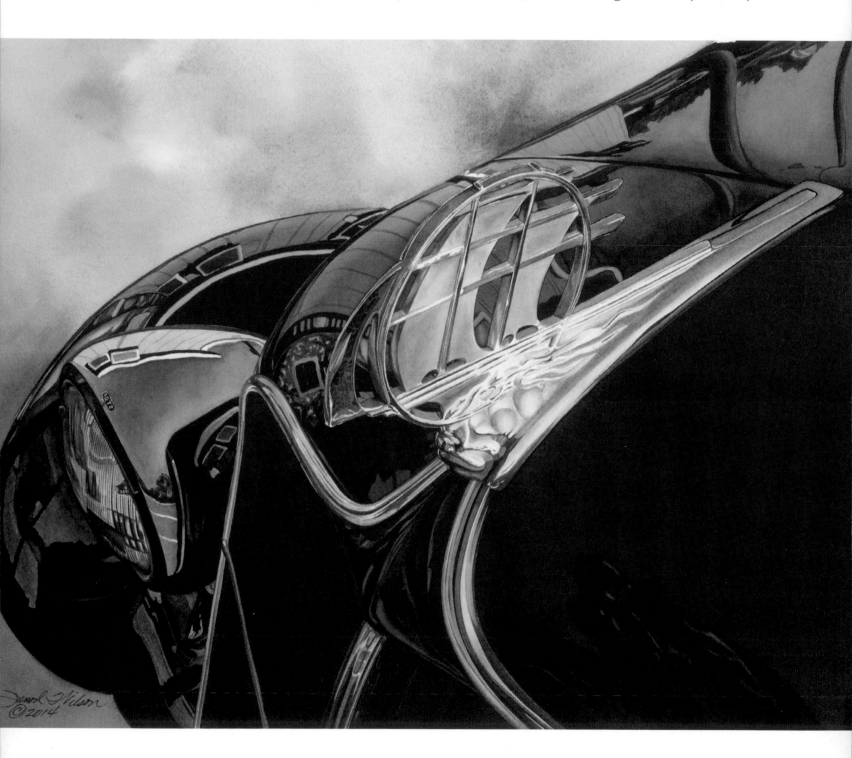

 HAIL TO THE FOAM
Jarrod Wilson
Transparent watercolor on 140-lb.
(300gsm) cold-pressed Arches
15¼" × 19¼" (39cm × 49cm)

BEJEWELED AMERICAN CLASSICS
Old American automobiles! The sleek lines of these American beauties, bejeweled with glistening
reflective chrome on equally shiny body panels, have been for me a source of love and inspiration
since early childhood. In this case, the lowly, bottom-line 1935 Plymouth with its circular hood
ornament of a proud masted ship cutting through waves of chromium foam was just too good to pass
up. Plymouth always used a ship as their emblem, and on the '35 model the entire ornament was
covered in chrome. The chrome caught the glow of the early evening Tar Heel sky as I snapped my
photo. I opted to title my painting *Hail to the Foam*, a phrase from the U.S. Navy anthem.

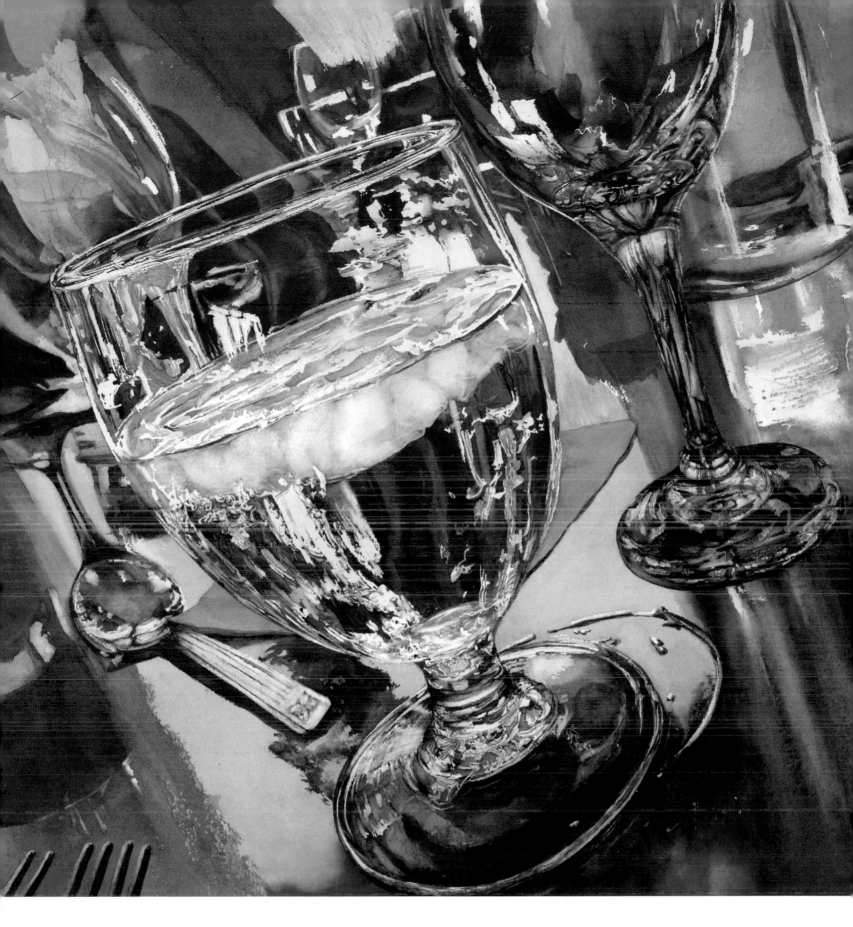

WATERLINE DANCE
Cheryle Chapline
Transparent watercolor on 300-lb.
(640gsm) cold-pressed Arches
22½" × 22" (57cm × 56cm)

COMPLEX SIMPLICITY
Inspiration comes in the most unexpected ways. The intense light from the large windows backlit the subject, and an everyday view of glassware, water, ice and cutlery became the subject matter for a painting. Gold, teal, green and pink threads wove their way through the glass, reflecting and refracting, creating abstract shapes everywhere. A rather simple subject became complex and inviting. It deserved a monumental presentation in order to record the astounding quantity of detail and color, providing the viewer an opportunity to encounter this rich visual experience.

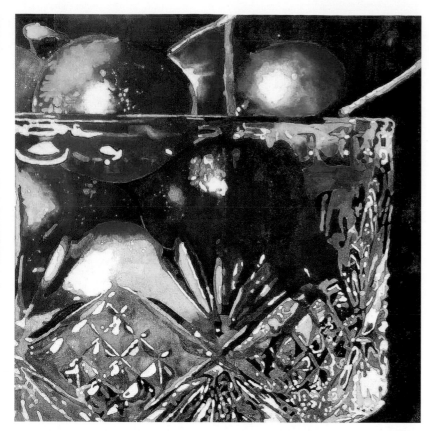

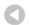

CHERRY BOWL
Anthony Rogone
Transparent watercolor on 140-lb. (300gsm) cold-pressed Arches
30" × 30" (76cm × 76cm)

CRYSTAL LIGHT AND COLOR
I have always been inspired by the fascinating shapes and colors that are created when light bounces through glass, and how that light interacts with objects inside the glass. I wanted to keep this one simple. I set up a single 100-watt bulb just to the left of the bowl to bring out the reflections and distortions in the glass. After taking many photographs, I chose this image because of its solid composition and the brilliance of its colors. My painting process began with applying masking to save the white, followed by pouring, and then completing the painting with brushwork.

If it's something that I'm not sure I can successfully reproduce in watercolor, then that's what I want to paint next. —Alisa Shea

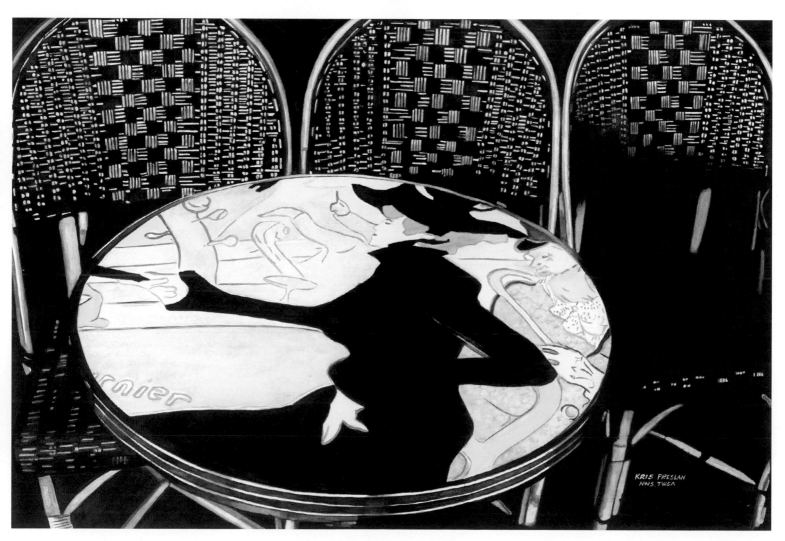

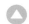

DINNER'S ON JANE
Kris Preslan
Transparent watercolor on 140-lb. (300gsm) cold-pressed Arches
17" × 24" (43cm × 61cm)

ART EVERYWHERE TELLS THE STORY OF PARIS
Imagine walking along a boulevard in Paris on a sunny day. The ubiquitous bistro is not yet open, but the tables and chairs are already outside, theater style, waiting to be occupied. One table has the beckoning image of Jane Avril, cabaret dancer and Toulouse-Lautrec's friend, on it. This became my story, my way of chronicling Paris and translating what I experienced into shapes and color on watercolor paper.

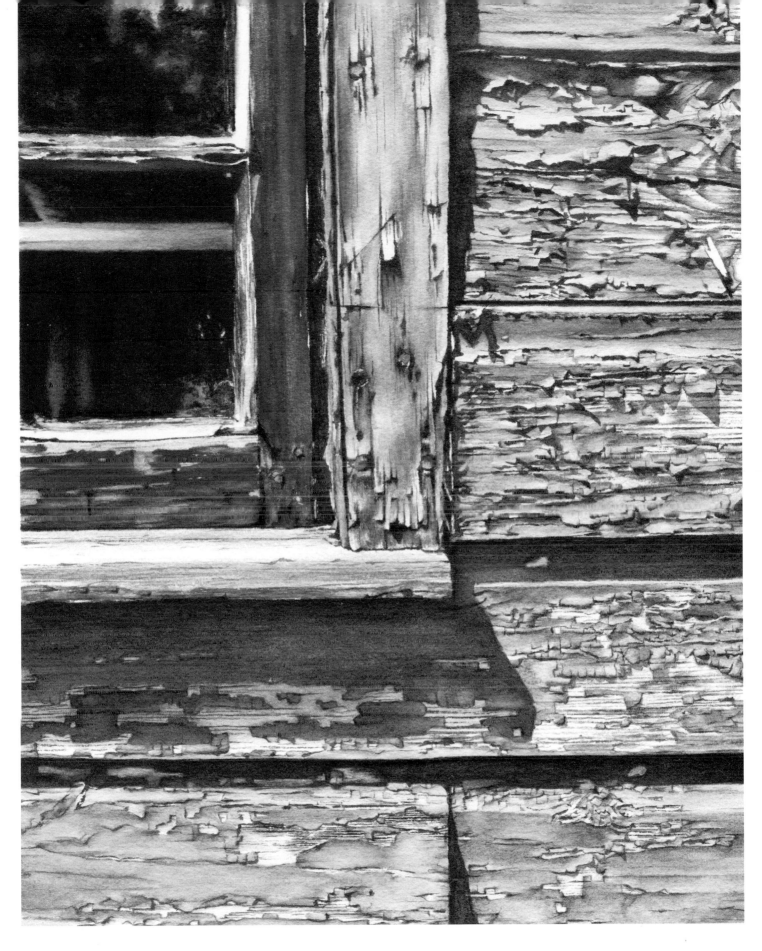

PAINTED LADY
Alisa Shea
Transparent watercolor on 140-lb.
(300gsm) cold-pressed Arches
14" × 10½" (36cm × 27cm)

KEEP YOUR EYE TUNED TO COLOR AND DETAIL ALL AROUND
I use my smartphone camera to capture moments of color and detail everywhere I go. I am especially drawn to texture and bits of our everyday surroundings that go unnoticed. When deciding what to paint out of my photographic reference material, I often choose subjects based on perceived level of difficulty. The nervous tension I feel when painting a subject or detail I've never tried before is very creatively exciting. I chose to create *Painted Lady* because I found the peeling paint in the photograph to be technically intimidating, and that's exactly the kind of challenge I like.

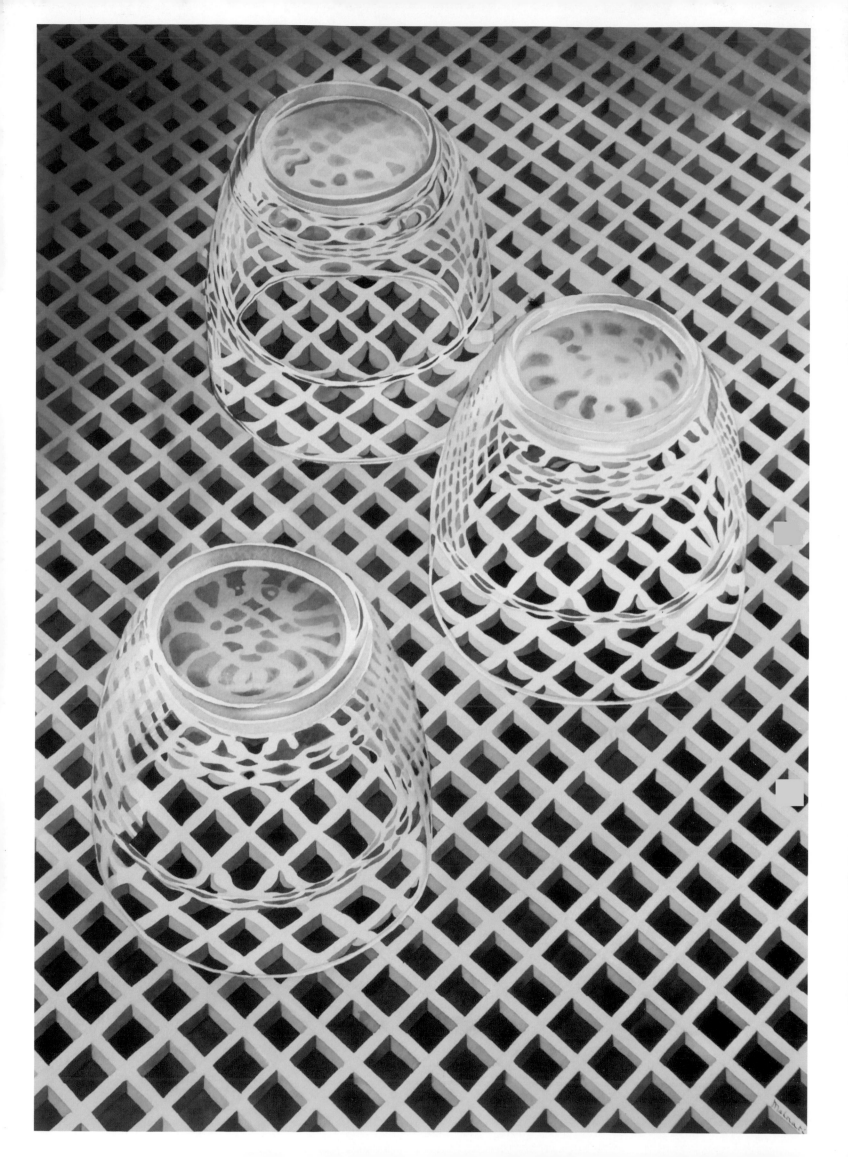

GLASSES IN DISHWASHER

François Malnati
Transparent watercolor on 140-lb. (300gsm) cold-pressed Arches
27½" × 19½" (70cm × 50cm)

SUDDEN EPIPHANY OF BEAUTY IN THE ORDINARY

Members of the French Watercolor Society meet each year for
several days of artistic and practical exchanges. All artists are
expected to carry out some chores; I volunteered to wash the
dishes. Amidst working, I was suddenly struck by the beauty of the
plastic yellow mesh of the dishwasher being distorted by the curved
glasses. I hurried to fetch my camera to the amazement of my fellow
watercolorists. Entranced by the visual feast unrolling before my
eyes, I feverishly took a series of shots with two, three, four glasses,
upright and upside down. A few painters now discussed whether
I should paint exactly what I photographed or whether I should
leave a part of the picture blurred. This reflects the eternal choice
between the romantic and realist approaches. In the quiet of my
studio, I settled for a precise description of three glasses, the trinity
being in my eyes the most effective composition I could achieve.

REFLECTIONS IN BLUE AND GOLD

Gloria Ainsworth Mout
Transparent watercolor on 140-lb. (300gsm) cold-pressed Arches
14" × 21½" (36cm × 55cm)

REFLECTING ON THE SHINE OF CLASSIC CARS

My heart always beats a little faster when I'm headed to a classic
car show. I wander amongst the cars looking for reflections. This
particular morning I was excited to get some super photographs of
wheels. I returned home and cropped my best photos for a pleasing
layout from which to draw. The drawing is where I can remove such
things as the reflection of a shoe, a dog's hind leg or even myself. I
did not use Miskit but rather painted around white areas, and I paid
close attention to values.

Ponder the beauty of all things and you will discover significance at every turn. —L.S. Eldridge

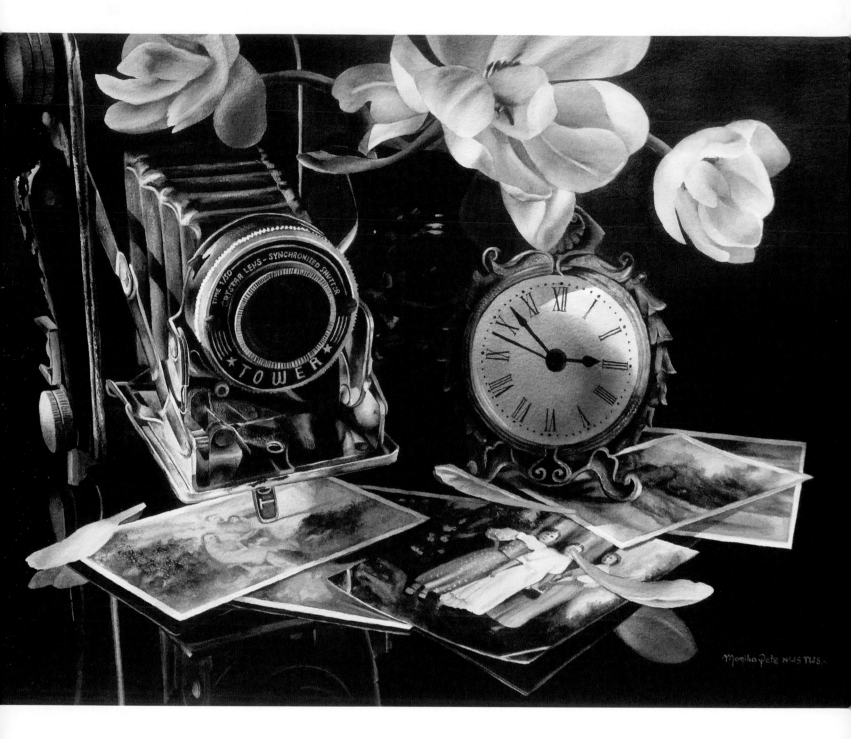

MEMORIES
Monika Pate
Transparent watercolor on 300-lb.
(640gsm) cold-pressed Arches
21" × 27" (53cm × 69cm)

STOPPING THE CLOCK ON EMOTIONAL MEMORIES
Cameras, paintings, and minds all capture emotional memories that withstand the ticks of time. It is rewarding when all three work in harmony. Photographs and mental images support each other by forming pathways to the past, present and future. This is the inspiration for *Memories*. This painting was done in my studio from a still-life setup consisting of personal items including a family camera and photographs passed on to me from my ancestors. I applied layers of transparent watercolor working from light to dark and occasionally dark to light.

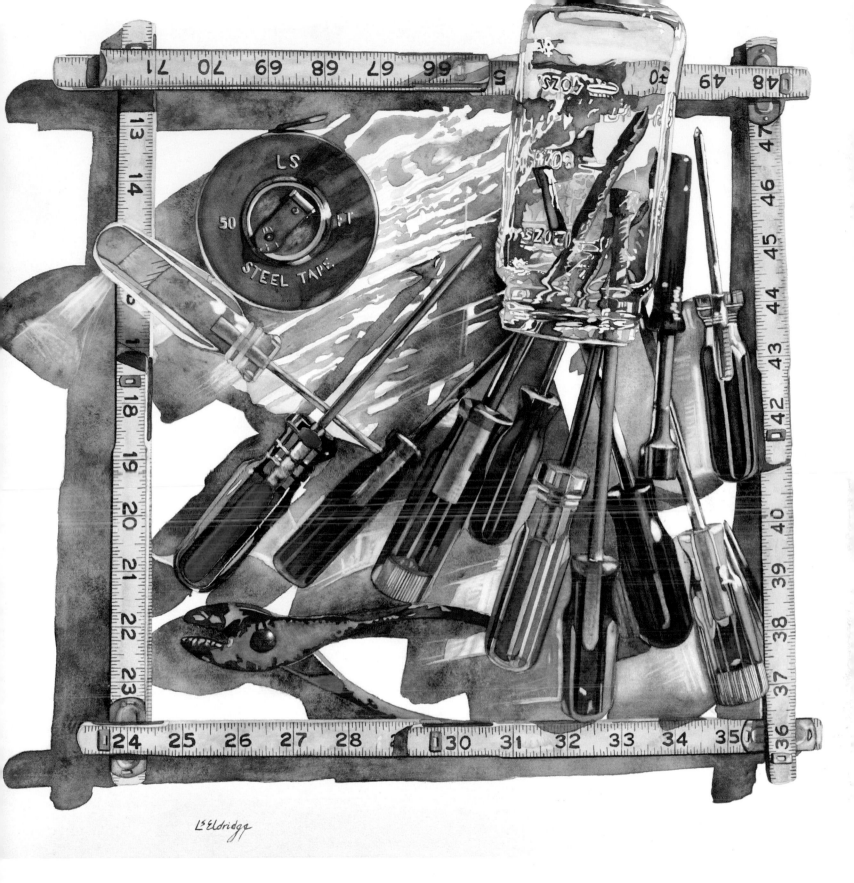

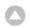 **THE MEASURE OF TOOLS**

L.S. Eldridge
Transparent watercolor on 260-lb.
(550gsm) cold-pressed Arches
24½" × 24¾" (62cm × 63cm)

JEWELS FROM A SCREECHING METAL DRAWER

Going through a dusty, spider-webbed shed, I struggled to open a screeching metal drawer. When it finally left its confines, what rolled and rattled forward were the tools for my current series of paintings. In the dust-infused light I studied their jewellike fire paired with the glint of polished metal. I was drawn to the screwdriver that had, under great pressure, bent in order to complete its task. I took measure of my surroundings, this sanctuary filled with gauges, scales and rules. I placed the tools in a nearby bucket and carted the inspirational objects out the door. The building was torn down, but it was just a shell; I carried its spirit home with me.

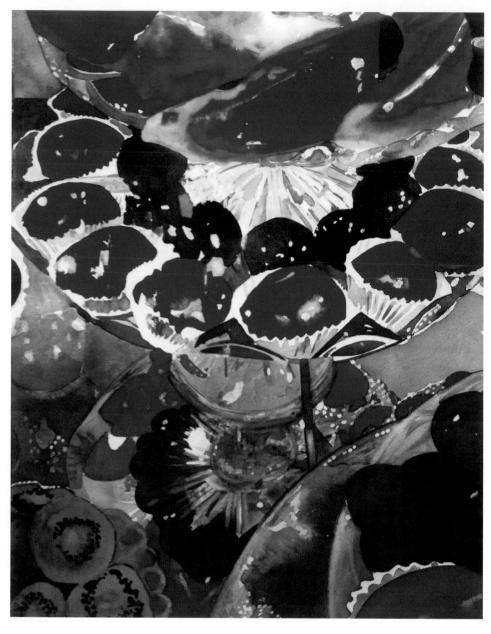

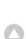

LONDON SWEETS
Charlene Collins Freeman
Watercolor on 140-lb. (300gsm) cold-pressed Arches
19" × 15" (48cm × 38cm)

DISPLAYS OF COLORFUL OBJECTS

I am visually intrigued by collections of objects in interesting light. I was instantly drawn to this display of sweets with its bold colors and crystal reflections. I don't overthink what I want to paint. When I see something I have a strong response to, I take several photographs. When reviewing my photographs, I consider all the details. The smallest difference between where a sprinkle of highlights occurs in one photo as compared to the next becomes very important. I question if the image still provokes my initial emotion. If it does, I draw it on my watercolor surface in great detail and have a solid foundation on which to start painting.

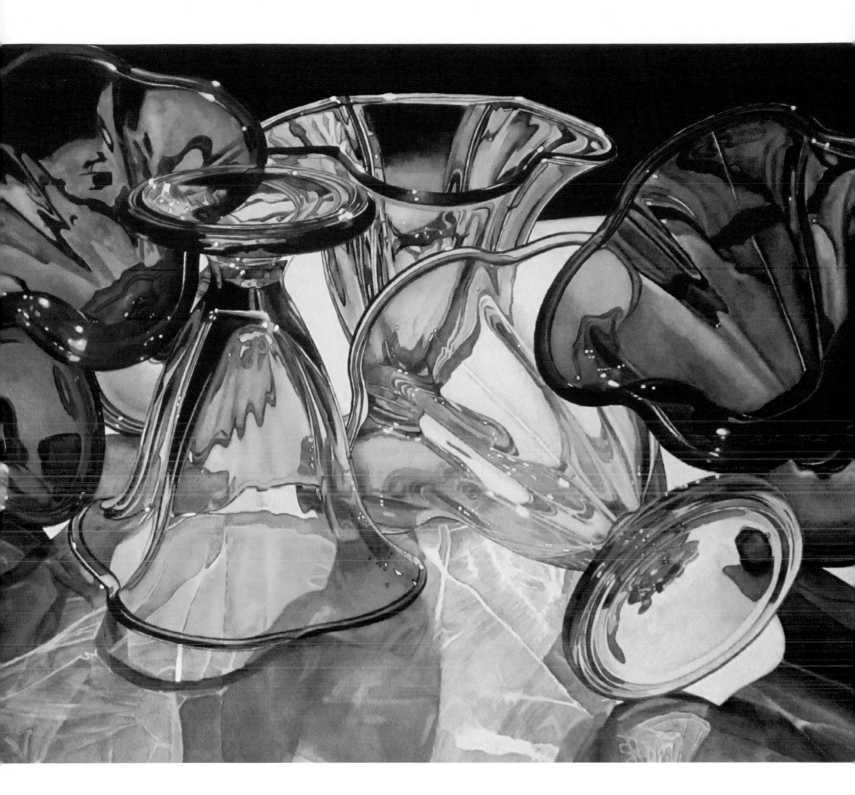

SIX WAYS TO SUNDAE
Judy Nunno
Watercolor on 300-lb. (640gsm)
cold-pressed Arches
20" × 30" (51cm × 76cm)

COLORED GLASS BRINGS HAPPY THOUGHTS
As soon as I spotted these colorful ice cream dishes at a local store, I was anxious to paint them. Glass, with its ability to reflect and refract light, is one of my favorite subjects. Breaking the Rule of Odds for composition and painting six dishes enabled me to use the catchy title (a play on the old idiom "six ways to Sunday"). I did a detailed drawing from my photograph and saved the whites with masking fluid. To create the intricate reflections, I first painted all the activity with neutral tint, then carefully applied glazes of color. A rich mixture of Alizarin Crimson, Sepia and Indigo for the background helped make the colors pop.

Break a rule if it results in a more interesting painting.
—Judy Nunno

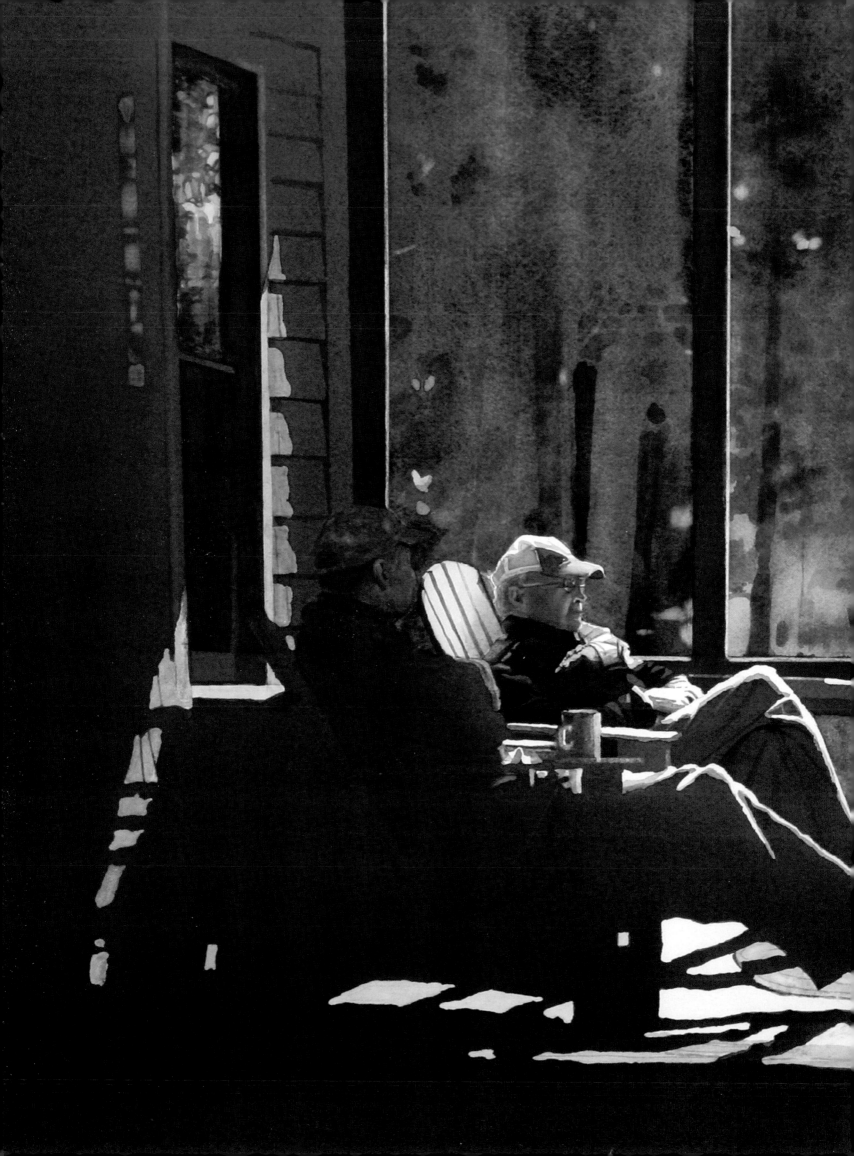

6 PEOPLE

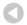

PAUL'S PORCH
Catherine P. O'Neill
Transparent watercolor on 140-lb.
(300gsm) cold-pressed Arches
20" × 23½" (51cm × 60cm)

CLIMBING THE LADDER OF SUCCESS
Fortunately, my father and brother ignored me when I climbed onto a ladder to take the reference photo for *Paul's Porch*. I had tried earlier to snap a discreet shot when their quiet conversation drew me to the scene, but my view was impeded by the low vantage point. Just as I reached the top of the ladder, the sun broke through the clouds. I couldn't wait to paint this one.

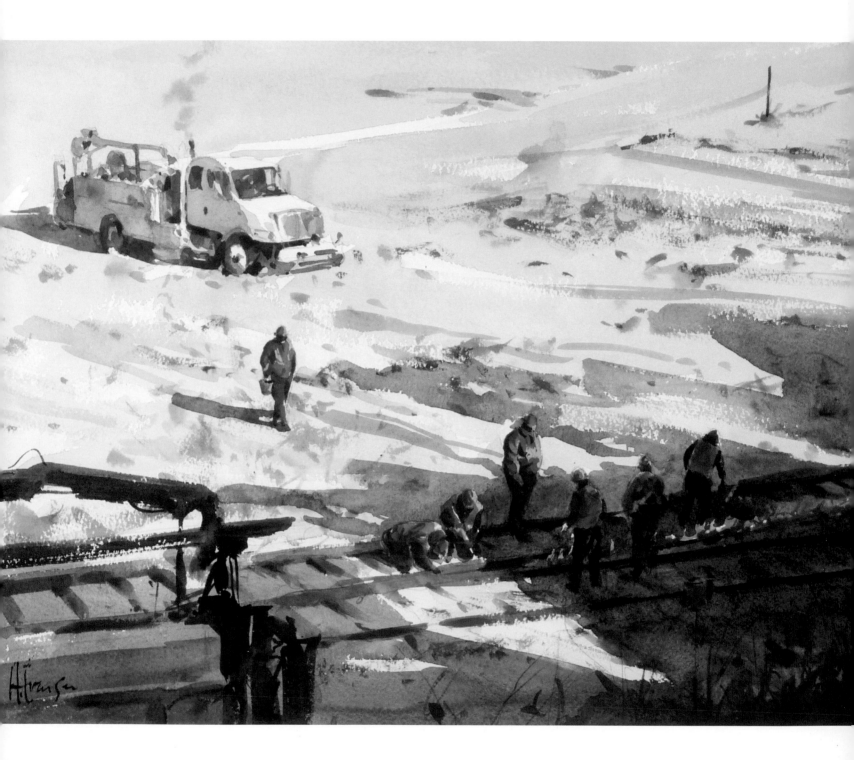

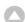

THAWING THE SPUR
Andy Evansen
Transparent watercolor on 300-lb.
(640gsm) cold-pressed Arches
14" × 19" (36cm × 48cm)

PERSPECTIVE OUT THE WINDOW PROMPTS PAINTING
I was grabbing lunch with a painting friend on a frigid day when we noticed this scene unfolding out the window. I love when inspiration strikes when you least expect it! The wonderful warm colors of the crew's vests and the flames were a perfect complement to the cold colors of the day. I am drawn to this kind of unique and interesting activity more than to picturesque scenes. The elevated viewpoint made for difficult drawing but lent a great perspective to the workers and shadows. I love to draw and am inspired by scenes that require a bit of work, and a human element always adds a story to the painting.

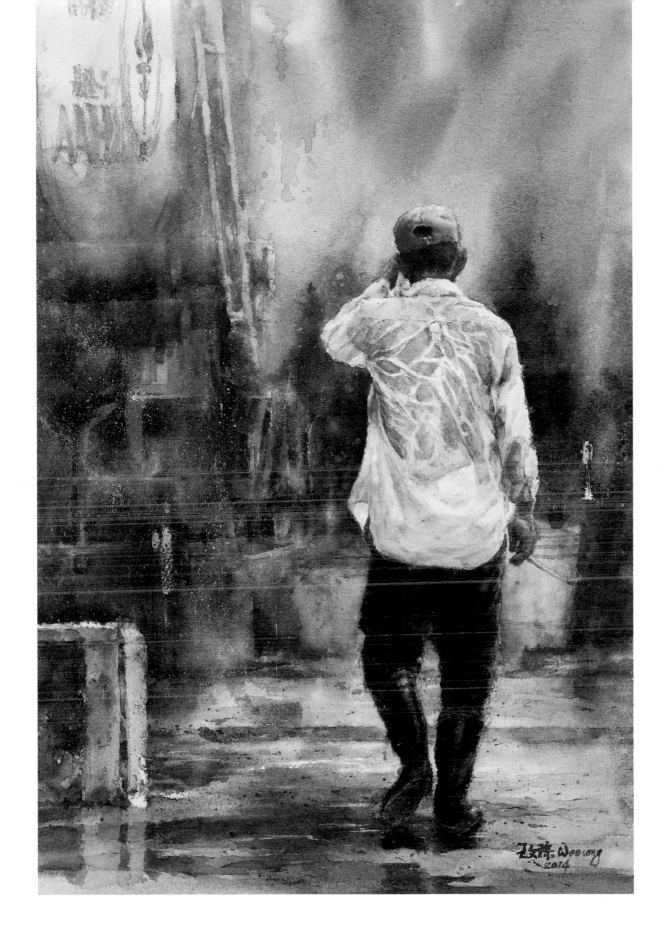

TANKER WASH WORKER
Wen-Cong Wang
Transparent watercolor on 300-lb.
(640gsm) cold-pressed Arches
20" × 13" (51cm × 33cm)

MOVED BY UNHERALDED STRENGTH AND ENDURANCE
In deciding the theme of my work, every aspect of human beings, especially anonymous ones, has consistently been appealing to me. The moment I saw the tanker truck washer, I was strongly impressed by his exhausted but doughty appearance. Without applause or spotlight, these low-ranked employees work in some dark corners with strength and endurance. I wanted to talk to him, but he was too shy and returned to work. I was deeply touched by his rear profile, which made a humble, down-to-earth statement of his life. Hoping to translate his hidden story of extreme hardship into watercolor, I used this image as a reference. For the effect of watery fluidity, I set my easel upright to display the misty atmosphere in the background.

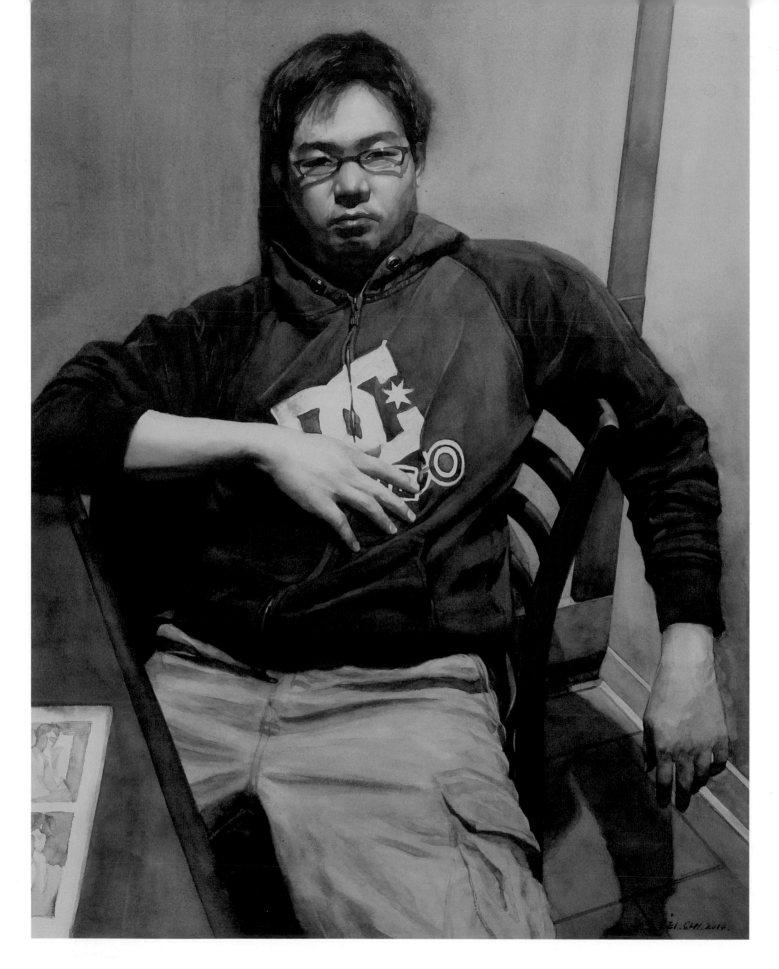

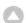

CHILLING OUT

Lei Chi
Watercolor with gouache accents
on 140-lb. (300gsm) cold-pressed
Fabriano Artistico
22½" × 17" (57cm × 43cm)

PRESERVING A MOMENT OF HUMANITY

Chilling Out is a portrait of my husband, created from a photo reference. It is one of those relaxed moments after a long day's work. I'm drawn to the sense of contemplation and the quiet spirit that naturally emanates from his expression and gesture. Painting in the classical tradition, my goal is to transcribe and preserve the distinct humanity and harmony that we often pass by when it graciously presents itself in our everyday lives. In order to portray the figure with life and solidity, I built up the painting with many layers of glazes while retaining the spontaneity in applying the brushstrokes.

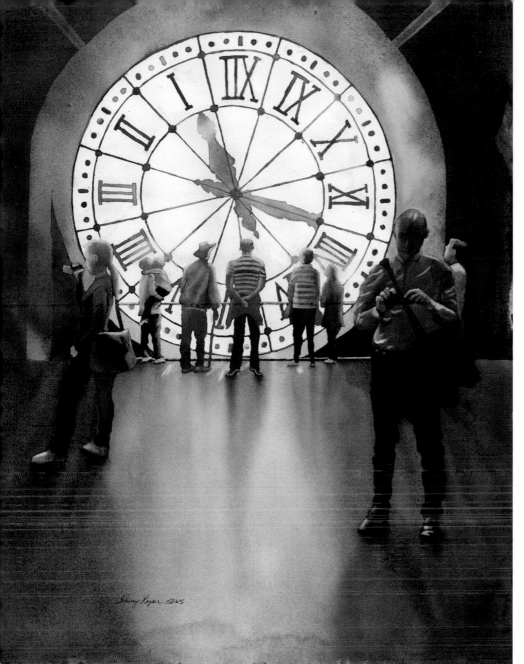

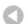

PASSING TIME II
Sherry Roper
Transparent watercolor on 140-lb. (300gsm)
cold-pressed Arches
24" × 18" (61cm × 46cm)

ENHANCE YOUR INSPIRATION WITH COLOR
While visiting the Musée d'Orsay in Paris, I took several pictures of the giant clock window, which overlooks the Seine and the Louvre. I was struck by how the sunlight coming through the window silhouetted the diverse mixture of figures, but the image presented a problem: There was almost no color in my photos. I decided to use a pouring technique, focusing on getting the values just right, while using bright primary colors at random. After masking out the clock face, I poured diluted transparent watercolor in light warm colors, allowing the paint to mingle on the wet paper, then dry. I repeated this process four or five times with increasingly darker, cooler colors, masking areas that were dark enough. Finally, all the masking fluid was removed, a little lifting was done, and some minor brushwork completed the piece.

Intense light and shadow is what attracts me to a subject more than anything.
 Sherry Roper

HONEYSUCKLE ROSE
Robert Houck
Transparent watercolor on 300-lb. (640gsm) cold-pressed
Arches
22" × 22" (56cm × 56cm)

INVENTING OFFBEAT SUBJECT MATTER
I prefer to work with fresh subjects that I have not seen in watercolor before. I particularly like images that are edgy. I work from life, photos and memory. First, an accurate drawing establishes credibility. Placement of the legs parallel to the picture plane is intentional. Wet-into-wet and layering techniques are used to generate the fleshy translucent look of the nylon-clad legs. Dry-on-dry and lifting were employed to create the shiny quality of the heels. Complementing the dominant red bias of the foreground, a dull green was used in the background area. The memory of this antique wallpaper and its rendering in watercolor is what makes the painting work.

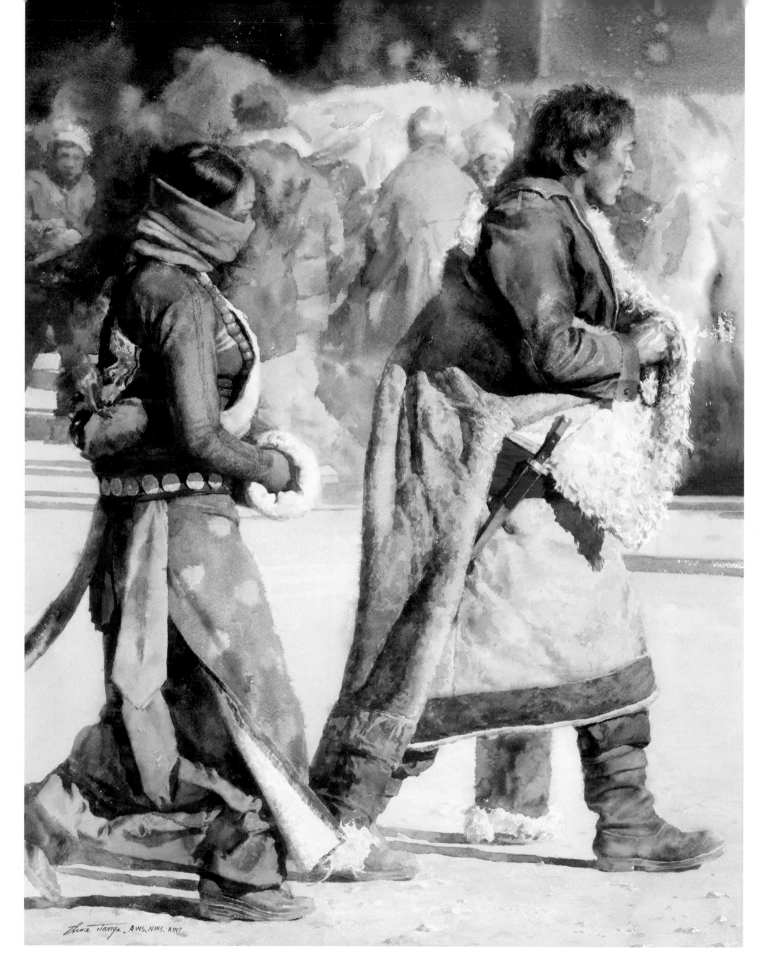

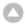 **GO TO TOWN**

Zhou Tianya

Transparent watercolor on
Fabriano Artistico

30" × 22" (76cm × 56cm)

INTERPRETING A COLORFUL CULTURE

I enjoy painting Tibet's spiritual world through its people's daily life. This is a realistic piece and shows the most ordinary scene in a small Tibetan town. My focus is not on innovation but how to perfectly express the reality. For this, one needs the original painting language, i.e., composition, modeling, light, color and brushstrokes. This painting has a serious structure with fairly soft handling. The color is rich yet subtle. It appears three dimensional and at the same time maintains transparency.

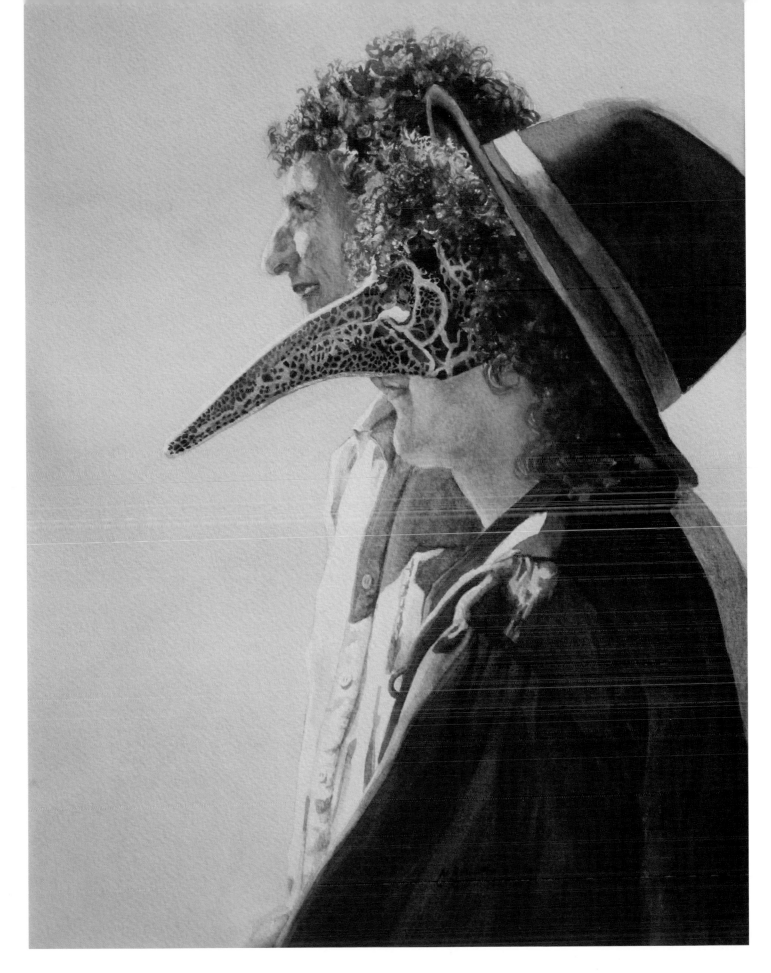

NASO MASQULINE
Marcella M. Martin
Watercolor on 140-lb. (300gsm)
cold-pressed Kilimanjaro
14½" × 10½" (37cm × 27cm)

COSTUMED MODELS ABOUND

Every spring and fall a Renaissance faire comes to a park nearby. For the price of admission, you have all these models walking about in period costumes! I snap hundreds of photos, then later view them as thumbnails. If a thumbnail grabs my attention, then a larger painted version should grab the viewer's attention too. The bond between this couple was obvious, but mysterious: Who is behind the mask? The mask is a traditional *naso masquline* Venetian mask, which means "male nose." It makes me laugh because the man has such a fine example of one.

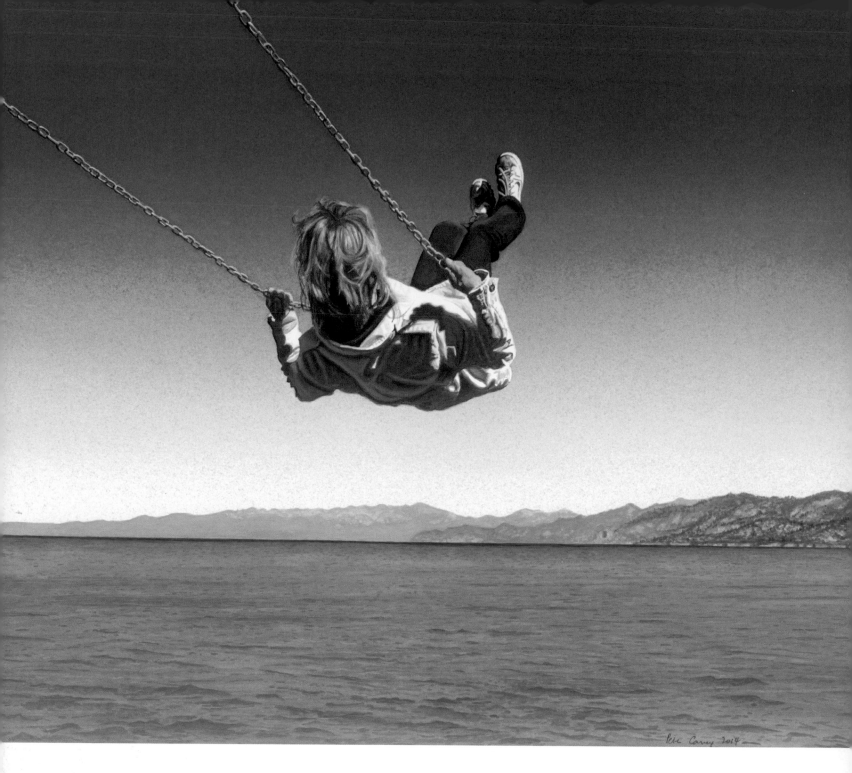

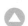 **SWINGING TAHOE**
Peter Carey
Watercolor on Strathmore 500 illustration board
15" × 17" (38cm × 43cm)

SPECIAL VACATION MOMENTS

My wife and I were on vacation in Lake Tahoe when we came upon this playground. I took a bunch of photographs of her on the swings. When I saw this one enlarged, I knew I wanted to paint it. The chains holding the seat were coated with a bright yellow plastic, which I edited to silver. Other than that, it reflects the photo pretty faithfully. I painted the sky using a mouth atomizer. This involves many layers of spray until the sky is blended light to dark. I masked the shape of my wife to keep some white paper for the highlights.

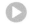 **CHASING VISTA**
Beth Verheyden
Transparent and opaque watercolor on 300-lb. (640gsm) cold-pressed Arches
21" × 29" (53cm × 74cm)

PLAYING WITH MOVEMENT

When choosing a subject, I look for good shapes and a compelling story. Then I go to work creating movement. If I see it in the photograph, I exaggerate it in the painting. What if I can't see it but can feel it? I wanted *Chasing Vista* to convey a sense of wind and speed. I exaggerated the bend of the figures and trees, made brushstrokes through the wet edges of most shapes, exaggerated the curve of the tracks, and, finally, moved a wet brush right through the darkest darks of the foreground figure, creating a whoosh of wind behind him.

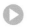 **FOUNTAIN**
Valerie Larsen
Transparent watercolor on 140-lb.
(300gsm) cold-pressed Arches
7½" × 10½" (19cm × 27cm)

WHEN LIGHT HITS EVERYDAY FUN
It pays to slow down and be mindful of
one's surroundings. I am intrigued by
everyday moments made extraordinary by
lighting, gestures and human interactions.
On the technical side, watercolor is the
perfect medium for depicting water spray.
It's natural for watercolor to look a little
out of control. To start, keep a few water
droplets crisply white by masking them
with frisket. Wet the dark areas with
water. Create an irregular edge by lightly
spraying the white area with water. Drop
in the dark paint, allowing it to run up to
the white irregular edge. This all takes a
little practice.

My paintings are an invitation to enter into a scene at a close human level. —Valerie Larsen

SELFIE
Sandrine Pelissier
Watercolor, acrylic, India ink
and colored pencil on 300-lb.
(640gsm) hot-pressed Arches
15" × 22" (38cm × 56cm)

BLENDING DRAWING AND PAINTING
I am particularly interested in mixing elements of drawing and painting in my work. My daughter took a selfie in front of the mirror and I saw an opportunity to use the circular shape of the camera lens as the starting point for concentric patterns. After painting the figure with watercolors, I applied a layer of India ink all over the background, followed by a layer of white acrylic, leaving some black ink to show around the edges of the figure to form an outline. On top of the acrylic I drew all the patterns with a red colored pencil, then accentuated a few areas with a watercolor wash painted on top of the colored pencil.

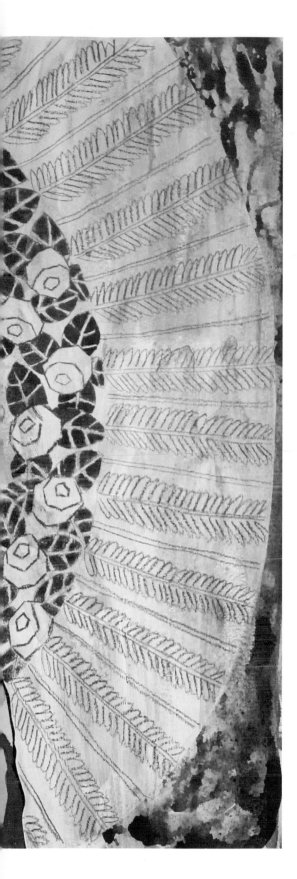

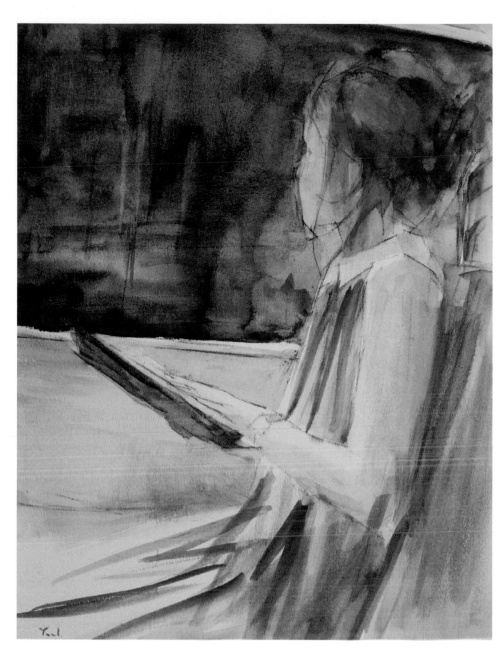

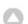 **WAR ZONE**
Yael Maimon
Watercolor on 140-lb. (300gsm) Fabriano Artistico
16" × 12" (41cm × 30cm)

DEPICTING FEAR
I live in Ashkelon, Israel. Ashkelon is located only 8 miles (13km) north of the Gaza border. Needless to say, I live in constant fear of attack. *War Zone* was painted immediately after the 2014 Israel-Gaza conflict, also known as Operation Protective Edge. To capture the distant view of combat, I aimed to render the dust, ash and smoke; the chaos-texture of high-tech combat. My painting demands visual and emotional attentiveness. It gives the viewer awareness that many people look out their windows and see a world devastated by hatred, war and despair. If you look out your window at peaceful scenery, you have reason to be grateful. Let us live in a world of peace.

Sometimes we can be inspired by the nightmarish qualities of reality. —*Yael Maimon*

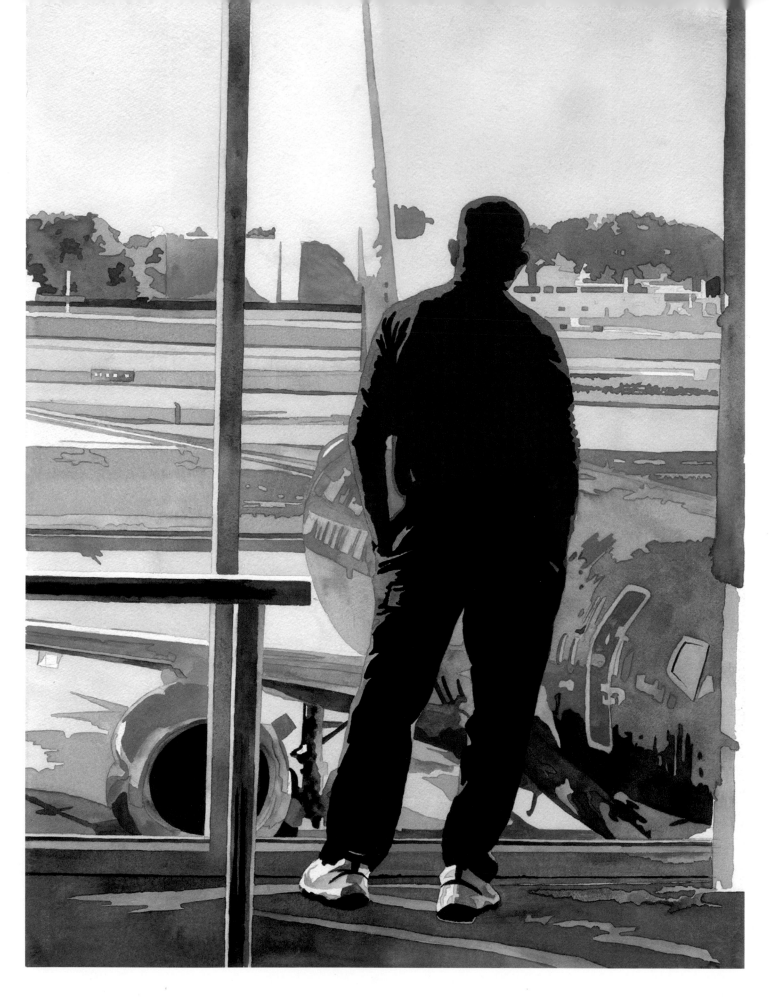

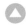
FLY THE FRIENDLY SKIES
Anne Abgott
Opaque watercolor on 300-lb.
(640gsm) cold-pressed Arches
30" × 22" (76cm × 56cm)

MAKING USE OF DOWNTIME
I am always on the lookout for interesting and different subject matter—not an easy task! I find sitting in airports very boring and so I decided a year ago to do a series of air travelers. I love to paint backlit subjects and *Fly the Friendly Skies* is the first in that series. Another first is the use of opaque paint by this transparent artist.

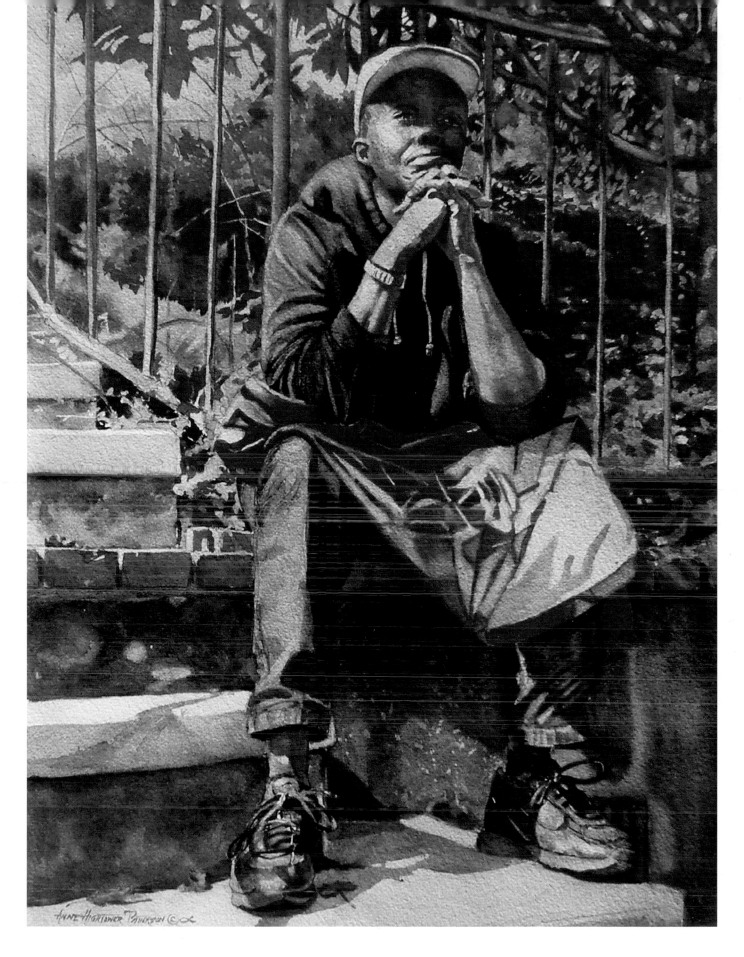

HOPE FOR THE HOMELESS
Anne Hightower-Patterson
Transparent watercolor and casein on
140-lb. (300gsm) cold-pressed Arches
24" × 18" (61cm × 46cm)

UNLIKELY CONNECTION ON THE STREET

While out photographing images of Columbia, South Carolina, for an upcoming show, I was approached by this panhandler. As I looked up, I saw a person I knew I must paint. I told her that I would not give her any money, but would pay her a fee to let me photograph her. Her name was Adrienne. She shared that she was homeless and had lost custody of her children. As I snapped my pictures we talked, and she told me her hope of getting a job and getting her children back. Hope was truly in her eyes. I now look at painting the homeless as an opportunity to let others see humans who are often invisible in our daily lives.

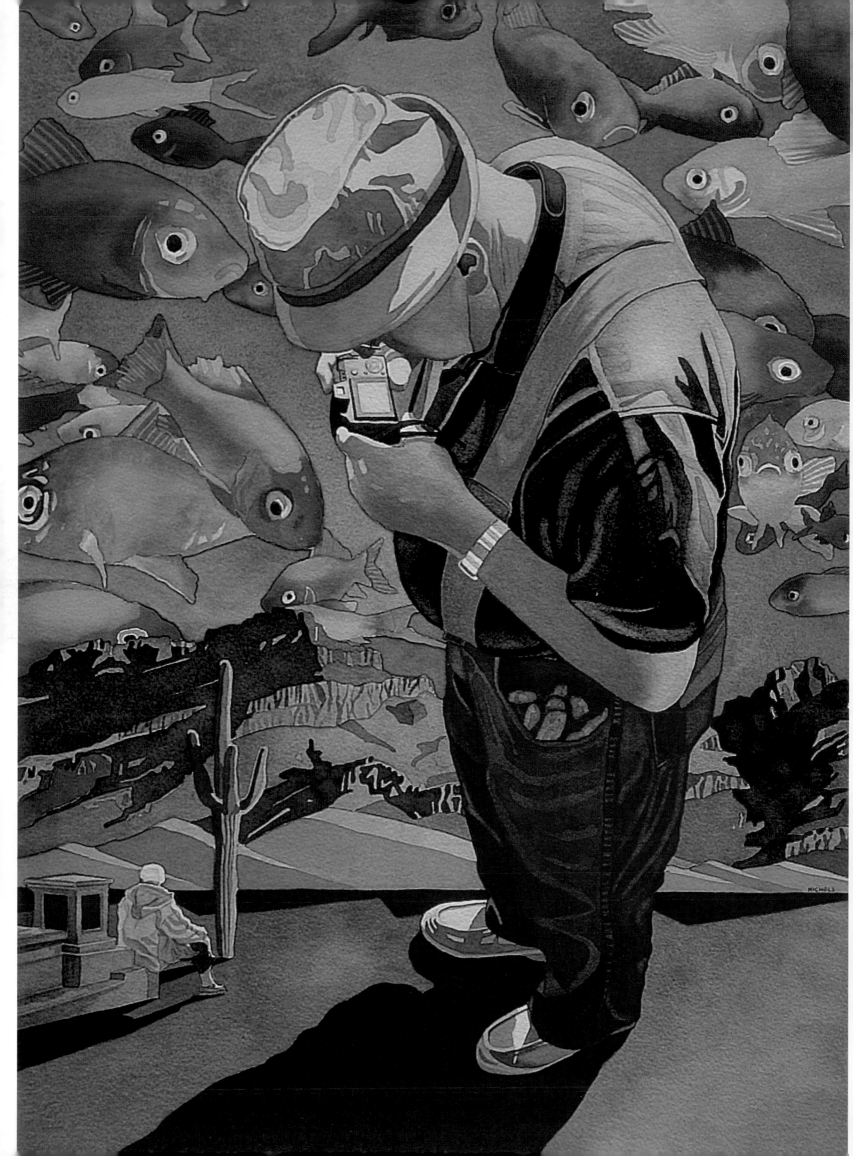

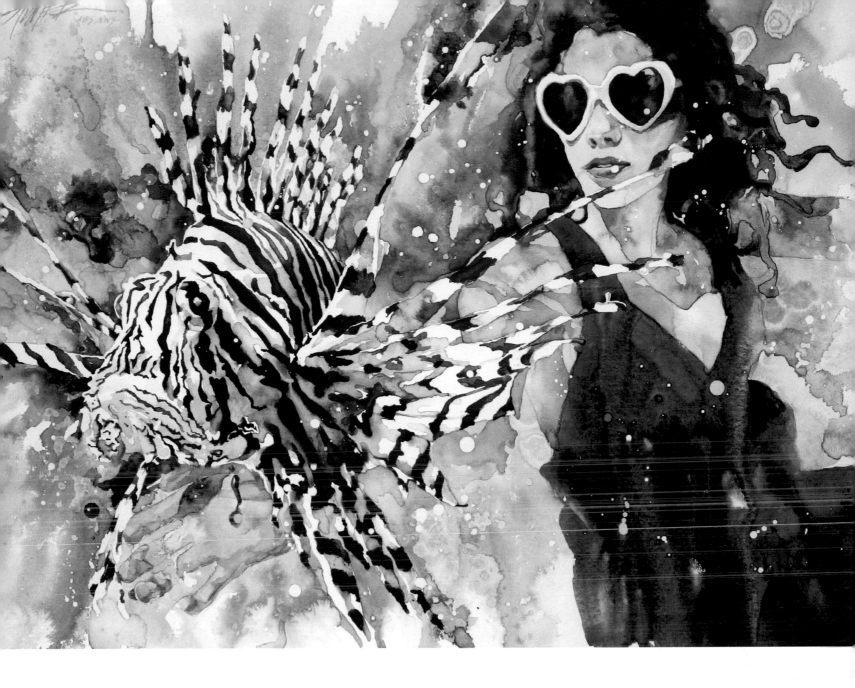

CATCH AND RELEASE: FT IV
Lance Hunter
Transparent watercolor on illustration board
16" × 22" (41cm × 56cm)

SET UP A VISUAL METAPHOR
Fish tales are stories often characterized by embellishments and omissions. *Catch and Release* is a practice in recreational fishing and is the title of the fourth painting in my evolving *Fish Tales* series. The lionfish has complex mating behaviors and its dual essence fascinates me. The beauty and elegance of this species is alluring as it glides through the depths, yet it is extremely venomous to touch. A struggle with culturally manufactured myths and the fragility of relationships inspired me to create this image. Masking fluid, denatured alcohol and a spray bottle filled with water were utilized in the creation of the painting.

TOPSY TURVY
r. mike nichols
Transparent watercolor on 300-lb. (640gsm) cold-pressed Fabriano Artistico
20½" × 14½" (52cm × 37cm)

DREAM UP YOUR OWN PERSPECTIVE ON THINGS
Everyone seems to respond to *Topsy Turvy*. The main figure came from a photo I took of our friend at a garden tour. He was taking pictures of one of his favorite subjects, cacti. I made him the focus, developing the rest of the composition around him. I used several photo sources to create a surreal world where fish inhabit the sky. The play of light and shadow and the vibrant color palette complement the invented perspective. Sadly, the real world lost this kind man. I am pleased his image will forever be recorded in this beautiful publication.

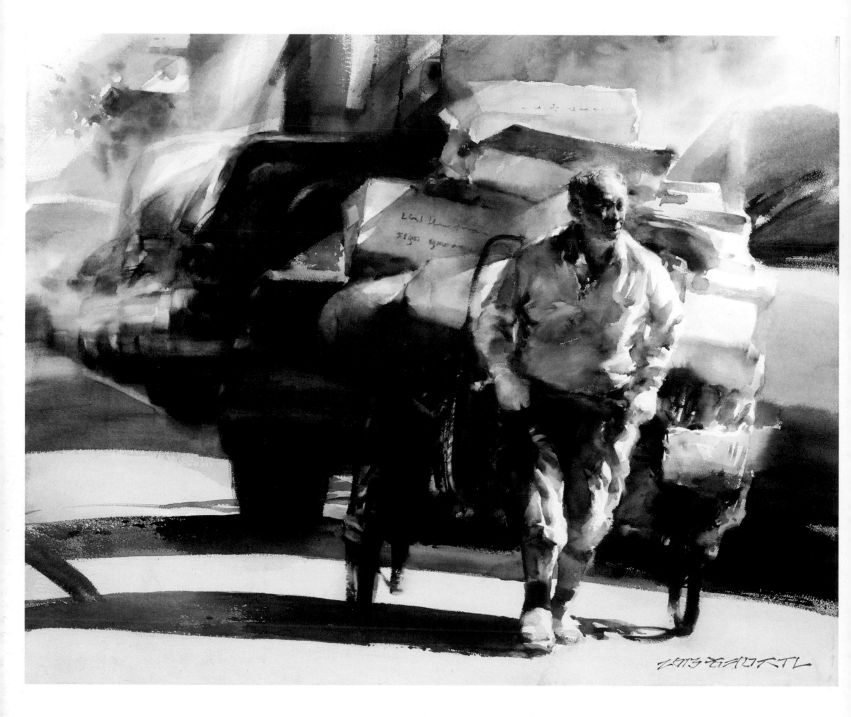

 A DAZZLING DAY
Hyoung Jun Lee
Watercolor on 260-lb. (550gsm) rough Arches
28½" × 36" (72cm × 91cm)

FOCUS ON FAMILIAR SURROUNDINGS
I often get ideas for my work from the street I routinely pass. One bright day, I captured this moment in a photo. The light displays its numerous faces, on different planes, shining in various colors. The individual parts of the picture appear to have many small and abstract elements, but I recomposed those elements to be reborn as a single story. I incorporate contrasts, such as cool/warm colors, complementary colors, and thick and thin objects. I like to discover humble and sincere scenes in which ordinary people appear, and I like to share the modest beauty of nature, which may not be noticed, but is omnipresent around us.

 FORGOTTEN
Patricia Guzmán
Watercolor and white acrylic on 140-lb. (300gsm) cold-pressed Arches
28" × 20" (71cm × 51cm)

SPOTLIGHT A FAVORITE CAUSE
The title *Forgotten* is a reference to indigenous Mexican people (Tarahumara/Raramuri) who, since the Spanish conquest, have experienced a constant migration. The blur of mist on the left side of the painting symbolizes being forgotten, as they are disappearing visually and literally in real life. However, I'm also reflecting on the resettling phenomenon that happens everywhere. People leave ways of life without knowing what the future will bring. The baby looks at the spectator not being able to understand why. All figures were painted with many layers of transparent watercolor. I used Titanium White, applied with airbrush, to give the sensation of the background mist. Then I applied very soft shadows over the white to obtain a sense of depth.

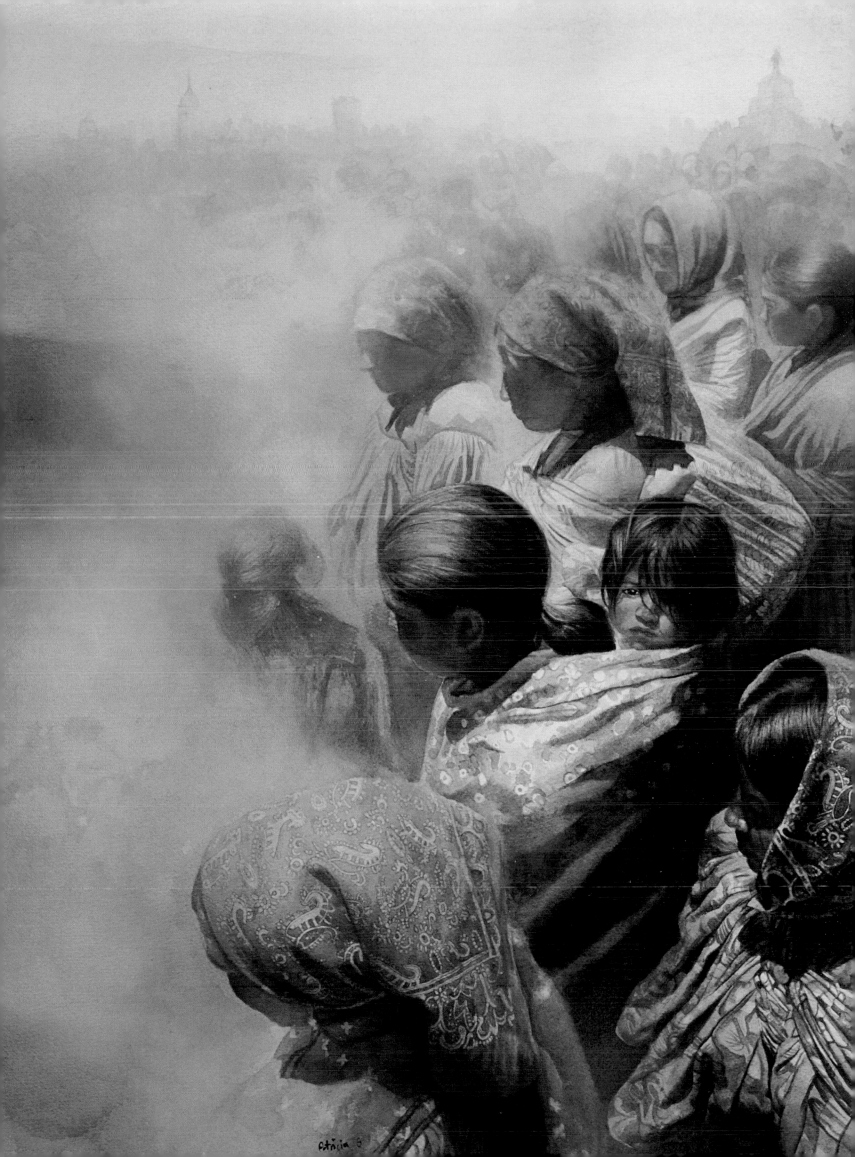

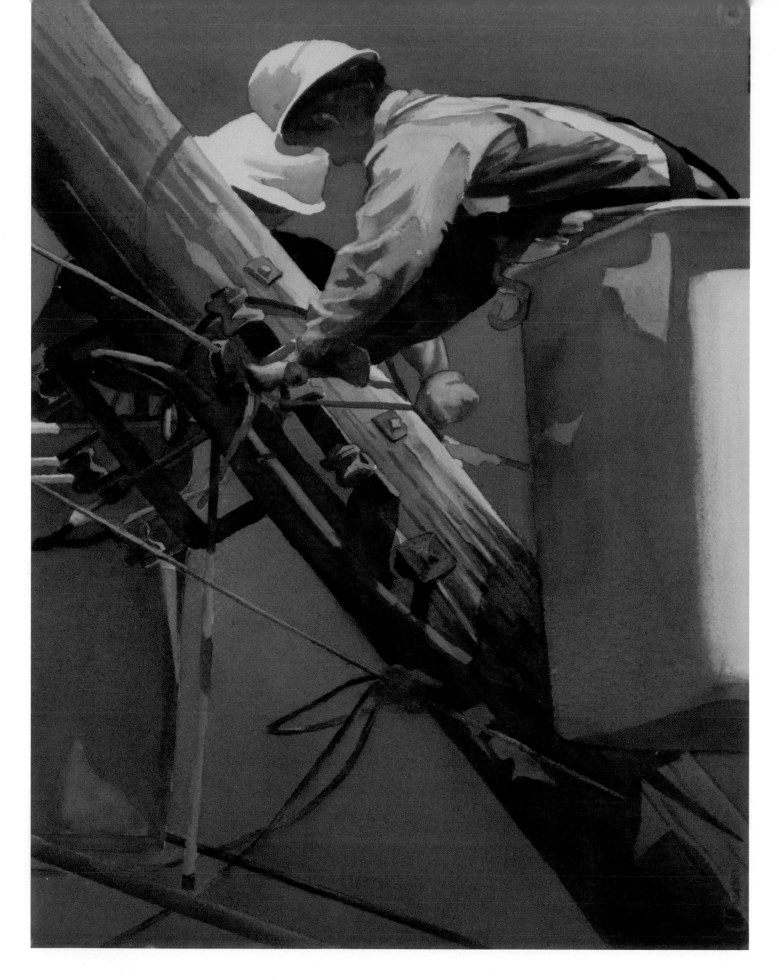

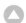 **LINE DANCE**
M.E. "Mike" Bailey
Transparent watercolor on 140-lb.
(300gsm) rough Arches
22" × 15" (56cm × 38cm)

TENSION FRAMES DESIGN
In the search for interesting and unusual subject matter, I find that there is something about men in precarious working conditions that catches my attention. Watercolor, with its capricious behavior, is the very medium to express these odd and sometimes dangerous conditions. These scenes also offer many appealing shapes, lines and details. Stumbling across these fellows repairing a broken utility pole and then struggling with all the conditions of the design made this painting a worthwhile challenge!

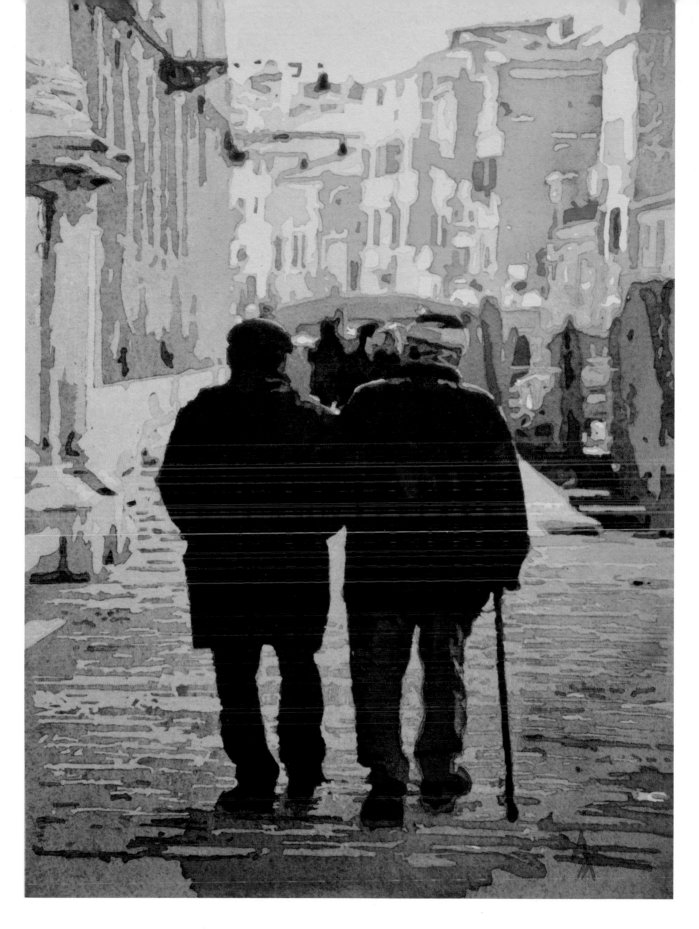

PROBLEM SOLVING?
Anne McCartney
Transparent watercolor on 300-lb.
(640gsm) cold-pressed Arches
16" × 11" (41cm × 28cm)

IMAGINE A STORY BEHIND YOUR SUBJECT
When we travel, my daughters and I enjoy secretly capturing images of people we encounter on the streets. We followed these two men for quite a while, as discreetly as possible, as we imagined the conversation they were having. This provided a story that I could translate into a painting. We imagined that these men were finding solutions to all the problems of the world.

I painted this in my studio long after I had returned from my trip; it brought back all those fun memories. I made sure that these men were the focus of the piece by creating high contrast, putting them in the foreground and putting light ahead of them.

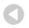

IN THE MORNING
Daqing Cao
Transparent watercolor on 300-lb.
(640gsm) cold-pressed Arches
22" × 30" (56cm × 76cm)

AN EXTRAORDINARY LOCATION REMEMBERED
The ancient French town Saint-Goustan is known for its post-industrial revolution-style architecture. The antique wooden houses and the gigantic granite eroded by the mist are some of its most memorable features. My family visited Saint-Goustan and brought back photos and video clippings of this unique, historic town. Inspired by its beauty and serenity, I started painting by depicting the sky and river with one continuous wash of subdued colors on wet paper, leaving the sky natural and breathable. I then sprayed the back of the paper again before adding the houses, the boats, the bridges, the cars. The moisturized paper helped create the tranquil, dreamy effect as I blurred the edges of overlapping images with diffused colors and soft strokes.

**BOATS IN THE BAY –
HOWTH, IRELAND**
Laurin McCracken
Transparent watercolor on 300-lb.
(640gsm) soft-pressed Fabriano
Artistico
18" × 20" (46cm × 51cm)

FIND THE ESSENCE OF A COMPLEX SCENE
I took a photo of the small bay, or harbor, in Howth near Dublin, and hoped it might be a worthy subject for a watercolor. I scratched my head about it for several years until I realized that the story should be about the boats, the colors of the boats, the rigging, etc., and not about the harbor area. The detailing of the boats challenged my continuing efforts to paint realism in watercolor.

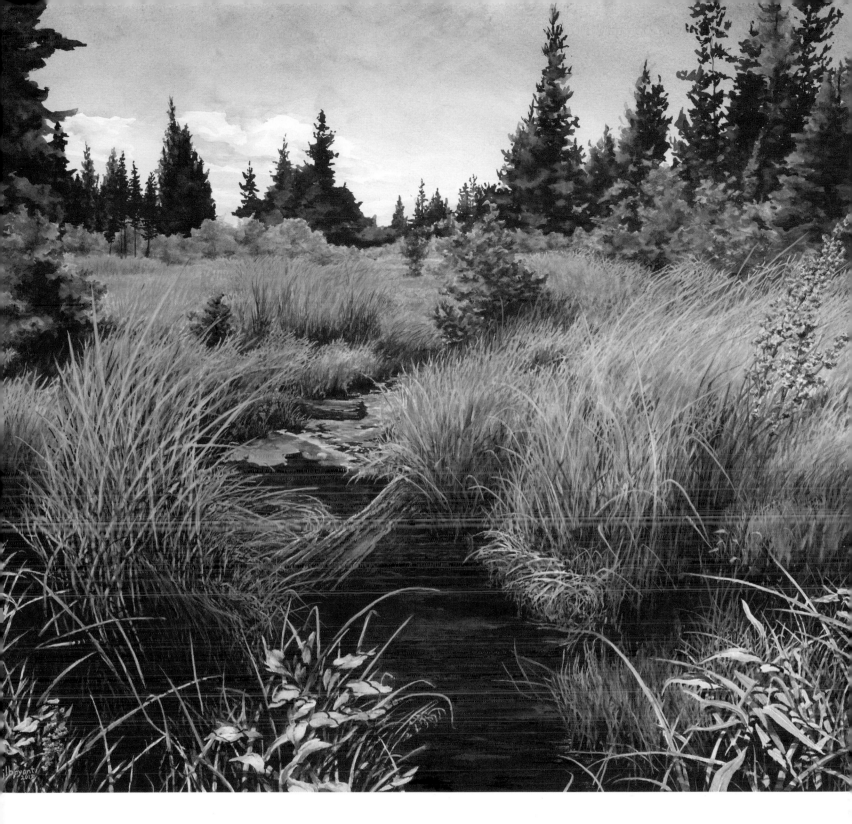

LITTLE DEATH CREEK
Jessica L. Bryant
Watercolor on 140-lb. (300gsm)
cold-pressed Arches
21" × 23" (53cm × 58cm)

CAPTURING A LAND'S UNIQUE PERSONALITY

Land is my love, from deserts to prairies to mountains. My experience motivates my brush. Capturing the unique personality of a place is my chosen challenge: finding the means to convey smell, sound and feeling through paint. I approach painting as a novelist: planning, rewriting and agonizing over detail. *Little Death Creek* was painted in my studio from a series of photographs of this meadow on my family's property in Michigan's Upper Peninsula. I labored over designing an effective composition while keeping the essence of the setting. Planning was extensive, and the painting process took over seventy hours to complete with much layering and dry brushwork. The rewards of this process motivate my efforts toward the next painting.

Paint what you love, in the style you love, and don't agonize over why; this is who you are. —Jessica L. Bryant

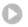

HERBAL EQUATION
Jerry Smith
Transparent watercolor on 140-lb. (300gsm) cold-pressed watercolor paper
11" × 29" (28cm × 74cm)

ENDLESS VARIETY IN FAMILIAR FARM LANDSCAPES
Inspired by the Midwest landscape that has surrounded me throughout my life, I continually return to traditional farms and their surroundings for source material. The approach I take depends on the inspiration provided by the subject. For *Herbal Equation* I combined washes, hard-edge painting and wet-into-wet passages. I tried to stay within a low-light, saturated color realm, emphasizing the wide variety of colors and textures in the deep foreground. I like a stretched out format for this type of subject to pull in a long stretch of buildings or trees without having to deal with an excessively large sky or foreground area.

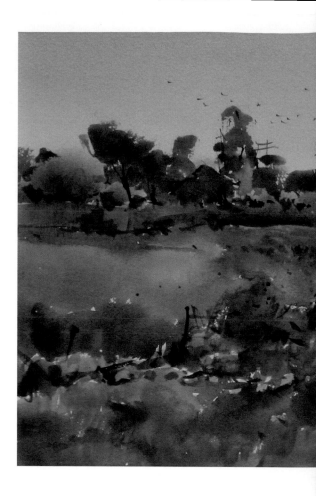

MORNING LIGHT
Sujit Sudhi
Transparent watercolor on 300-lb. (640gsm) Indigo handmade paper
11" × 15" (28cm × 38cm)

MOTIVATED BY THE LIGHT OF HAPPY MEMORIES
Morning Light was inspired by a lot of happy childhood memories. I often got a chance to visit my grandparents, and my recollections are full of the warm golden light of the morning sun. I spent a lot of time observing the quiet countryside around me, and those experiences surely helped shape the artist in me. The light was often dramatic and the shadows full of character. I believe that leaving a lot to the imagination of the viewer helps to evoke a wider range of emotional responses.

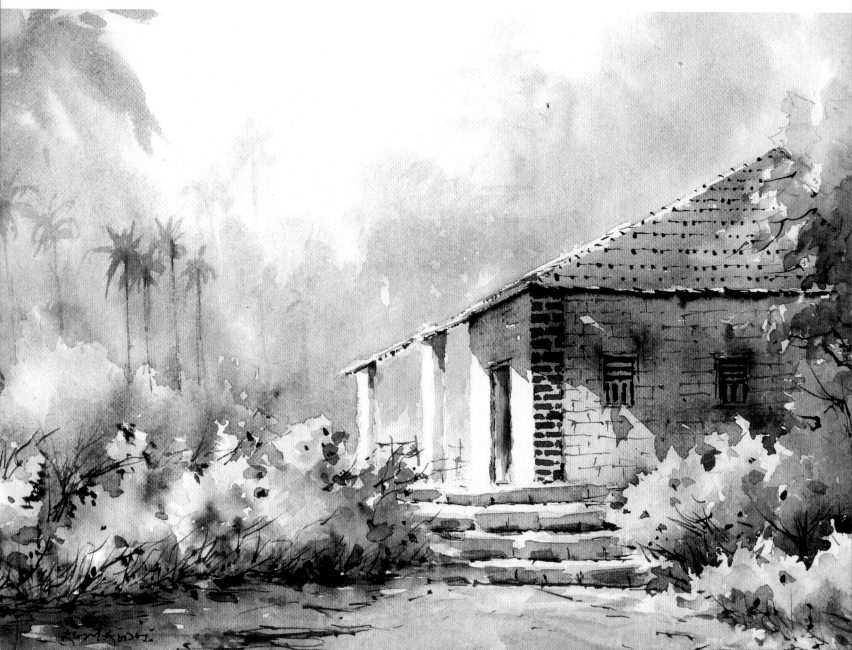

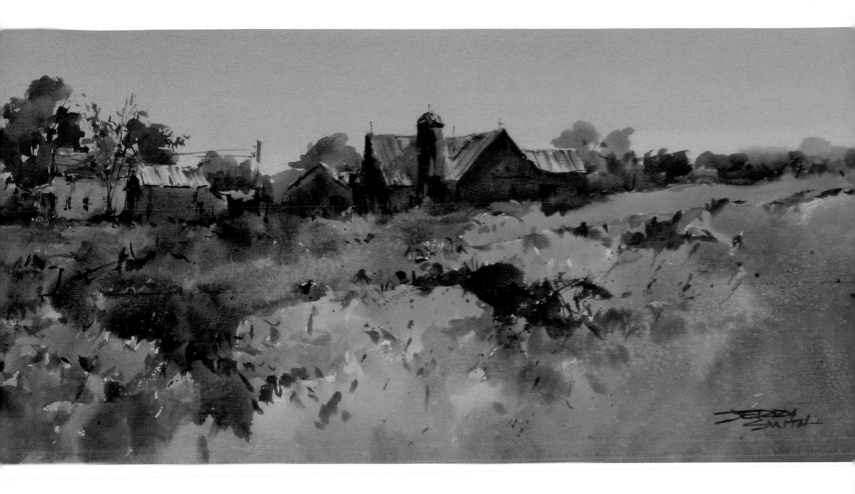

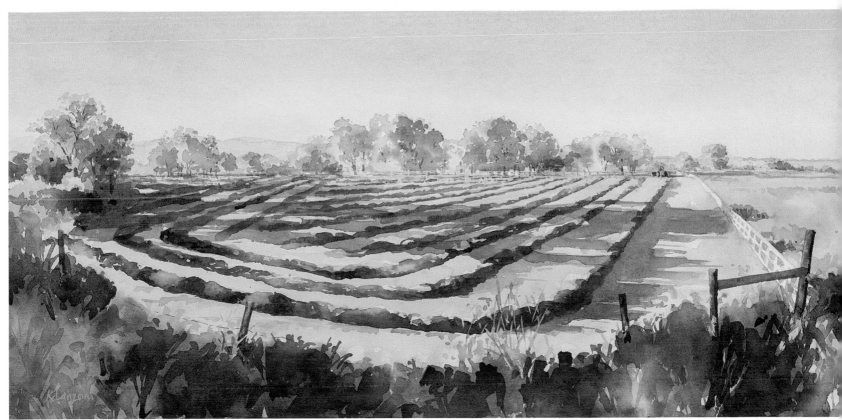

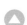 **PASTORAL AFTERNOON**
Kathleen Lanzoni
Transparent watercolor on 300 lb.
(640gsm) rough watercolor paper
13" × 30" (33cm × 76cm)

A PARTICULAR DAY, A PARTICULAR LIGHT

Driving past this historical farm on a daily basis, I watch the progress of the seasons as they unfold in the fields. One afternoon in June, the hay was freshly cut and the sunlight was making beautiful long shadows across the field. The scene was so warm, peaceful and harmonious that I knew I had to capture it. Back in my studio, the first step was painting the entire sheet of paper with a light wash of New Gamboge for the warmth of the sun. I then painted wet-into-wet, creating mountains and distant trees. While that was drying I added middle-ground trees and then worked in progressive layers to describe the foreground trees and field while leaving the white of the fence. I finished with the darks of the foreground plants and the fence posts.

119

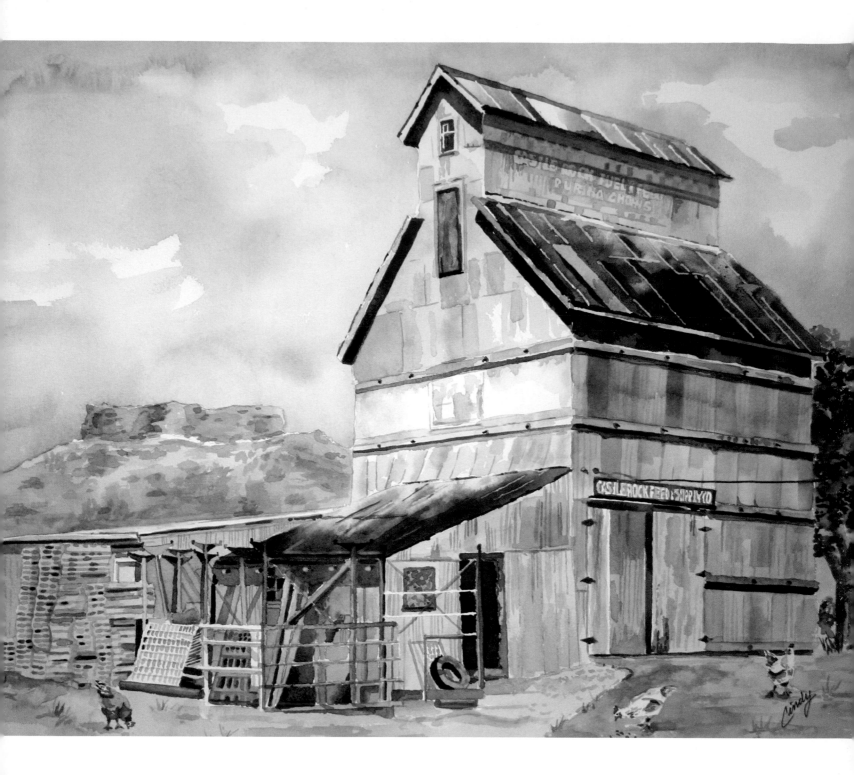

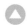 **CASTLE ROCK FEED & SUPPLY**
Cindy Welch
Transparent watercolor on 140-lb. (300gsm) cold-pressed Arches
16" × 20" (41cm × 51cm)

BRINGING HOMETOWN HISTORY TO LIFE
I am fascinated with Colorado history, specifically the rich past of my hometown, Castle Rock. Castle Rock Feed & Supply was established in 1902. The pioneer spirit of the early settlers inspires me, and I work from my own photos and sketches. Visually I am inspired by the weathered metal of this structure, showing the passage of time in exciting coloration. I began with the weathered roof by dropping vibrant colors onto wet paper and letting them mix and mingle. This is my favorite aspect of watercolor … surprises! Next, in the background I added the landmark Castle Rock, which is the most recognizable image in town. Lastly I added the chickens to capture the historic past along with the current charm of this building.

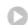 **ACCUMULATE #92**
Jayson Yeoh Choon Seng
Transparent watercolor on 140-lb. (300gsm) cold-pressed Saunders
with rough finishes
21½" × 14½" (55cm × 37cm)

ASSEMBLING EMOTIONAL MEMORIES OF CHILDHOOD
My connection to fishing villages has been engraved in my life. The deeply embedded conversation between us has given rise to a myriad of poetic scenes. I let my imagination flow between semi-abstract and figurative images. *Accumulate #92* is from my latest series inspired by my life experiences growing up in a fishing village. Before painting, I prepared by taking lots and lots of photos related to assemblage or accumulation of any kind, whether orderly or disorderly. Such groupings spark my creative juices. I plan all my design, composition, values and colors during my sketching process and then paint from the sketch. I usually prefer Holbein Artists' Watercolors and enjoy allowing the water and color to integrate on the paper for amazing effects.

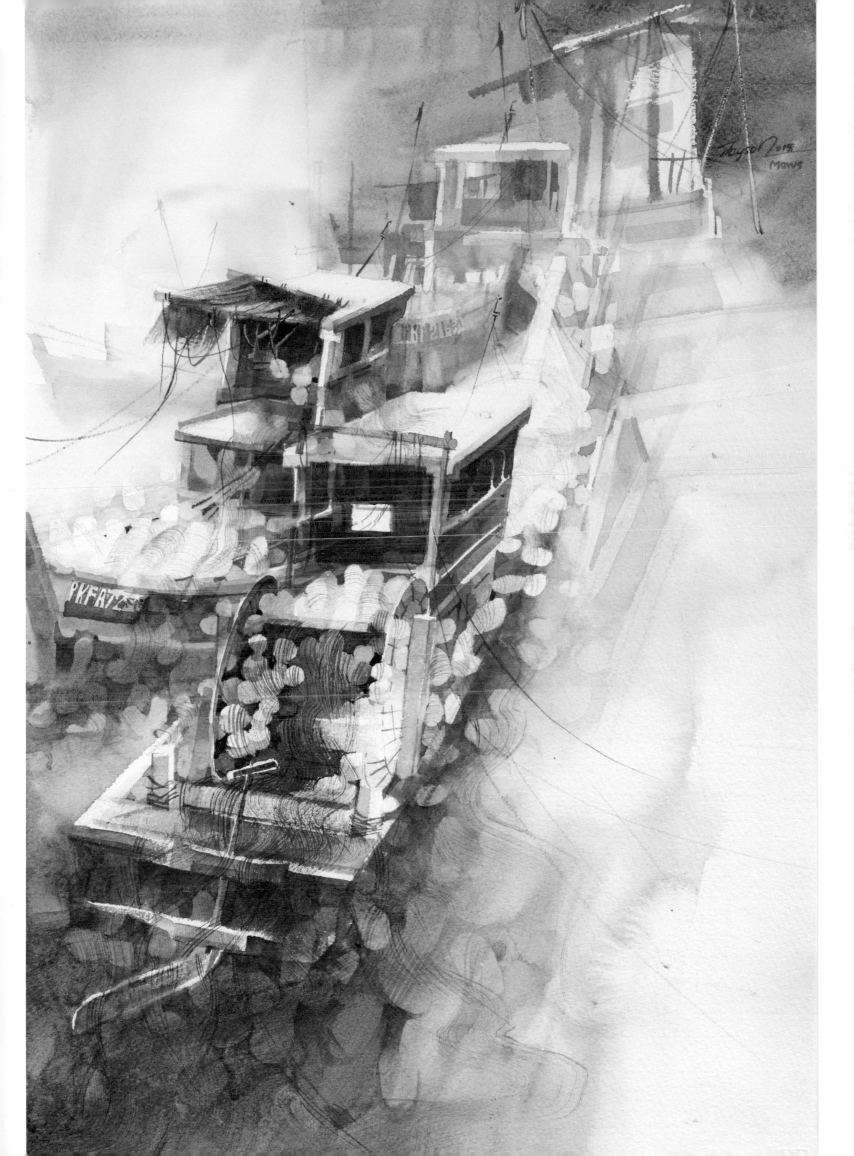

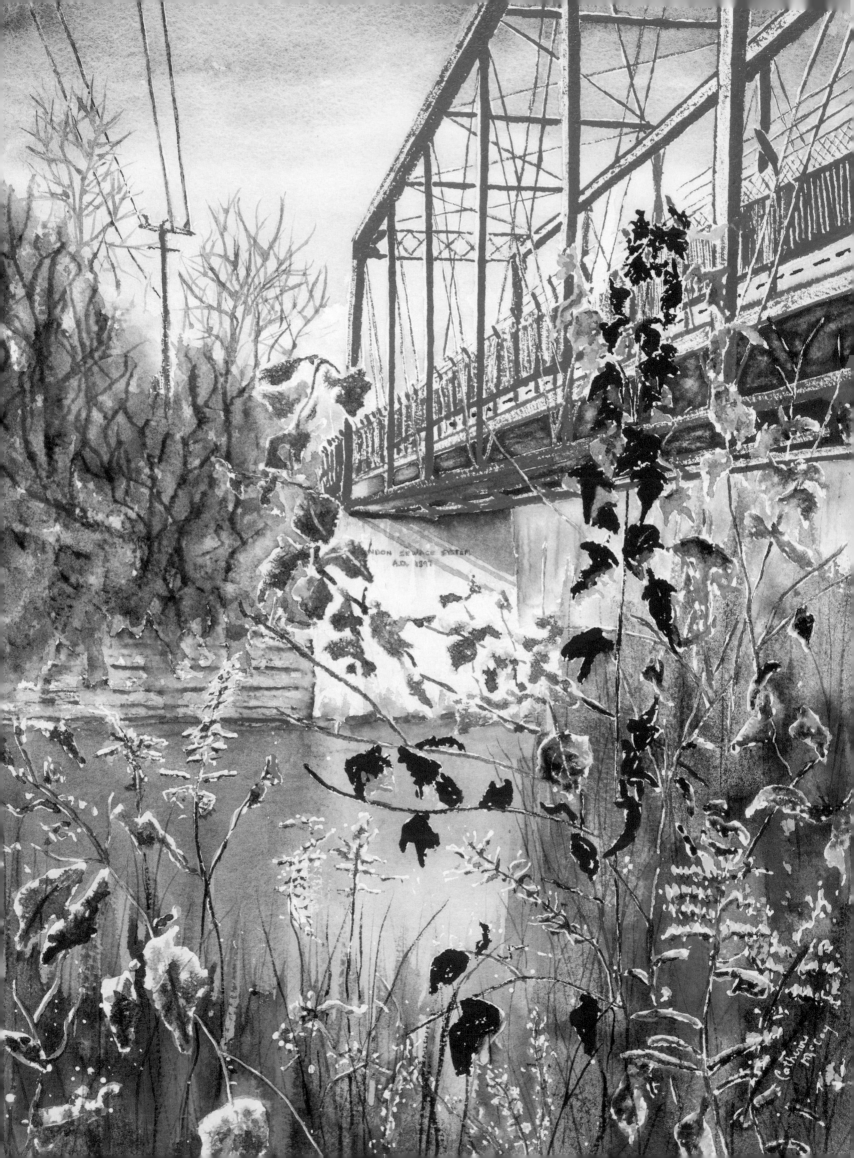

When I have a deep emotional reaction to a subject, it seems to come through in the end result. —Catherine McCoy

OLD FORT FARM
James Scott Morrison
Watercolor with gouache for haze accent on Arches
16" × 20" (41cm × 51cm)

THE POWER OF STRONG LIGHT AND COLOR CONTRAST
I like strong light and values and a strong focal point. I take a lot of photos. I do not sketch on-site anymore; it takes too much time and I can lose a photo reference from the next spot down the road. For *Old Fort Farm* I began with a mix of Cerulean Blue and Yellow Hansa Light washed over the whole paper to give an early morning warm glow. I painted the far trees first and did a lot of spritzing over most of the painting for tree texture. For the haze on the far trees I layered Zinc White gouache until I got the effect that I wanted. I waited about a day between each layer to make sure it was fully dry. I used the edge of a palette knife with yellow for the fine lines on the grasses and bushes.

AUTUMN UNDER THE FOOTBRIDGE
Catherine McCoy
Transparent watercolor on 300-lb. (640gsm) cold-pressed Arches
15" × 11½" (38cm × 29cm)

A FAVORITE RIVER IN VIBRANT AUTUMN
The Thames River in London, Ontario, Canada, is my main source of inspiration. This is a pin-connected truss bridge built in 1897 and is one of several historic bridges crossing the river. I walk past this spot in all seasons, but one day in October the scene took my breath away. I took a photo with my cell phone and knew I had to paint it. After a painstaking exercise in perspective, I masked out the bridge and all of the foliage in the foreground before painting the sky and other background detail. After removing the masking I used dry brushwork on the Cadmium Green bridge to achieve the effect of sparkle from the sun. Of all the paintings I've done of the Thames, this is one of my favorites.

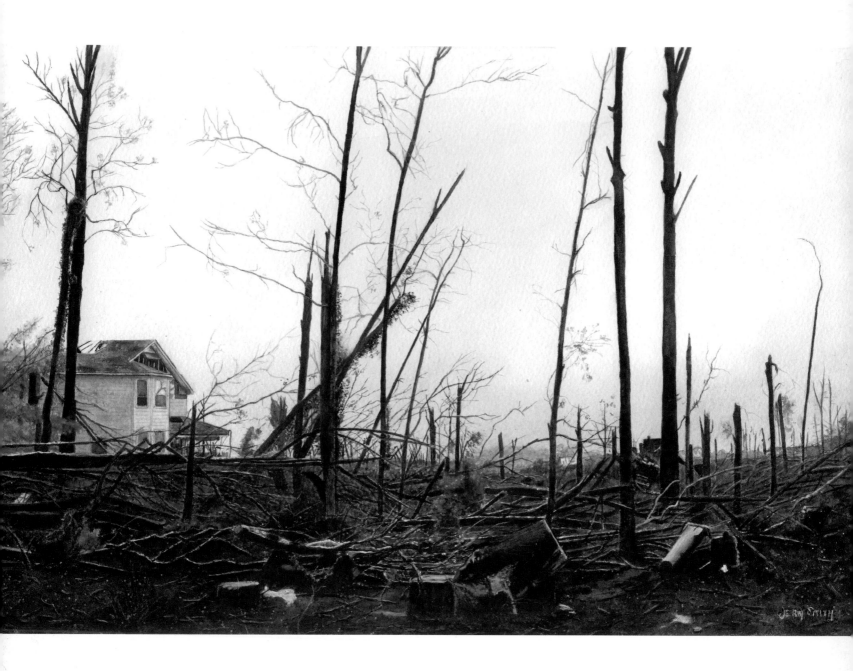

 DISASTER IN ALABAMA
Jean Smith
Watercolor on 300-lb. (640gsm) cold-pressed LANA
12½" × 17½" (32cm × 44cm)

RESPONSE TO A REGIONAL DISASTER
Our son and granddaughter visited this area near Birmingham, Alabama, as part of the effort to do cleanup work in 2011. He took several pictures and I chose this one to show the power of a natural disaster. To capture the effects and the depth of destruction I painted many layers of each color. I started painting the background and then moved forward to capture the bare trees and finally the foreground. I was inspired to paint this picture to document the striking starkness of the devastation produced by the worst tornado in the history of the area. I don't normally paint this type of subject.

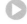 **ONE INCH SNOW**
William C. Wright
Transparent watercolor on 140-lb. (300gsm) hot-pressed Arches
16" × 12" (41cm × 30cm)

THE MUTED QUIETUDE OF WINTER
This is a view from a ridge overlooking our house. I walked our property with my camera thinking of the cold and silence of this one-inch snow. Everything was gray. I love painting gray. The stillness of winter scenes is very attractive to me, and this image had it all: the subtle grays, muted color and the strong contrast of the trees. I start with a detailed drawing directly on the watercolor paper with a regular no. 2 pencil. I work in a traditional watercolor technique, painting light to dark. My first wash was a gray mix of Cerulean Blue and Cadmium Red Light. I let it dry and then started layering in darker and more subtle colors. I paint carefully with small brushes, paying close attention to my drawing. I finished by drawing in the house siding and the upper twigs in pencil.

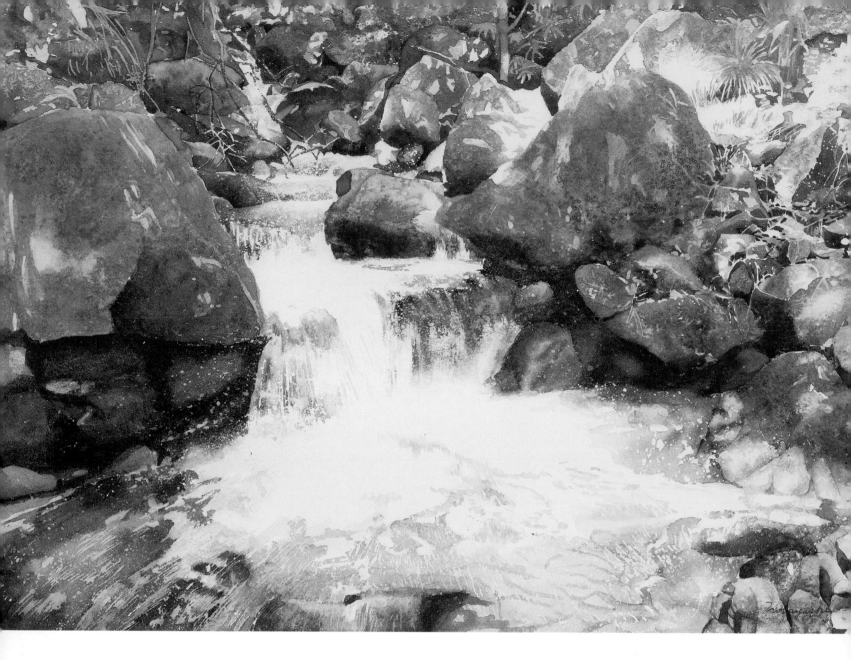

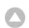 **MOSS-GROWN STREAM**
Keiko Kobayashi
Transparent watercolor on 140-lb. (300gsm) cold-pressed Arches
12" × 18" (30cm × 46cm)

NATURE'S POWER CAN REST THE SOUL

Touched by the serenity of the stream and its surroundings, I painted this piece hoping to express the gentle and comforting sunlight shining through foliage and to provoke a sensation of being there, feeling the soft air and rushing stream. I create my paintings indoors based on photographs I take. At exhibits, people often ask me how I paint the moss-grown rocks. I sprinkle salt over a small area of freshly painted rock while it is still wet. Various patterns are born depending on how wet the painted surface is and how much salt is sprinkled. The surface is left to dry on its own. Then you'll have a rock with totally natural-looking moss growing on it.

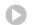 **ASSESSED**
Dan Mondloch
Watercolor, gouache and colored pencil on 140-lb. (300gsm) cold-pressed Arches mounted to an aluminum composite panel and then clear-coated with soft gel gloss and satin varnish
48" × 32" (122cm × 81cm)

THE INSTANT THAT LIGHT REVEALS

When lighting conditions suddenly reveal the character of a subject, I get inspired. *Assessed* is based on several photographs I took near our family's lake cabin, a very special place to me. The way the lines articulated the forms lent a graphic quality and led my eye through the scene in a very exciting way. Farm fields can have a wonderful architectural feeling with carefully laid out sections and rows that reveal the topography of a landscape. I tried to express that with the energy of lines and overlapping shapes. I also used tape to create some very smooth edges, which contrasted nicely with the gritty and highly textured areas. A quality painter's tape works well because it releases easily, and when it comes into contact with water its adhesive gels at the edge and creates a barrier against the paint.

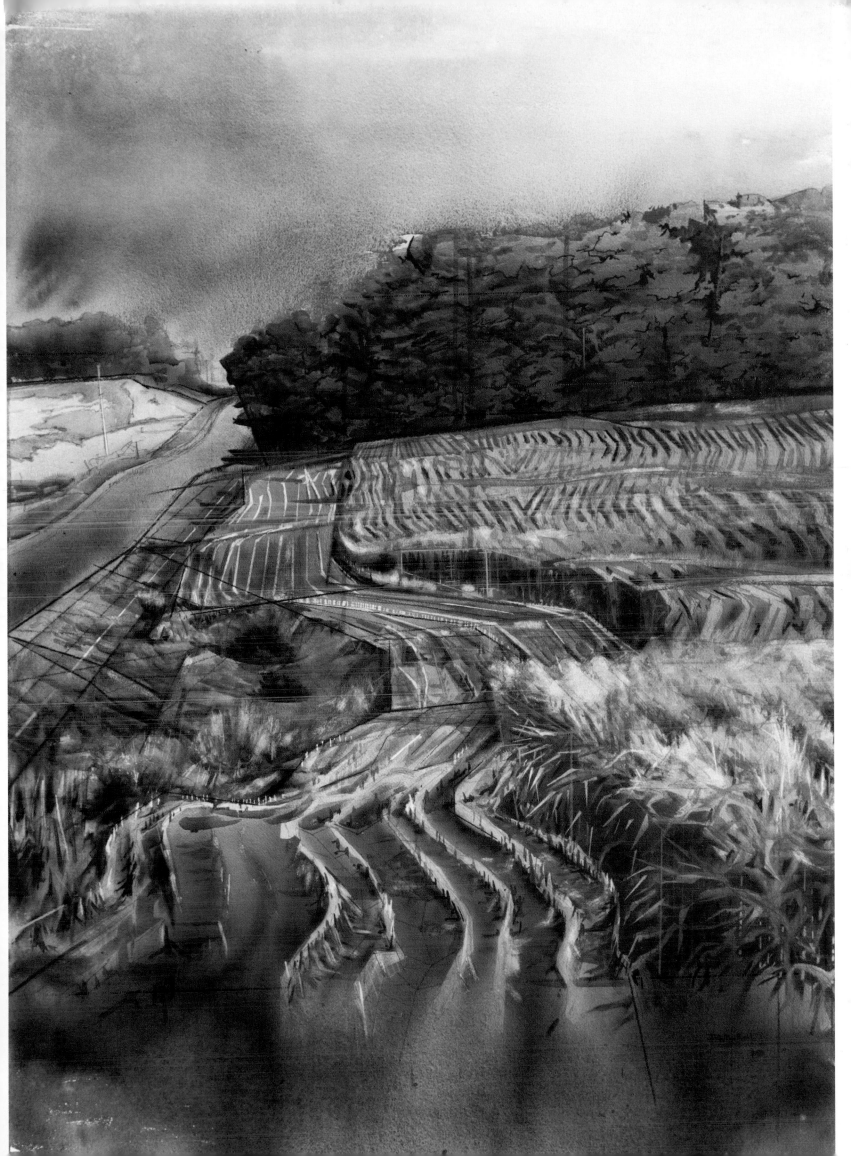

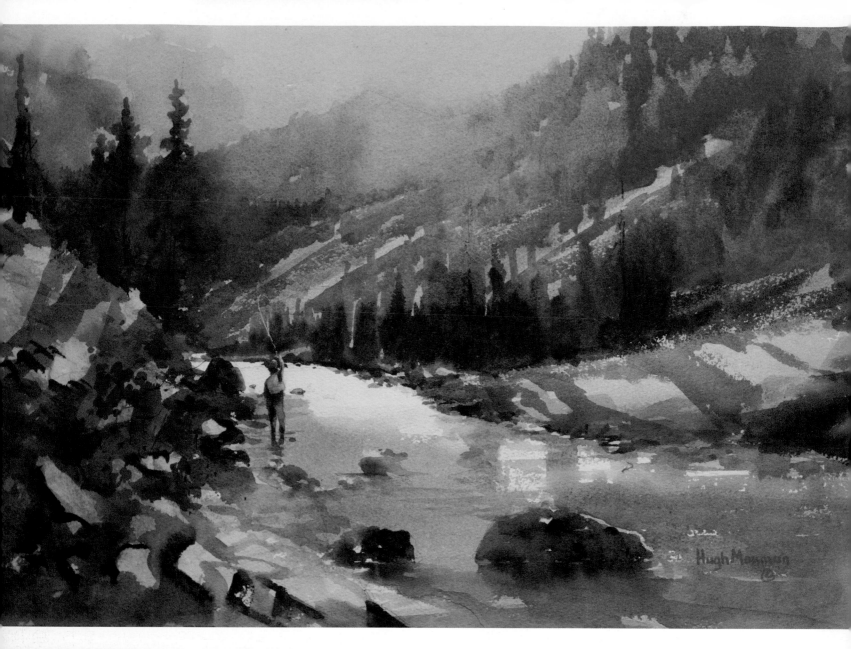

DISCUSSING GRANDPA'S HOUSE
Brienne M. Brown
Watercolor with gouache accents on 140-lb. (300gsm) cold-pressed Arches
16" × 20" (41cm × 51cm)

EVENTS IN THE LIVES OF EVERYDAY PEOPLE
I am inspired by ordinary people and everyday life. This house is near where I live and I have painted it many times. About the time I painted this, the owner was forced to enter an assisted living facility, and the family had to sell the house. Many families have experienced this, including my own. This story is not just about the weighty decision of selling the family home, but also about the memories that are always with us to bring a measure of peace.

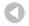 **GONE FISHING**
Hugh Mossman
Transparent watercolor on 140-lb. (300gsm) rough Saunders Waterford
15" × 22" (38cm × 56cm)

DEPICTING A FAVORITE ACTIVITY
Fly fishing and watercolor are two of my favorite things, and I enjoy painting subjects of what I like to do. This is a studio work, depicting a generic place resembling many of the trout streams I've fished in Idaho. I start with a drawing to set the basic shapes. The next step is pure fun: wet-into-wet washes to create mood and color. I emphasized the passage of light by preserving some light wash values. Final steps: Set the values, add texture and details.

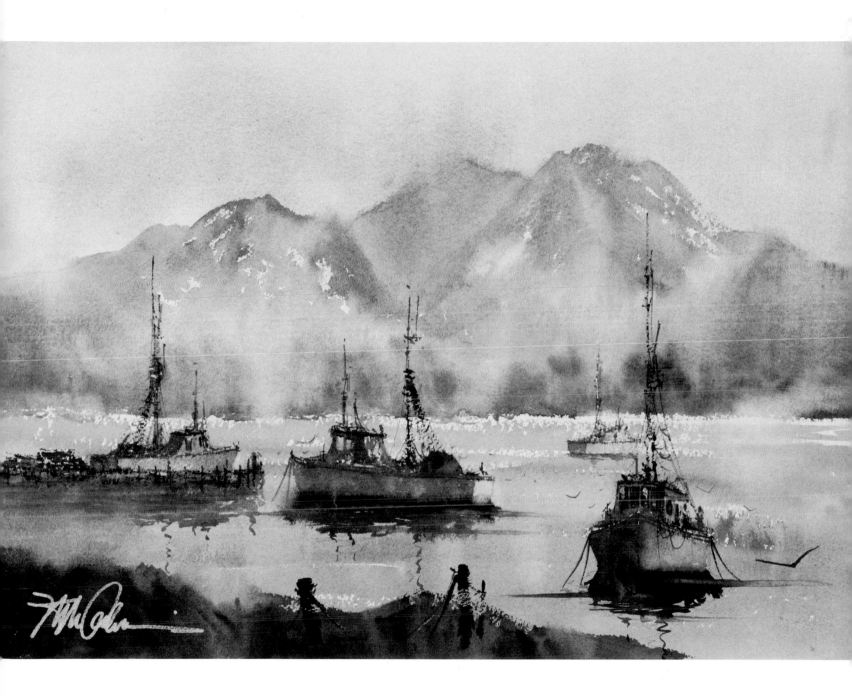

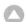 **MORNING IN SITKA**
Mick McAndrews
Transparent watercolor on 140-lb. (300gsm) rough Saunders Waterford
15" × 22" (38cm × 56cm)

RELIVING A MAGICAL MOMENT
My wife, Becky, and I made a trip to Alaska, where there's enough inspiration to last a lifetime! I've always been attracted to weathered fishing boats and the lifestyle that surrounds them. When the morning fog lifted at Sitka harbor with its majestic mountain backdrop, I took photos to paint from later. In my studio I designed the painting and then worked very fast and loose to capture the character of this moment. I believe in a partnership between artist and medium, of finding a balance between the skill of the painter and the unplanned magic that makes watercolor so distinctive.

Painting should be great fun. When we're having fun it can be seen by the viewer in our finished work! —Mick McAndrews

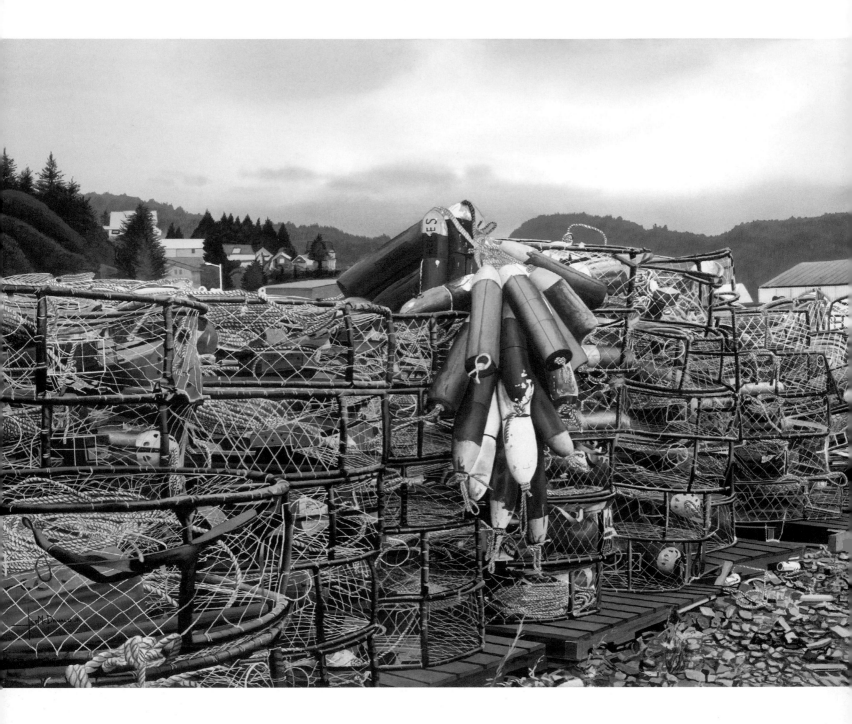

 ALASKA CRAB TRAPS
Leslie C. McDonald Jr.
Watercolor with gouache on 300-
lb. (640gsm) cold-pressed Arches
22" × 30" (56cm × 76cm)

SUDDEN INSPIRATION BRINGS HARD WORK

We were on a salmon fishing trip out of Cordova, Alaska. There was a weather layover so I decided to drive around town and go by the Cordova Harbor. Checking out the boats and the docks, I came across a large stack of crab traps. The buoys with their splash of color hanging off the stack intrigued me, and I took a number of photos. Some years later when I started the painting, I realized it was going to be a laborious task. I worked for five months to complete the painting. It was a challenge to paint all of the detail inside the traps before I added the wiring.

 A TIME TO REAP
Christine Misencik-Bunn
Transparent watercolor on 140-lb.
(300gsm) cold-pressed Arches
21" × 27½" (53cm × 70cm)

THE EXTRAORDINARY ENTERPRISE OF GROWING GRASS

The idea for *A Time to Reap* began with several photographs and studies at my friend's farm. I wanted to paint the touch, the smell, the taste and the noise of that moment. My biggest challenge was understanding and capturing the different textures of the grass as it was being mowed: low-lying grass, standing tall grass, various colors. Masking fluid was applied randomly. After wetting an area, I dropped in several colors and allowed them to mingle. A toothbrush became my favorite brush for lifting and softening. The farmer, standing tall, exhibits never-ending work and patience. Just to have hay to feed the cattle, he must plant the hay crop, cut it down at the right time, turn it over several times for drying, bale it, store it and then feed it. My painting was challenging to execute but led me to appreciate the hard work of a farmer.

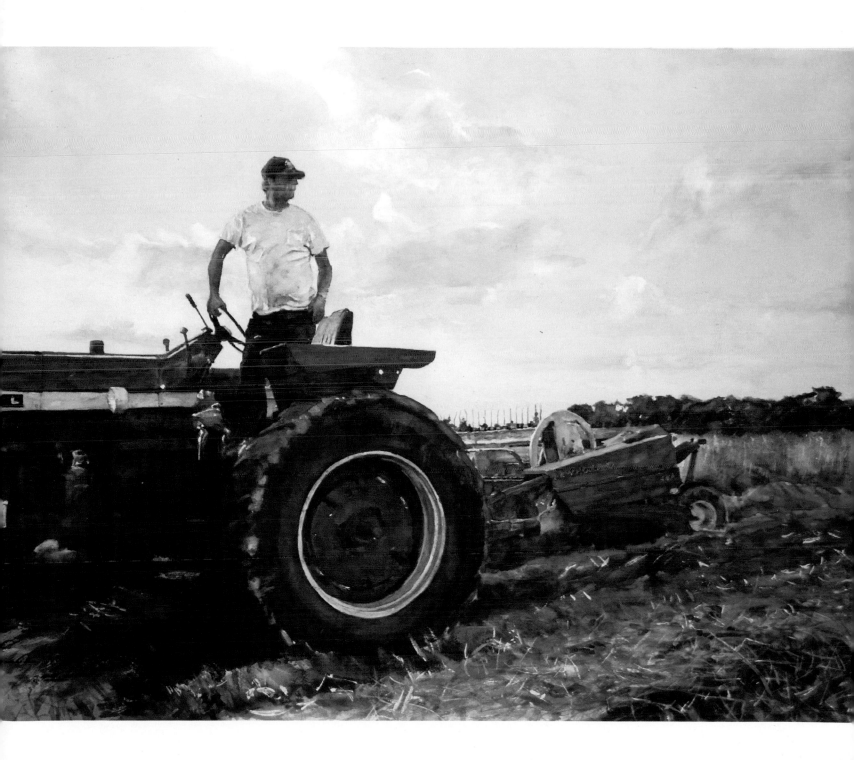

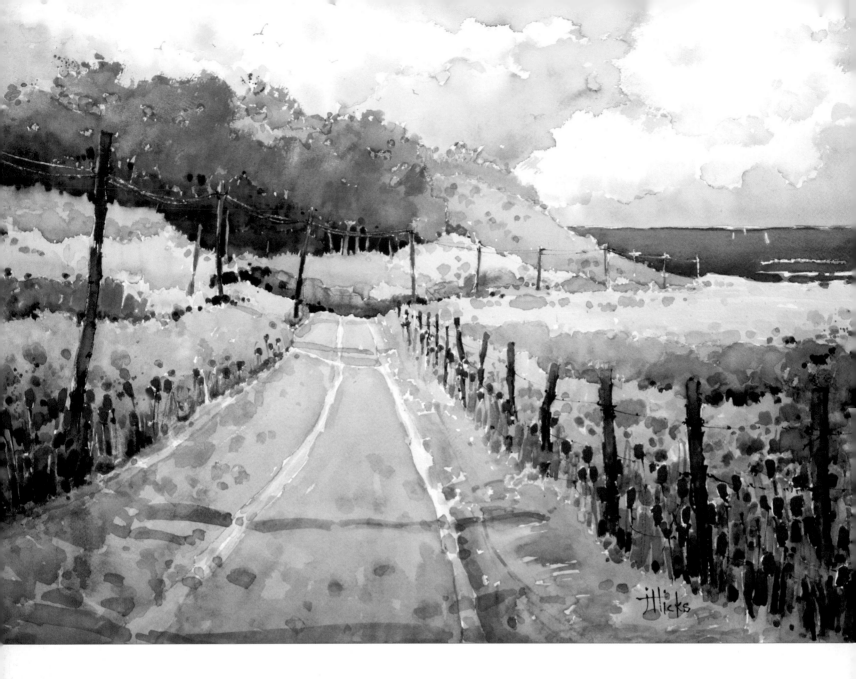

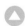 **PERFECTLY PEACEFUL PACIFIC**

Joyce Hicks
Transparent watercolor on 140-lb.
(300gsm) cold-pressed Arches
18" × 24" (46cm × 61cm)

CAPTIVATED BY THE VIEW ON A DESERTED ROAD

Each subject I paint begins with a moment when I'm totally captivated. This connection to your subject matter is what your painting should be about. An unusual shape or bright color may be all it takes! I record my unique impressions with notes and small color sketches. Brilliant red wildflowers along a country road came into view one sunny day while traveling down a deserted coastal road. The blue Pacific lay quietly in the background and gave the entire scene a feeling of peacefulness. This inspiring chance encounter became the theme for *Perfectly Peaceful Pacific*.

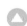 **BOAT HARBOR AT DUSK**
Chris Breier
Pen and ink with watercolor on
hot-pressed Fabriano Artistico
8" × 10" (20cm × 25cm)

VISIT A FAVORITE PLACE TO BE INSPIRED

The Buffalo, New York, waterfront is a relaxing place to visit and find inspiration for watercolor paintings. I enjoy walking near the water and often bring my camera to take reference photos of the boats, people, industrial architecture and skyline. The boats provide a variety of shapes, and the surface of the water is constantly changing; in this instance it had a silvery reflective quality. I often combine pen and ink with watercolor because the pen allows me to quickly define the details, and then I can focus on applying the washes of color. I chose a hot-pressed watercolor paper because the smooth surface works well with pen and ink.

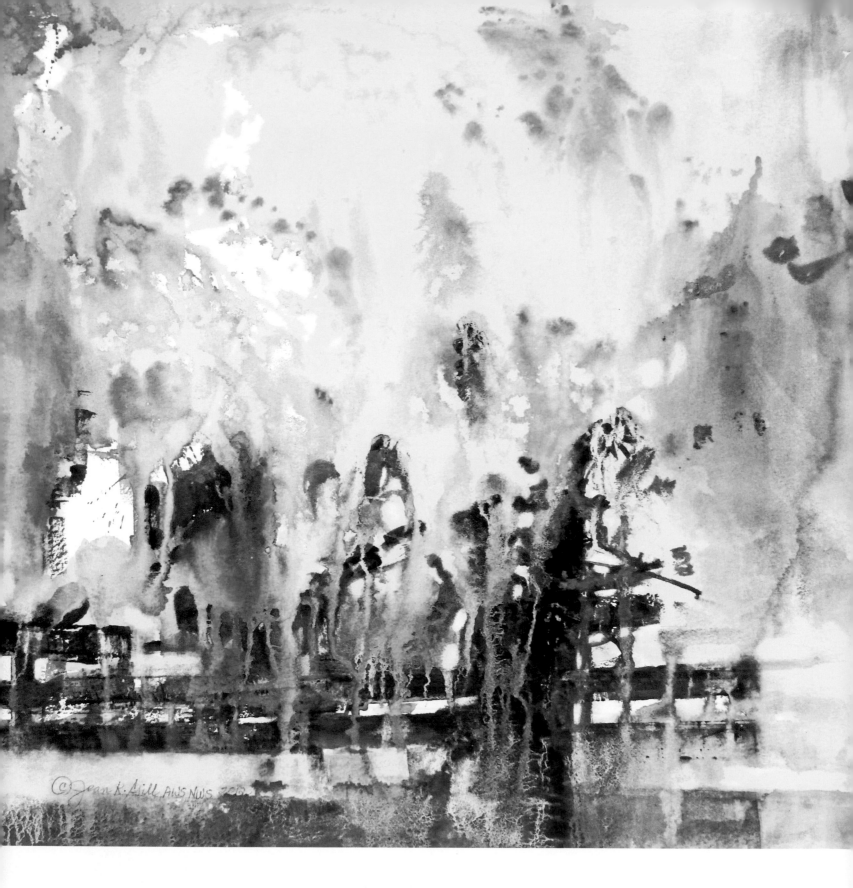

 YELLOW RAIN
Jean K. Gill
Transparent watercolor on 300-lb.
(640gsm) rough paper
18" × 18" (46cm × 46cm)

ALLOWING YOUR COLOR FREE REIGN

Every October I shoot reference photos of fall foliage because the beauty of autumn inspires me to paint. The photo provides a blueprint, and my technique allows improvisation. I enjoy methods such as painting on vertical paper, using gravity and strategic misting to facilitate and direct downward flow. This fluid process is risky but entertaining, and it encourages color mixing, varied edges, granulation and spontaneous expression. In *Yellow Rain* I kept the intense autumnal hues and exaggerated value contrasts. The square format and suggested fencing add some geometric elements. The splendor of peak foliage is ephemeral, and for me, drips and blurs represent energy, motion, transition, and the inevitable release that wind, rain and time will produce.

Viewers tell me that my paintings make them smile; this is my intent. —Roger H. Parent

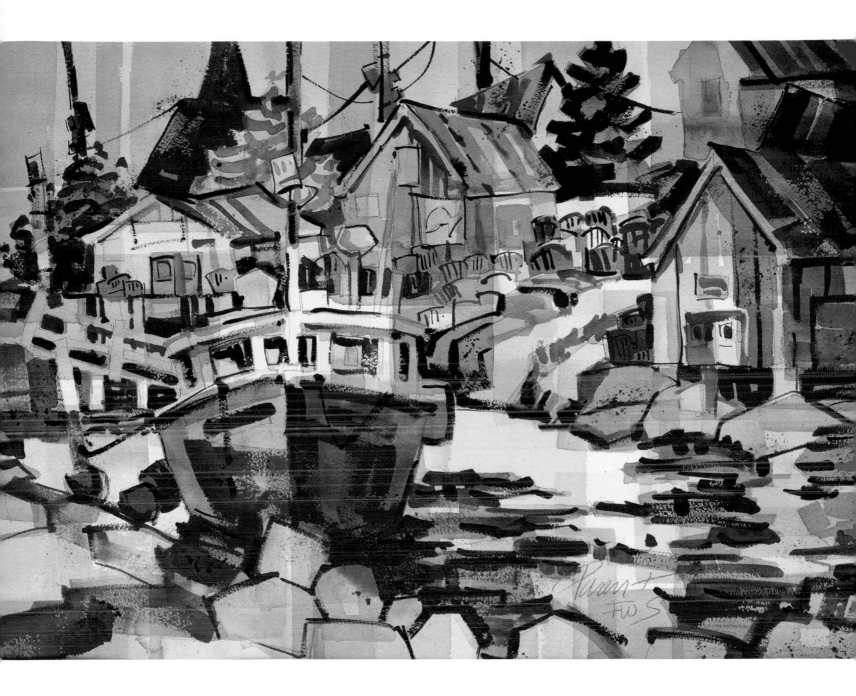

HARBOR GLOW
Roger H. Parent
Watercolor on 140-lb. (300gsm)
rough Arches
21" × 29" (53cm × 74cm)

COMBINE IMPRESSIONS AND WHIMSY
Travel provides my inspiration. Ideas are sparked by light and shadow patterns, unusual shapes of buildings, harbors, markets and such. I take photos for reference and to remind me of the excitement that I felt. I am less interested in the specifics of a particular scene but am fascinated by combining multiple impressions into a whimsical recollection of a trip. I also take photos of many details along the way, like amusing signs or colorful objects at markets. Each painting evolves from sketches and studies into an amalgam of many impressions and elements, often from scenes where colors are vibrant.

CONTRIBUTORS

ANNE ABGOTT
AWS, NWS
Cortez, FL
annecabgott@gmail.com
anneabgott.com
p106 Fly the Friendly Skies

FRANCES ASHLEY
NWS/S; Western Federation of Watercolor Societies/S;
Southern Watercolor Society/S
Austin, TX
francesashley@hotmail.com
francesashley.com
• *Three Roses*—Second Place, Waterloo Watercolor
Group, Austin, TX; Juried into the AWS Annual Exhibition
and the NWS Member Exhibition
p12 Three Roses

M.E. "MIKE" BAILEY
AWS, NWS
Santa Cruz, CA
mebaileyart@comcast.net
mebaileyart.com
• *Line Dance*—2015 Dick Blick Award, Missouri Water-
color Society; San Diego Watercolor Society
p112 Line Dance

CAROL BAKER
Arizona Watercolor Association, Arizona Artists Guild
Scottsdale, AZ
carolbakerart@cox.net
carolbakerart.com
• *Tiny Umbrella*—M. Graham Award, 2015 Arizona
Watercolor Association; Accepted 2015 Exhibit Western
Federation of Watercolor Societies
p33 Tiny Umbrella

NANCY BALDRICA
Scottsdale Artists League
Avondale, AZ
nbaldrica@aol.com
p15 Coconut Palm

ELENA BALEKHA
Duvall, WA
art@elenabalekha.com
elenabalekha.com
p47 Tivoli Lights

LEA BARCLAY
Toronto, ON, Canada
leabarclay@rogers.com
p8 Lemons and Limes

JOANNA BARNUM
Baltimore Watercolor Society, Maryland Society of
Portrait Painters
Abingdon, MD
joanna@joannabarnum.com
joannabarnum.com
• *Kalindi Eating a Banana*—Golden Art Supplies Award,
Baltimore Watercolor Society Mid-Atlantic Exhibition, 2013
p29 Kalindi Eating a Banana

SEAN BARRETT
NWS, WHS
contact@sbwatercolors.com
sbwatercolors.com
• *Thanksgiving*—John C. Dioszegi Memorial Award of
Merit, TWSA
p78 Thanksgiving

CHRIS BECK
NWS, TWSA
Los Altos, CA
chris@chrisbeckstudio.com
chrisbeckstudio.com
p77 Quack

RICHARD BÉLANGER
AWS, CSPWC, SCA
East Bolton, QC, Canada
richardbelangersca@hotmail.com
richardbelanger.ca
Tilting at Windmills Gallery, Manchester, VT
• *The Welder*—Merit Award, Louisiana Watercolor
Society, 2012
p22 The Welder

ROBIN BERRY
TWSA, WW, AFC
tabetberrystudio@comcast.net
natureartists.com/robin_berry.asp
p60 The Gathering

ANNELEIN BEUKENKAMP
Burlington, VT
abwatercolors@gmail.com
abwatercolors.com
p27 The Spectator

DENNY BOND
AWS, NWS, TWSA
East Petersburg, PA
bond004@msn.com
dennybond.com
• *92*—Award of Excellence at Faces & Figures National
Exhibit, PWCS Member 1st Place
p30 92

CHRIS BREIER
Buffalo, NY
chrisbuffalony@gmail.com
cbreier.com
p133 Boat Harbor at Dusk

BRIENNE M. BROWN
PWS, UWS
bmb@briennembrown.com
briennembrown.com
p128 Discussing Grandpa's House

HELEN BROWN
Sunriver, OR
hbrownart@aol.com
hbrownart.com
Tumalo Art Co., Bend, OR
p6 Bee My Guest

JESSICA L. BRYANT
Coeur d'Alene, ID
jessicabryant.com
• *Little Death Creek*—Accepted into the 146th Annual
International Exhibition of the American Watercolor
Society in 2012
p117 Little Death Creek

DAQING CAO
caodaqing@msn.com
p132 In the Morning

PETER CAREY
SCVWS
San Jose, CA
petercarey@aol.com
petercareypaintings.com
p102 Swinging Tahoe

SHERRY PHILLIPS CARLSON
Saucier, MS
sherry12carlson@hotmail.com
pinkrooster.net
The Pink Rooster/Gallery Garbo, Ocean Springs, MS
p35 Nice Dreads

OOI AIK CEONG
Selangor, Malaysia
acooi75@yahoo.co.uk
p71 Think & Thought

CHERYLE CHAPLINE
AWS, NWS, CTWS
Woodway, TX
cachapline@yahoo.com
cherylechapline.com
• *Waterline Dance*—Best in Show at CTWS
p85 Waterline Dance

NADINE CHARLSEN
Salmagundi Club, National Association of Women Artists,
Hudson Valley Art Association
Asheville, NC
nadine@nadinepaints.com
nadinepaints.com
310 Art Gallery, Riverview Station, Asheville, NC
• *At the Opera*—Loring W. Coleman Award for Water-
color, New Jersey Watercolor Society
p51 At the Opera

MARVIN CHEW
Singapore Watercolour Society
Singapore
marvinchew.art@gmail.com
marvinchew.com
p46 Fruit Stalls in Penang, Malaysia

LEI CHI
NWS
Santa Clara, CA
michelle.chi@line.com
michellechi.com
• *Chilling Out*—Mijello Mission Gold Merchandise
Award-Martin F. Weber Company, NWS 94th Annual
International Exhibition
p98 Chilling Out

TAN SUZ CHIANG
NWS/S, AWS, Malaysian Watercolour Society, Singapore
Watercolour Society
Johor, Malaysia
tansuzchiang@gmail.com
tansuzchiang.com
Y2ARTS Gallery, Singapore
• *Chit Chat*—Selected for 2 Edition Eau en Couleurs
International Watercolour Biennial, Belgium
p49 Chit Chat No. 2

CHIEN CHUNG-WEI
AWS, NWS
hibariprince@gmail.com
chienchungwei.com; facebook.com/hibariprince
p36 Song of Siena

MARK A. COLLINS
NWS, Watercolor West, SAA
Charlottesville, VA
markcollinsfineart.com
p62 Eager to Launch

NANCY COLLINS
nancycollinsart@sbcglobal.net
nancycollinsart.com
p65 The Ring Bearers

LAUREL COVINGTON-VOGL
AWS, NWS, RMWMS
Durango, CO
laurelvogl@gmail.com
Karyn Gabaldon Fine Arts, Durango, CO
p39 Sunrise: Fushimi Inari

DAVID COX
Washington, DC
dcox20016@gmail.com
p16 Casa Blanca Lily

RON CRAIG
Vallejo, CA
roncraig@me.com
roncraigart.com
• *Stands the Time*—Outstanding Acrylic, Bold Brush
Painting Competition, December 2014
p45 Stands the Time

BRENDA CRETNEY
NFWS
Brockport, NY
bcretney@rochester.rr.com
p63 Shy Penny

EVELYN DUNPHY
New England Watercolor Society, International Guild of
Realism, American Society of Marine Artists
West Bath, ME
artist@evelyndunphy.com
evelyndunphy.com
• *Tea and Sushi*—Daniel Smith Award, Canadian Society
of Painters in Water Colour; included in The Art of
Watercolour World Watercolour Competition
p81 Tea and Sushi

KELLY EDDINGTON
IWS, MOWS
Monroe City, MO
kellyeddington@gmail.com
kellyeddington.com, artfinder.com
• *Hooked*—Illinois Watercolor Society National Juried
Exhibition, May 2015
p70 Hooked

L.S. ELDRIDGE
NWS/S, AWS, MSW
Rogers, AR
lse123a@gmail.com
lseldridge.com
p91 The Measure of Tools

LINDA ERFLE
NWS/S; Watercolor West
Placerville, CA
linda@lindaerfle.net
lindaerfle.net
The Artery, Davis, CA
p10 Fall Magnolia
p11 Mantis with Chives

ROBIN ERICKSON
AWS, NWS, WW
ericksonart2@gmail.com
robinericksonart.com
• *Apple NYC – Inside and Out*—Combined Donors
Award, NWS 94th International Exhibition
p55 Apple NYC – Inside and Out

ANDY EVANSEN
AWS, PAPA
aevansen@gmail.com
evansenartstudio.com
p96 Thawing the Spur

CHERYL A. FAUSEL
NWS, Signature Member; SW; Tallahassee Watercolor
Society
Cape Coral, FL
cherartist@aol.com
cherylafausel.com
Creations Gallery Inc., Punta Gorda, FL

• *Reflected Flowers*—First Prize, Barrier Island Gallery,
Sanibel FL; Mary Bryan Memorial Medal, AWS 148th
Annual International Exhibition
p20 Reflected Flowers

CHARLENE COLLINS FREEMAN
NWWS, Women Painters of Washington
Kenmore, WA
charlene.freeman@me.com
charlenecollinsfreeman.com
Tsuga Fine Art, Bothell, WA
• *London Sweets*—President's Merit Award, NWWS
Waterworks Exhibit 2012
p92 London Sweets

AARON GAN
contact@aarongan.com
aarongan.com
p44 Rebuilding a Nation

KATHLEEN S. GILES
NWS/S; WHS/S; Niagara Frontier Watercolor Society/S
Gasport, NY
kgilesstudio@hotmail.com
kgilesstudio.com
p31 Even the Angels Cried

JEAN K. GILL
AWS, NWS
Oak Hill, VA
jkgillwatercolor@aol.com
jeankgill.com
• *Yellow Rain*—5th Annual Fallbrook Signature American
Watercolor Exhibition, 33rd Annual Adirondacks
National Exhibition of American Watercolors
p134 Yellow Rain

PATRICIA GUZMÁN
SMA, IWS México Representative
México, D.F.
patriciafineart@gmail.com
patriciaguzman.org
• *Forgotten*—First Place, Watercolor Competition, Col-
lection Beaux-Arts Réaliste, 2014; Fourth Place, Homer
Love & Peace Through Art Online Contest, 2015
p111 Forgotten

JOYCE HICKS
AWS
jhicks@jhicksfineart.com
jhicksfineart.com
p114 Perfectly Peaceful Pacific

ANNE HIGHTOWER-PATTERSON
South Carolina Watermedia Society, Member in Excel-
lence; Watercolor Society of Alabama/S; Mississippi
Watercolor Society/S
Leesville, SC
patter816@aol.com
annehightower-patterson.com
Charlotte Fine Art Gallery, Charlotte, NC
• *Hope for the Homeless*—Award Winner, Traveling
Show 2013, South Carolina Watermedia Society; First
Place Watercolor, 2014 South Carolina State Fair
p107 Hope for the Homeless

MICHAEL HOLTER
NWS, SWS, SWA
Plano, TX
michael@michaelholter.com
michaelholter.com
Thunder Horse Gallery, Ruidoso, NM
• *Keeping Myself in Check*—First Place Watermedia,
Texas & Neighbors Regional Art Exhibition
p28 Keeping Myself in Check

ROBERT HOUCK
Beloit, WI
houchstudios@gmail.com
houckstudios.com
p99 Honeysuckle Rose

HUANG HSIAO-HUI
AWS, NWS
colorok3h@gmail.com
facebook.com/hsiaohui.huang.79
• *Faith*—Di Di Deglin Award, 148th AWS Annual
International Exhibition
p40 Faith

LANCE HUNTER
AWS, NWS, WHS
lance@lancehunter.com
lancehunter.com
• *Catch and Release: FT IV*—Watercolor USA Honor
Society Award of Excellence, 2015
p109 Catch and Release: FT IV

LEE HYOUNG JUN
Korea Watercolor Association
Seoul, Korea
gopalette@naver.com
cafe.naver.com/gopalette
p110 A Dazzling Day

CLAUDIA IHL
Nome, AK
claudiaihlart@gmail.com
claudiaihl.com
Artique, Ltd. Anchorage, AK
p17 Kauai Ferns #1

PETER V. JABLOKOW
TWSA, IWS
peterillustrator.com
Paige Wiard Gallery, Calumet, MI
p59 Engine 4436 – Cab

JOYCE K. JENSEN
Watercolor Society of Indiana/S; Indiana Artisan;
American Women Artists
Zionsville, IN
joycekjensen@aol.com
joycekjensen.com
p82 Still Life with Tea Caddy

RUSSELL JEWELL
NWS, TWSA
Easley, SC
jewellart@charter.net
russelljewell.com
Charlotte Fine Art, Charlotte, NC
p141 Oxford Morning

KIM JOHNSON
AWS, NWS, TWSA
Phoenix, AZ
kim@kj-art.com
kj-art.com
p64 So Easily Distracted

CHIZURU MORII KAPLAN
chizurukaplan@gmail.com
chizuruart.com
Hubert Gallery, New York, NY
p41 St. Patrick's, NYC

KEIKO KOBAYASHI
IAA, JWS
mtsk645123.exblog.jp
p126 Moss-Grown Stream

CHRIS KRUPINSKI
AWS-DF, NWS, TWSA-Master
Fairfax, VA
chris@chriskrupinski.com
chriskrupinski.com
• *Lemons and Grapes on a Quilt*—Jeanette Thayer
Schmidt Memorial Award, NWS, 2014; Katie Hill Vaden
Memorial Award, Virginia Watercolor Society, 2015
p19 Lemons and Grapes on a Quilt

KATHLEEN LANZONI
AWS, NWS, Colorado Watercolor Society
Boulder, CO
kathleenlanzoni.com
p119 Pastoral Afternoon

VALERIE LARSEN
NWS, WHS
Webster, NY
vlarsen@valerielarsen.com
valerielarsen.com
ARTISANworks, Rochester, NY
• *Fountain*—Thomas Moran Memorial Award, Salma-
gundi Club Non-Members Exhibition
p103 Fountain

JAN LONG
Eagle Point, Vic, Australia
jan@janlong.com.au
janlong.com.au
p67 Shared Grass

YAEL MAIMON
Ashkelon, Israel
yael_mai@walla.co.il
yaelmaimon.com
p105 War Zone

FRANÇOIS MALNATI
French Watercolor Society
Selestat, France
malnatifrancois@yahoo.fr
malnaquarelle.over-blog.fr
p88 Glasses in Dishwasher

MARCELLA M. MARTIN
SDWS
Escondido, CA
mmartinwatercolors@cox.net
mmartinwatercolors.com
p101 Naso Masquline

MID MARTINEZ
Burlingame Art Society
Foster City, CA
artbymid@gmail.com
p66 Mimi

ANTONIO MASI
American Watercolor Society (President), Allied Artists
of America, Philadelphia Watercolor Society
Garden City, NY
antoniofineart@gmail.com
antoniomasi.com
p54 Family Walk – Manhattan Bridge

MICK MCANDREWS
Downingtown, PA
mick.mcandrews@gmail.com
mickmcandrewsfineart.com
Visual Expansion Gallery, West Chester, PA
p129 Morning in Sitka

ANNE MCCARTNEY
CSPWC, NWS, TWSA
Edmonton, AB, Canada
mcanne1960@gmail.com
mccartneyartworks.com
Daffodil Gallery, Edmonton, Canada
p113 Problem Solving?

CATHERINE MCCOY
London, ON, Canada
catherinemccoy56@gmail.com
catherinemccoy.com
p122 Autumn Under the Footbridge

LAURIN MCCRACKEN
AWS, NWS, WHS
Fort Worth, TX
laurinmc@aol.com
lauringallery.com
Greenberg Fine Art, Santa Fe, NM
• *Lady Churchill Cigars*—Selected for inclusion in the
Beijing International Art Biennale 2015
p78 Lady Churchill Cigars
p116 Boats in the Bay – Howth, Ireland

LESLIE C. MCDONALD JR.
Watercolor Art Society-Houston
Houston, TX
les@lesmcdonald.com
lesmcdonald.com
Mustang Island Art Gallery, Port Aransas, TX
• *Alaska Crab Traps*—AWS 2014 International Show;
Third Place, WAS-H 2014 Annual Membership Show
p130 Alaska Crab Traps

CHRISTINE MISENCIK-BUNN
TWSA, WW, PWS
Fredericktown, OH
chris.m.bunn@gmail.com
facebook.com/watercolorbychristinemisencikbunn
p131 A Time to Reap

DAN MONDLOCH
St. Cloud, MN
artist@danmondloch.com
danmondloch.com
Seasons on St. Croix Gallery, Hudson, WI
p127 Assessed

JAMES SCOTT MORRISON
Hendersonville, NC
morrisonart.com
Framing Arts, Hendersonville, NC
p133 Old Fort Farm

HUGH MOSSMAN
Idaho Watercolor Society, Watercolor West, California
Watercolor Society
Boise, ID
hmossman@gmail.com
mossmanwatercolors.com
p128 Gone Fishing

GLORIA AINSWORTH MOUT
Federation of Canadian Artists, International Guild of
Realism, South Surrey White Rock Art Society
Surrey, BC, Canada
gloriaainsworthmout.com@shaw.ca
gloriaainsworthmout.com
Federation of Canadian Artists Gallery, Vancouver, BC
p89 Reflections in Blue and Gold

DANIEL NAPP
Muenster, Germany
email@daniel-napp.de
facebook.com/napp.watercolour
p53 Politechniou Street, Thessaloniki

MARIE NATALE
NJWCS, PWCS
Egg Harbor Township, NJ
mariedezines@comcast.net
marienatale.com
p56 Happy Hour at the Ebbitt Room

R. MIKE NICHOLS
SDWS, WW, NWS
Riverside, CA
mnico13@yahoo.com
mnico.weebly.com
p69 Quorra Amongst the Gladiolas
p108 Topsy Turvy

JUDY NUNNO
FWS
Weston, FL
jnunno@aol.com
judynunno.com
• *Six Ways to Sundae*—First Place, Weston Art Guild
Show, 2014; People's Choice, Gold Coast Watercolor
Open Show, 2015
p92 Six Ways to Sundae

CATHERINE P. O'NEILL
AWS, NWS, TWSA
Hamburg, NY
kconeill@roadrunner.com
catherineponeill.com
p94 Paul's Porch

LISA O'REGAN
CSPWC, PWS
Saint-Hubert, QC, Canada
lisa.oregan@gmail.com
p32 Sunoculars

ROGER H. PARENT
Florida Watercolor Society/S; Southern Watercolor Society
Osprey, FL
rogerparent@verizon.net
fineartamerica.com/profiles/roger-parent
• *Harbor Glow*—Honorable Mention, Florida Suncoast
Watercolor Society, 2014
p135 Harbor Glow

MONIKA PATE
AWS, NWS, TWSA
College Station, TX
map352@gmail.com
monikapate.com
p90 Memories

SANDRINE PELISSIER
AFCA, SDWS, NWWS
sandrine@watercolorpainting.ca
sandrinepelissier.com
p104 Selfie

LUIS F. PEREZ
Northern Westchester Artists Guild
Armonk, NY
luisfdoperez@aol.com
p57 View of Venice Within Venice

LYNN D. PRATT
Vermont Watercolor Society/S
Pawlet, VT
pratt.lynn@gmail.com
lynndpratt.com
p74 Money Laundering

KRIS PRESLAN
NWS, TWSA, WW
Lake Oswego, OR
krispreslan@me.com
preslanart.com
Portland Art Museum Gallery, Portland, OR
p86 Dinner's on Jane

DAVID RANKIN
Ohio Watercolor Society, Society of Animal Artists, Artists
for Conservation
University Heights, OH
davidrankinwatercolors@gmail.com
davidrankinwatercolors.com
facebook.com/davidrankinwatercolors
p68 Arundhati at the Ganges

CHRIS ROGERS
Brazos Valley Art League
Hilltop Lakes, TX
crnovelist@earthlink.net
carogersart.com
The Arts Council of Brazos Valley, College Station, TX
p34 Head Study of Nelson DeMille

ANTHONY ROGONE
NWS
Rocklin, CA
rogonewatercolors.com
• *Cherry Bowl*— Award of Merit, California State Fair,
2014; Inside Publications Award
p86 Cherry Bowl

SHERRY ROPER
SDWS
San Diego, CA
sroper15@cox.net
sherryroper.com
p99 Passing Time II

THOMAS W. SCHALLER
AWS, NWWS, CAC
Marina del Rey, CA
thomasschaller.com
p48 Steps of Rocamadour

LYNN SCHILLING
SCWS, Member in Excellence; WSA, Signature Member
Lake Wylie, SC
lms763art@gmail.com
• *Dressed to the Nines*—Accepted into 2015 AWS
International Exhibition
p25 Dressed to the Nines

JAYSON YEOH CHOON SENG
Missouri Watercolor Society, Singapore Watercolor
Society, Malaysia Watercolor Society
Kedah, Malaysia
jaysonyeoh@gmail.com
jaysonart.com
p121 Accumulate #92

ALISA SHEA
Northport, NY
alisa@alisashea.com
alisashea.com
p87 Painted Lady

THERESA SHEPHERD
Virginia Watercolor Society, Central Virginia Watercolor
Guild, Colorado Watercolor Society
Midlothian, VA
terry@theresashepherdwatercolors.com
theresashepherdwatercolors.com
• *Badger Hound*—Juror's Choice Award, Central Virginia
Watercolor Guild, 2013; Award of Distinction, Virginia
Watercolor Society, 2015
p68 Badger Hound
p73 Extended Lunch Break

JEAN SMITH
WSI of Indiana, Indiana Artists Club, Hoosier Salon
Fishers, IN
1puttjr@msn.com
• *Disaster in Alabama*—Best of Show, Indiana Artist's
Club 2012 Fall Membership Exhibit; Winner in the *The
Artist's Magazine* 2014 Over 60 Art Competition
p124 Disaster in Alabama

JERRY SMITH
AWS, TWSA, ASMA
Crawfordsville, IN
jsmith@jsmithstudio.com
jsmithstudio.com
Brown County Art Guild Gallery, Nashville, IN
• *Herbal Equation*—Merit Award, Transparent Water-
color Society of America 2015 Exhibition
p118 Herbal Equation

KAY STERN
Houston, TX
p24 Mike Our Mailman

DAVID L. STICKEL
AWS, NWS, Watercolor Society of North Carolina
Chapel Hill, NC
dlstickel@juno.com
davidstickel.com
waverlyartistsgroup.com gallery
• *Fashion Facade*—WSNC Award, 69th Annual Juried
Exhibition
p42 Fashion Facade

RON STOCKE
AWS, NWWS, CSPWC
ronstocke@yahoo.com
ronstocke.com
Cole Gallery, Edmonds, WA
p43 Morning Market, Seattle
p58 Paris Light

LUANNE STONE
Gepp, AR
lustone@centurytel.net
luannestoneartist.com
• *Too Many Stripes*—Second Place, Mid-Southern
Watercolorists
p83 Too Many Stripes

SUSAN M. STULLER
NWS, TWSA, MOWS
Midlothian, VA
susan.stuller@comcast.net
susanstuller.com
Crossroads Art Center, Richmond, VA
p76 An Apple a Day

SUJIT SUDHI
Tripunithura, Kerala, India
ssudhi@gmail.com
p118 Morning Light

RON SUMNER
Windsor, CA
sonomron@pacbell.net
Upstairs Gallery, Healdsburg, CA
p72 Night Heron

JIMMY TABLANTE
NWWS, HWS
jtdesignsonline@gmail.com
p50 Early Morning Drive

NANCY MEADOWS TAYLOR
AWS, NWS, RMNW
Raleigh, NC
nmtpainter@bellsouth.net
nancymeadowstaylor.com
Wild Stream Studio, Raleigh, NC
p12 Summer Fire

DAVID J. TETER
NWS
San Pedro, CA
davidteter@att.net
davidteterart.blogspot.com
p44 E. 4th St. Bridge

ZHOU TIANYA
AWS, NWS, AWI
Shenzhen City, Guangdong Province, China
ztianya@126.com
www.zhoutianya.com
• *Go to Town*—Morris J. Shubin Memorial Award, AWS
148th Annual International Exhibition, 2015
p100 Go to Town

THOMAS VALENTI
Allied Artists of America (President); Salmagundi Club,
Honorary Member; New Jersey Watercolor Society
Washington Township, NJ
thomasv102@aol.com
thomasvalenti.com
Studio 7, Bernardsville, NJ
p52 Temple of Karnak

BETH VERHEYDEN
WSO, NWWS
Boring, OR
vstudios@comcast.net
bethverheyden.net
• *Chasing Vista*—Glenda Bertram Memorial Award,
Western Federation of Watercolor Societies, 2015; Sixth
Place, Watercolor Society of Oregon, 2014
p103 Chasing Vista

CARRIE WALLER
LWS
PSC 78 Box 4167
APO, AP 96326
carriewallerart@gmail.com
carriewallerfineart.com
• *Banned*—Dana Bartlett Award, NWS; Runner-up, Art-
ist of the Year, *Artists and Illustrators Magazine*
p80 Banned

JUDY WALLER
WSO
Roseburg, OR
johnandjudywaller@charter.net
johnandjudywaller.com/art
• *Fine-Tuning Allis*—Silver Medal Award, Emerald National
Juried Show, 2014
p34 Fine-Tuning Allis

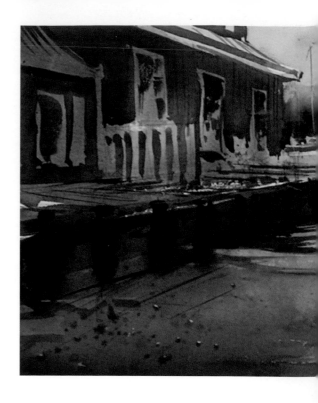

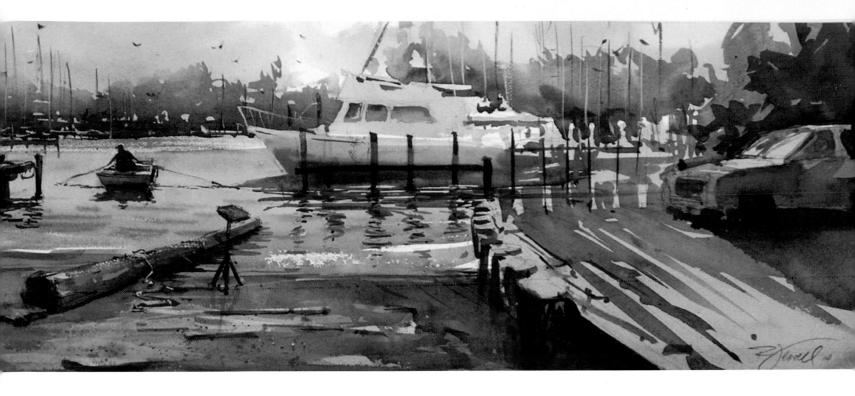

OXFORD MORNING

Russell Jewell

Watercolor on cold-pressed
Arches watercolor board

12" × 36" (30cm × 91cm)

TENSION BECOMES CREATIVE CATALYST

Serene as *Oxford Morning* may appear, the painting was actually created under the duress of intense competition. It was John Singer Sargent who said, "Painting in watercolor is like making the most of an emergency!" This 12" × 36" (30cm × 91cm) emergency was painted on a mid-July morning from 6:00 A.M. to 9:00 A.M. while competing in Plein Air Easton, one the most prestigious plein air competitions in the United States. Maryland's eastern shore offers stunning scenery to competitors who paint with an ever-mindful sense of trepidation. My watercolor board was precut to the size of the frame with the edging protected by masking tape. Once the painting was completed, the tape stripped away, the piece was ready for framing and exhibition.

TANIA WALTERS

Marin County Watercolor Society, California Watercolor Association, Artist of Marin Museum of Contemporary Art
San Rafael, CA
taniaawalters@yahoo.com
taniawalterswatercolors.com
• *Garden's Brightest Glories*—Honorable Mention, Marin Society of Artists 87th Annual Members Show
p18 Garden's Brightest Glories

WEN-CONG WANG

New Taipei City, Taiwan (R.O.C.)
wencong.w@gmail.com
wangwencong.com
p97 Tanker Wash Worker

MARNEY WARD

SFCA; SCA; Federation of Canadian Artists, Senior Signature Member
Victoria, BC, Canada
marney@marneyward.com
marneyward.com
p14 Zinnia

SOON Y. WARREN

AWS, NWS, TWSA
Fort Worth, TX
soonywarren@gmail.com
soonwarren.com
Your Private Collection Art Gallery, Granbury, TX
• *Sunflowers*—Best of Show, Texas & Neighbors Regional Art Exhibition

• *Chinese Lantern*—Best of Show, SWA; Joan Pechman Memorial Award, Rocky Mountain Watermedia
p13 Sunflowers
p21 Chinese Lantern

SALLY R. WEBB

Amite, LA
sallyrwebb@yahoo.com
p79 Lucky Butterflies

CINDY WELCH

CWS
Castle Rock, CO
cindy@cindywelchdesign.com
cindywelchdesign.com
Colorado Art and Framing Gallery, Castle Rock, CO
• *Castle Rock Feed & Supply*—Honorable Mention and People's Choice, City of Front Range National Arts Program Exhibit
p120 Castle Rock Feed & Supply

JARROD WILSON

Virginia Watercolor Association/S
Galax, VA
info@jarrodwilsonfineart.com
jarrodwilsonfineart.com
p84 Hail to the Foam

CATHARINE MILLAR WOODS

CWS
Boulder, CO
cathy.woods@comcast.net
catharinewoods.com
p9 Great Grannies

WILLIAM C. WRIGHT

AWS, BWS, MAPAPA
Stevenson, MD
wmwrights@gmail.com
williamcwrightstudio.com
M.A. Doran Gallery, Tulsa, OK
• *One Inch Snow*—Watercolor USA 2013, Springfield Art Museum, Springfield, MO
p125 One Inch Snow

DIETER WYSTEMP

DAGWS (German Watercolor Society)
Langen, Germany
flickr.com/photos/wystemd
p5 Purple Rain

KEIKO YASUOKA

AWS, NWS, TWSA
Houston, TX
keiko_yasuoka@hotmail.com
2collaboratingartists.com
Harris Gallery, Houston, TX
• *Sunset in Victoria*—First Place, Watercolor Art Society-Houston Members Exhibition, 2014
p38 Sunset in Victoria

CHENG FEN YEH

Radford, VA
cyeh2000@yahoo.com
p26 The East

INDEX

ABOUT THE EDITOR

Rachel Rubin Wolf is a freelance editor and artist. She has edited and written many fine art books for North Light Books, including *Watercolor Secrets*; the *Splash: The Best of Watercolor* series; the *Strokes of Genius: Best of Drawing* series; *The Best of Wildlife Art* (editions 1 and 2); *The Best of Portrait Painting*; *Best of Flower Painting 2*; *The Acrylic Painter's Book of Styles and Techniques*; *Painting Ships, Shores and the Sea*; and *Painting the Many Moods of Light*. She also has acquired numerous fine art book projects for North Light Books and has contributed to magazines such as *Fine Art Connoisseur* and *Wildlife Art*.

ACKNOWLEDGMENTS

Many thanks to the editors, designers and staff at North Light Books who have collected and organized material for me, and took care of the technical ins and outs of our online entries. It takes a village to turn artwork and captions into this beautiful finished book. My gratitude to publisher Jamie Markle and production editor Jennifer Bass. Special thanks, as always, to senior editor par excellence Sarah Laichas and designer Jamie Deanne.

My continuing gratitude to all of the contributing artists who, with much generosity of spirit, shared with us their work and their thoughts. Your art is inspiring and so many of your words are insightful and thought-provoking. Thank you also for getting the properly formatted digital photos to us in a timely manner, and for your inspired perspective on life that enables you to create these beautiful paintings.

Splash 17: Inspiring Subjects. Copyright © 2016 by F+W Media, Inc. Manufactured in China. All rights reserved. No part of this book may be reproduced in any form or by any electronic or mechanical means including information storage and retrieval systems without permission in writing from the publisher, except by a reviewer who may quote brief passages in a review. Published by North Light Books, an imprint of F+W Media, Inc., 10151 Carver Road, Suite 200, Blue Ash, Ohio, 45242. (800) 289-0963. First Edition.

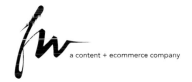

a content + ecommerce company

Other fine North Light Books are available from your favorite bookstore, art supply store or online supplier. Visit our website at fwcommunity.com.

20 19 18 17 16 5 4 3 2 1

DISTRIBUTED IN CANADA BY FRASER DIRECT
100 Armstrong Avenue
Georgetown, ON, Canada L7G 5S4
Tel: (905) 877-4411

DISTRIBUTED IN THE U.K. AND EUROPE
BY F&W MEDIA INTERNATIONAL LTD
Brunel House, Forde Close, Newton Abbot, TQ12 4PU, UK
Tel: (+44) 1626 323200, Fax: (+44) 1626 323319
Email: enquiries@fwmedia.com

DISTRIBUTED IN AUSTRALIA BY CAPRICORN LINK
P.O. Box 704, S. Windsor NSW, 2756 Australia
Tel: (02) 4560 1600; Fax: (02) 4577 5288
Email: books@capricornlink.com.au

ISBN 13: 978-1-4403-4129-8

Production edited by Sarah Laichas
Designed by Jamie DeAnne
Production coordinated by Jennifer Bass

Front cover image: Peter Carey | Swinging Tahoe | p102
Back cover image: Luis F. Perez | View of Venice Within Venice | p57

Be not discouraged by those who seem only to splash it on, for in every stroke a lifelong struggle goes hidden. —Russell Jewell

Metric Conversion Chart		
To convert	to	multiply by
Inches	Centimeters	2.54
Centimeters	Inches	0.4
Feet	Centimeters	30.5
Centimeters	Feet	0.03
Yards	Meters	0.9
Meters	Yards	1.1

Ideas. Instruction. Inspiration.

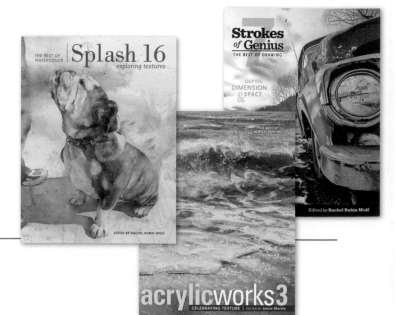